THE
RIVERSIDE GARDENS
OF
THOMAS MORE'S
LONDON

PUBLISHED FOR

THE

PAUL MELLON

CENTRE

FOR STUDIES IN

BRITISH ART

BY

YALE UNIVERSITY PRESS

NEW HAVEN AND LONDON

THE
RIVERSIDE
GARDENS
OF
THOMAS
MORE'S
LONDON

C. PAUL
CHRISTIANSON

Designed by Gillian Malpass

Printed in China

Library of Congress Cataloging-in-Publication Data

Christianson, C. Paul, 1933–
 The riverside gardens of Thomas Moore's London /
 Paul Christianson.
 p. cm.
 Includes bibliographical references and index.
 ISBN 0-300-10905-9 (cl : alk. paper)
 1. Gardens–England–London–History.
 2. Gardening–England–London–History.
 3. Great Britain--History–Tudors, 1485–1603.
 I. Title.
 SB466.G8L62 2005
 712'.09421'2'09031–dc22

 2005008416

A catalogue record for this book is available from
The British Library

Frontispiece: Adapted title page, from John Gerard, *The Herball, or Generall Historie of Plantes* (London, 1597). Bodleian Library, Oxford.

Botanical drawings used throughout the book are listed by name on p. 223
and are by and the copyright of George W. Olson

Contents

OLSON

Acknowledgments vi

Abbeviations vii

Introduction: Gardens Productive and Elegant 1

1 Eight London Gardens on the River Thames 21
 London Bridge House 23
 Tower of London 32
 Winchester Palace 42
 York Place and Whitehall Palace 50
 Lambeth Palace 66
 More's Chelsea Manor 74
 Fulham Palace 84
 Hampton Court 90

2 The London Gardeners 107

3 Tools of the Gardeners' Trade 123

4 Garden Design and Innovation 151

5 Garden Pride and Pleasure 175

 Epilogue: The Uses of Garden History 191

 Notes 199

 Appendices 213

 List of Botanical Illustrations 223

 Index 224

Acknowledgments

I THANK LIBBY BRUCH OF Quailcrest Farms, Wooster, Ohio, and the members of the Great Lakes Herb Society, at whose invitation I first addressed the topic of London's garden history. From this experience eventually grew the idea for the present book. Early support for this study of garden history came from the College of Wooster (Ohio), which awarded me a research leave to pursue the project's initial stages in 1995–6.

For use of archival materials in their keeping I thank James R. Sewell and Juliet Bankes at the Corporation of London Records Office, Miranda Poliakoff at the Fulham Palace Library, and the staff at the Hampshire Record Office, the Lambeth Palace Library, the Public Record Office, the Guildhall Library, the Lindley Library, and the Westminster Reference Library. I also wish especially to thank Hazel Forsyth at the Museum of London, Vivienne Aldous at the Corporation of London Records Office, Jonathan Foyle at Historic Royal Palaces, and Martha Carlin. For encouragement of this project, I wish to thank Becky Kendall, Pat Olson, Jacqueline Hoefer, and Todd Longstaffe-Gowan. I express special gratitude to George Olson for the botanical drawings and maps he created for this book and to Dale Doepke for his insightful and invariably helpful reading of the book's text. For permission to publish extracts from my articles entitled "Tools from the Medieval Garden" and "The London Gardener: A Tudor-Age Profile," pubished in volumes 7 and 8 of *The London Gardener* respectively, I thank Todd Longstaffe-Gowan, editor of the journal, and the London Historic Parks and Gardens Trust.

Abbreviations

BHA	Corporation of London Records Office, MS Bridge House Accounts, vols. 1–52 (1404–1829)
BHE	Corporation of London Records Office, MS Expenditures of the Bridge, ser. 1–3 (1404–45, 1505–38, 1552–1741)
Cal. Pat. Rolls	Calendar of Patent Rolls
CLRO	Corporation of London Records Office
EETS	Early English Text Society
HMSO	Her Majesty's Stationery Office
LCC	London County Council
LP Henry VIII	Letters and Papers Foreign and Domestic of the Reign of Henry VIII
PRO	Public Record Office
RIBA	Royal Institute of British Architects
SPCK	Society for Promoting Christian Knowledge

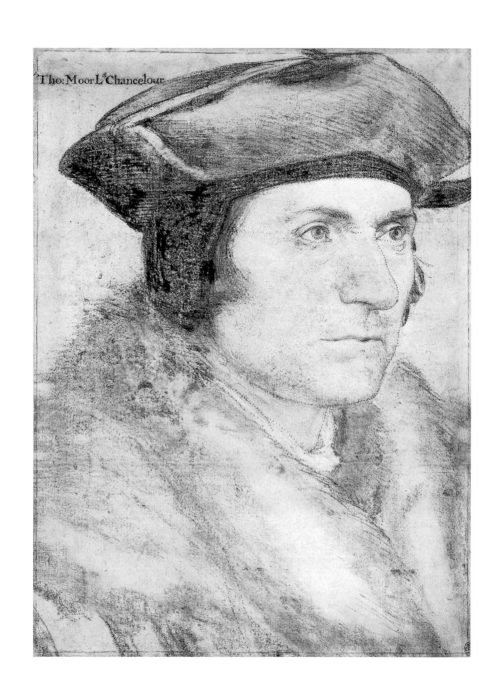
Tho: Moor Lᵈ Chancelour

Introduction Gardens Productive and Elegant

FOR ANYONE DRAWN TO LONDON'S HISTORY, especially to the period of intense cultural transition that began within the reigns of the first two Tudor monarchs, one figure must always stand out, a man whose memory consistently has beckoned later curiosity and interest. That person, of course, is Thomas More (1478–1535), who, because of the enigma his character represents, but also because of his starring role in public life, has often been seen as the quintessential Londoner of his day (pl. 1).[1] Indeed, one could argue, More as singular citizen has become a useful if not also necessary fiction for those who wish to imagine the city's late medieval and early renaissance past.

More's own imagining of London and its history, oddly enough, found its fullest expression in his best-known work, *Utopia* – "the happy place of More's dream" but "a land that will never be," as one writer has put it.[2] There, in the description of Amaurot, the principal city of Utopia – "the most worthy of all" – More presents, in the words of the sunburned traveler Raphael Hythloday, a thinly veiled, but clearly recognizable profile of the London he knew so well. The passage is worth quoting in full, not least for its fond idealization of urban life, but more significantly for the details about London that More found to be most revealing and hence worthiest of comment. The portrait begins with a description of the Thames, as always London's most distinguishing feature:

> Well, then, Amaurot [London] lies up against a gently sloping hill; the town is almost square in shape. From a little below the crest of the hill, it runs down about two miles to the river Anyder

[Thames], and then spreads out along the river banks for a somewhat greater distance. The Anyder rises from a small spring about eighty miles above Amaurot, but other streams flow into it, two of them being pretty big, so that, as it runs past Amaurot, the river has grown to a width of half a mile. It continues to grow even larger until at last, sixty miles further along, it is lost in the ocean. In all this stretch between the sea and the city, and also for some miles above the city, the river is tidal, ebbing and flowing every six hours with a swift current. When the tide comes in, it fills the whole Anyder with salt water for about thirty miles, driving the fresh water back. Even above that for several miles farther, the water is brackish; but a little higher up, as it runs past the city, the water is always fresh, and when the tide ebbs, the water is fresh all the way to the sea.

More then goes on to describe the city itself, beginning with London's prize asset, old London Bridge:

The two banks of the river at Amaurot are linked by a bridge, built not on wooden piles, but on many solid arches of stone. It is placed at the upper end of the city, farthest removed from the sea, so that ships can sail along the entire length of the city quays without obstruction. There is also another stream [presumably the Fleet], not particularly large, but very gentle and pleasant, which rises out of the hill, then flows down through the center of town, and into the Anyder. The inhabitants have walled around the source of this river, which takes its rise a little outside the town, and joined it to the town proper so that if they should be attacked, the enemy would not be able to cut off the stream or divert or poison it. Water from the stream is carried by tile piping into various sections of the lower town. Where the terrain makes this impractical, they collect rain water in cisterns, which serve just as well.

The town is surrounded by a thick, high wall, with many towers and forts. On three sides it is also surrounded by a dry ditch, broad and deep and filled with thorn hedges; on its fourth side, the river itself serves as a moat. The streets are conveniently laid out for use by vehicles and for protection from the wind. Their buildings are by no means paltry; the unbroken rows of houses facing each other across the streets through the whole

town make a fine sight. The streets are twenty feet wide. Behind each row of houses at the center of every block and extending the full length of the streets, there are large gardens.[3]

At this point in the cityscape – or, more properly, the riverscape – it is worth pausing to ask, how accurate was More's picture of London?[4] As a test, one can look at one of the early topographic representations of the city, that found in a woodcut by Franz Hogenberg, dating from around 1572 (pl. 2). Except for the placement of London Bridge, the image bears a striking similarity to More's verbal portrait, including the remarkable details with which he chose to conclude his idealized London description:

Every house has a door to the street and another to the garden. The doors, which are made with two leaves, open easily and swing shut automatically, letting anyone enter who wants to – and so there is no private property. Every ten years they change houses by lot. The Utopians are very fond of these gardens of theirs. They raise vines, fruits, herbs, and flowers, so thrifty and

2 Franz Hogenberg, *Civitas orbis terrarum*, *c*.1572. Guildhall Library, Corporation of London.

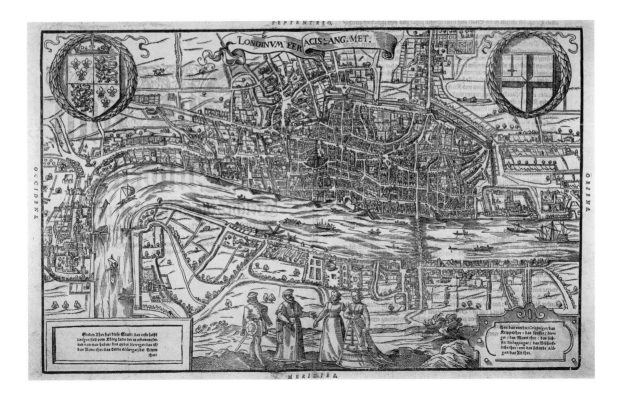

flourishing that I have never seen any gardens more productive or elegant than theirs. They keep interested in gardening, partly because they delight in it, and also because of the competition between different streets which challenge one another to produce the best gardens. Certainly you will find nothing else in the whole city more useful or more pleasant to the citizens. And for that reason, the city's founder seems to have made gardens the primary object of his consideration.[5]

The Hogenberg map, seen in light of this passage, shows clearly indeed what More found most noteworthy about life in London. It was a riverside city filled, both within and without its walls, with garden spaces.

For readers of *Utopia*, such emphasis on gardens and gardening is not surprising; it is reinforced by Hythloday's comment elsewhere about the citizens' lifelong involvement with agriculture:

Agriculture is the one occupation at which everyone works, men and women alike, with no exceptions. They are trained in it from childhood, partly in the schools where they learn theory, and partly through field trips to nearby farms, which make something like a game of practical instruction. On these trips they not only watch the work being done, but frequently pitch in and get a workout by doing the jobs themselves.[6]

Utopia notwithstanding, people attracted to studying More's life today perhaps find it most unlike him to have placed such value on farms and gardens as defining centers for an urban society. Yet upon reflection one need look no further than to his manor in Chelsea to be reminded of the degree to which More's family life, after 1525, was defined by the home he built there alongside the Thames. With its walled gardens nearby, one of them bordered by a gallery, library, and chapel, and with orchards and farming fields stretching inland and London's spires on the horizon, this Chelsea establishment was soon to be a place of family solidarity (pl. 3),[7] even as for More its riverside garden became a special setting where he could treat king, commoner, and family member alike, meeting them as equals on level ground. Indeed, perhaps the most appropriate use of a garden for More, or for the persona he spent a lifetime creating, lay in the witty exchange of ideas in a garden's stage-like setting, as was the

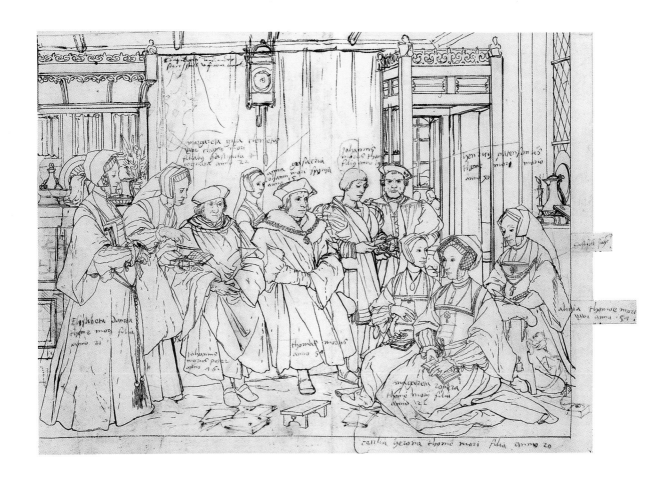

3 Hans Holbein the
Younger, study for *The
Family of Thomas More*,
*c.*1527. Kunstmuseum Basel,
Kupferstichkabinett.

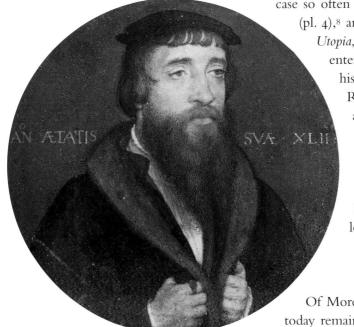

case so often with his son-in-law William Roper (pl. 4),[8] and as was imagined in Book 1 of *Utopia*, where in an Antwerp garden More entertains Raphael Hythloday and hears his amazing tale: "I turned toward Raphael. After greeting one another and exchanging the usual civilities of strangers upon their first meeting, we all went to my house. There in the garden we sat down on a bench covered with turf to talk together. He told us that. . . ."[9] And thus the long story begins to unfold.

★ ★ ★

Of More's Chelsea garden estate, nothing today remains, save the brick walls of a stable block lying to the northwest of the site of his mansion, and a shorter range to its east. A similar fate was to befall virtually all the other green garden spaces of late medieval London, whether inside or outside its walls or along its riverside, as well as their visual representations and even much of their historic record. Yet even though, at a distance of nearly five centuries, there is much that can no longer be known about these lost gardens, certain useful and at times tantalizing pieces of information about them stubbornly survive. Preserved by chance in archival documents, these fugitive garden data thus offer at least a glimpse of city gardens at the time, particularly a group of them that can be closely associated with More during his lifetime.

This book takes as its subject the riverside gardens of More's London in the late fifteenth and early sixteenth centuries. These include his own private garden in Chelsea as well as seven others, each of them once sited along the banks of the Thames, from the Tower of London westward to Hampton Court, and each belonging to one or another of More's close acquaintances. Like More's garden manor, these gardens owed their existence to the Thames, which still served, as it had for centuries, as the principal thoroughfare for the social and political world of London, a complex riparian culture that

4 Hans Holbein the Younger (attributed), *William Roper, c.*1527. The Metropolitan Museum of Art, Rogers Fund, 1950. (50.69.1) (reproduced larger than actual size).

More and his contemporaries knew intimately. Some of these gardens were ancient in origin, while others, like More's, dated from the years of his lifetime. In addition, unlike gardens within the City of London itself, which were for the most part understandably restricted in space, these riverside gardens were all large ones, meant to reflect honorably on their owners' social position and often on their political importance. Perhaps most important, all these gardens, because of their owners, can be tied to events in More's life that inform the biography of this preeminent Londoner.

Because of the Thames that linked these historic gardens, it is useful to return to a portion of the Hogenberg map of London that shows the river in relation to the City. To the left of center on this map detail (pl. 5), London Bridge, the important span connecting the City and Southwark (and until 1750 the sole bridge across the river), becomes a point of reference. To the right of the bridge, slightly downriver from its Southwark foot, appears the tower of St. Olave's church, directly to the east of which (although not visible on the map) was sited the ancient Bridge House, the administrative center for the bridge, within whose precincts lay the first of the gardens considered here. Long since forgotten by most modern historians, the Bridge House garden, throughout the 450 years of its recorded history (until 1831), had important ties to the City. The Lord Mayor and Aldermen maintained a vested financial interest in the lucrative Bridge House Estates, with its many properties held in trust, and regularly visited both the Bridge House and its garden, especially when overseeing the annual audit of Bridge income. As Under-Sheriff of the City for ten years (1510–19), More would likewise have known this garden well through official visits to the Bridge House, when, like his father before him and like his son-in-law William Roper, he served on occasion as legal counsel to the Bridge Wardens.[10]

For those who worked in or near the Bridge House, the garden there would have been a place of grim witness when, following More's execution at the Tower on 6 July 1535, his head was displayed on a tall pole at the gate of the bridge, its profile looming on the near horizon (such gruesome displays of "justice" continued even into the seventeenth century: pl. 6). At the time, some of those witnesses would have remembered, perhaps with a cruel sense of irony, a far different day, thirteen years earlier, when More had passed

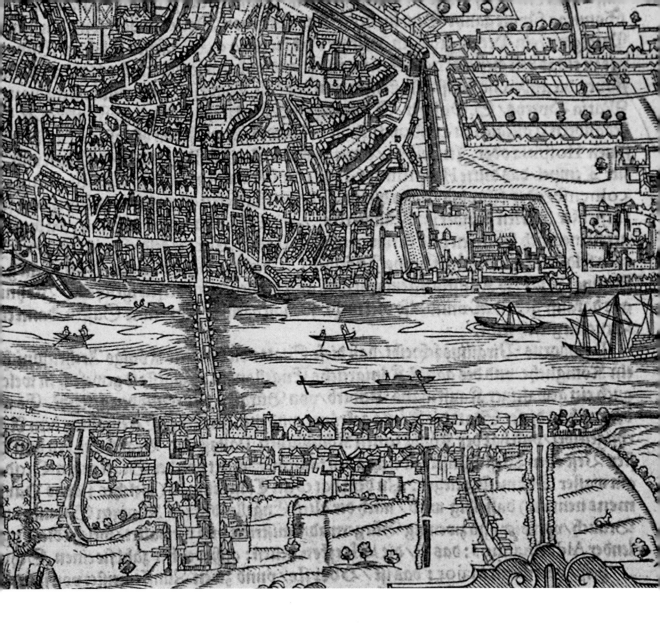

5 Franz Hogenberg, *Civitas orbis terrarum* (detail of pl. 2).

through the same gateway in the retinue accompanying the emperor Charles v upon his entry into London during his second visit to England, a grand procession that had begun with More reading the official address of welcome at St. George's Bar, near the bottom of the Borough High Street.[11]

Downriver from the Bridge House garden and on the opposite bank, the map detail next shows the Tower of London, with its familiar historic associations as the place where More was so long imprisoned (1534–35). To the southeast of its most distinguishing

feature, the White Tower, and extending on both sides of a curtain wall between two of its outer towers, lay a second garden here to be examined, the King's Privy Garden. Enlarged at the turn of the century by Henry VII, but rarely visited by Henry VIII, this garden served as the likely place where More, as a special prisoner, was allowed to take his exercise.[12] The map also shows, 100 yards to the north of the Tower precincts, the remnants of the walled orchard created by Henry III in the thirteenth century and still maintained by Henry VII in the fifteenth, later known as the Nine Gardens. Overlooking Tower Hill, this garden area would also have been a place for grim witnessing, in this case More's actual death at the hands of the royal executioner.

Returning to the map detail and looking left, only a short distance upriver from the bridge foot on the Southwark bank, one next sees the water frontage of Winchester Palace, the ancient London residence of the bishops of Winchester. Behind it, to the

6 C. J. Visscher, *Long View of London* (detail), 1616. Guildhall Library, Corporation of London.

The Globe

Beere bayting

7 Wenceslaus Hollar, *Long View of London from Bankside* (detail), 1647. Guildhall Library, Corporation of London.

south, lay the palace's extensive garden grounds, as may be seen in Wenceslaus Hollar's *Long View of London from Bankside*, first published in 1647 (pl. 7). Here, too, More would have visited, especially after 1500 during the tenure of Bishop Richard Fox, whose involvement in royal politics in many respects rivaled More's own. The godfather of Henry VIII, Fox later brought Thomas Wolsey to royal notice. More was also closely associated, at Winchester Palace and elsewhere, with Fox's successor, Stephen Gardiner, who served the king as royal secretary after 1529, when More succeeded Wolsey in the office of Lord Chancellor.

Other gardens that More would have known lay further upriver, as seen in another detail from the Hogenberg map, showing the

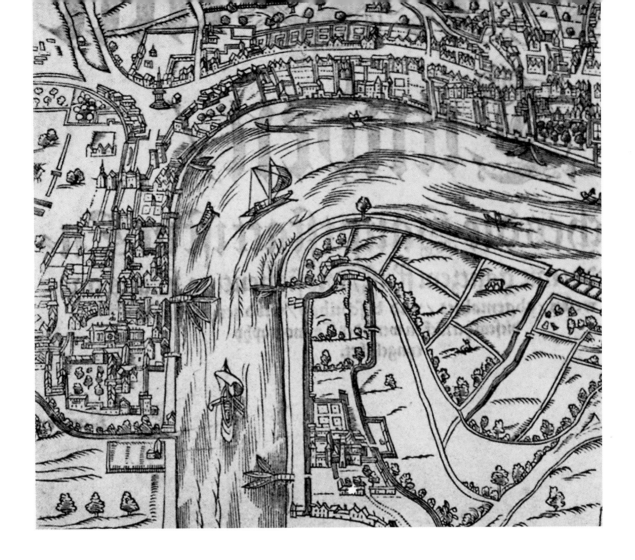

south bend in the river, with Westminster to the left (pl. 8). The first
of these is the garden at York Place (later Whitehall), here shown as
it was later laid out, in quadrants. First developed in 1514 by
Cardinal Wolsey (pl. 9), the property was, at his fall from power in
1529, surrendered to Henry VIII, who, in 1533, gave the estate to
Anne Boleyn as a wedding present. Again More would have been
quite familiar with this garden estate, especially during the 1520s. In
1523, for example, as reported by William Roper, More, then Speaker
of the House, visited Wolsey in his sumptuous riverside gallery,
recently built, which overlooked a portion of the garden nearby.
There, supposedly in response to Wolsey's reprimand, More adroitly
changed the subject: "And to wind such quarrels out of the

8 Franz Hogenberg, *Civitas
orbis terrarum* (detail of pl. 2).

9 Sir John Gilbert, *Cardinal Wolsey, Chancellor of England, on his Progress to Westminster Hall*, 1887. Guildhall Art Gallery, Corporation of London.

Cardinal's head, he began to talk of that gallery, and said, 'I like this gallery of yours, my lord, much better than your gallery at Hampton Court.'"[13] Nine years later, on 16 May 1532, this same garden area was presumably the site of More's last meeting with Henry VIII, the occasion his formal resignation of the Chancellorship.[14] Even at the time, York Place was in the process of being transformed into Whitehall Palace, its precincts now the site of Henry's own early ambitious horticultural schemes.

Again moving upriver, and across from Westminster Abbey, the map shows the garden and large park by Lambeth Palace, the London home of the archbishops of Canterbury. The Lambeth garden would have had special associations for More, first as a young boy in 1490 when serving as a page in the household of his great mentor, Cardinal John Morton.[15] More's esteem for Morton was recorded in *Utopia*, in the words of Hythloday:

At that time I was very deeply beholden to the reverend prelate John Cardinal Morton, Archbishop of Canterbury, and in addition at that time Lord Chancellor of England. He was a man, my dear Peter (for More knows about him, and can tell what I'm going to say), as much respected for his wisdom and virtue as for his

10 After Hans Holbein the Younger, *William Warham, Archbishop of Canterbury, c.*1527. National Portrait Gallery, London.

authority . . . His speech was polished and pointed; his knowledge of the law was great, he had a vast understanding and a prodigious memory – for he had improved extraordinary natural abilities by constant study and practice. At the time when I was in England, the king [Henry VII] depended greatly on his advice, and he seemed the chief support of the nation as a whole.[16]

Thirty years after his first experiences there, More also had daily contact for an extended period and on occasion at Lambeth Palace with Morton's successor, William Warham (pl. 10).[17] More's final visit to Lambeth and specifically its garden occurred in 1534, when he sat overlooking the garden expanse while considering his rejection of the Commissioners (including Warham's successor, Thomas Cranmer) assigned to examine his loyalty, and whose findings would cause him to be remanded to custody in the Tower.[18]

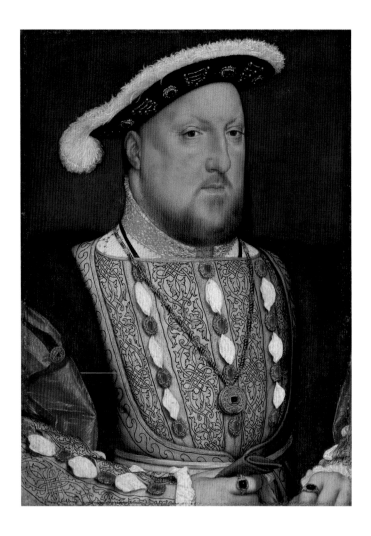

Two miles further upstream, and therefore outside the purview of the Hogenberg map, lay More's own estate in Chelsea, where he and his family spent the last ten years of his life. Especially during the period from 1525 to 1532, the manor house and its elaborate gardens became famous as a venue, frequented by many visitors arriving on business with More in his role as Chancellor of the Duchy of Lancaster (after 1525) and later as Lord Chancellor (from 1529). Other periodic visitors included a parade of visiting scholars, both from abroad and from Cambridge and Oxford, as well as distinguished friends, such as Thomas Howard, 3rd Duke of Norfolk, and even, on more than one occasion, the king himself (pl. 11).[19]

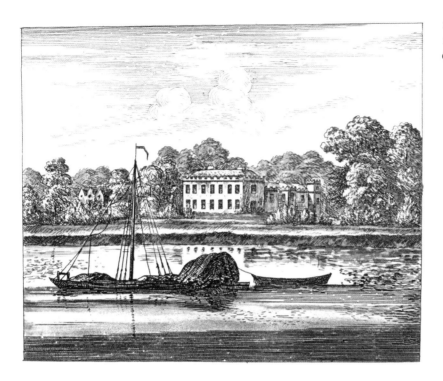

12 Anon., *Fulham Palace*, 1795. Guildhall Library, Corporation of London.

Beyond More's property, only a short distance away, in Fulham, lay the riverside garden and park by the palace there, the country home of the bishops of London, here shown in a late eighteenth-century view (pl. 12). Again, More would have known the Fulham estate well, especially in the 1520s when his old friend Cuthbert Tunstall was in residence,[20] but also later during the tenure of Tunstall's successor, John Stokesley, himself a frequent visitor to More in Chelsea, on more than one occasion using More's garden precincts as a place to interview heretics.[21]

Finally, approximately 12 miles further up the river, one finds the enormous new country palace and gardens of Cardinal Wolsey, at Hampton Court. As the most powerful ecclesiastical and political figure of his day, Wolsey would have seen More there on numerous occasions during the 1520s (even as their paths crossed elsewhere, especially in Westminster). Framed by the most famous of the garden sites here to be examined, Hampton Court between 1515 and 1529 saw lavish horticultural planning and expenditure by Wolsey, such investment of interest to be surpassed only by Henry VIII in the

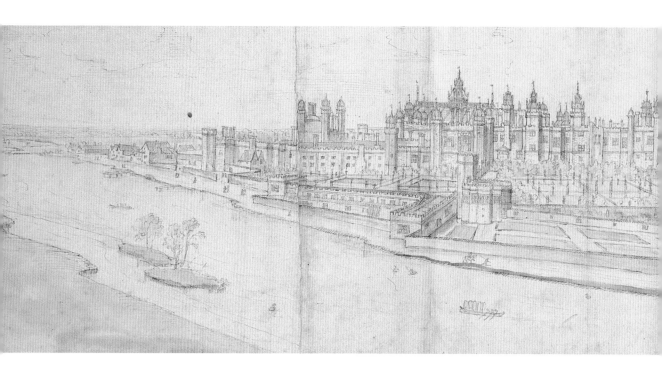

13 Anthonis van den
Wyngaerde, *Hampton Court
from the South* (detail) *c.*1558.
Ashmolean Museum,
Oxford.

1530s, after he had taken possession of the property, here as shown in
the earliest depiction of the palace and grounds, drawn by Anthonis
van den Wyngaerde in about 1558 (pl. 13). More would have seen
only the initial stages of Henry VIII's transformation of Wolsey's
gardens. His last visit to Hampton Court occurred in 1531.

★ ★ ★

Inevitably, any study of London gardens dated by More's lifetime
must pause to reflect on these years as transitional, a horticultural
period caught between the medieval and the modern, much as
was More's world itself. No longer solely defined by late medieval
gardening ideas, such as the *hortus conclusus* or walled private garden,
and not yet, in England, under the full French influence of Italian-
inspired humanist concepts of the garden as architectural space, this
time in the nation's garden history presents numerous problems for
those who study it. In the absence of hard evidence, little is to be
gained from asking whether English gardens at this juncture were
still simply a reflection of the past or were sure harbingers of the

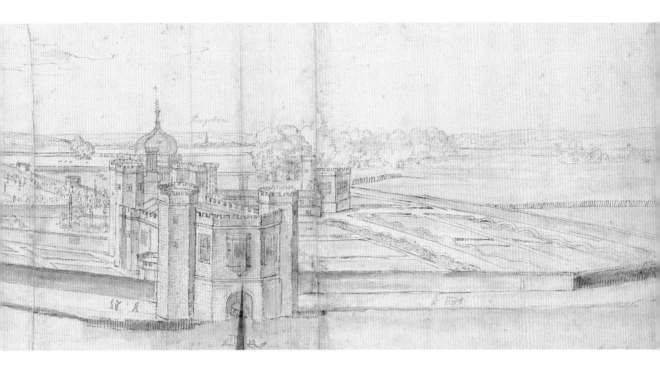

future. Nor is it of much help to say that some of them, especially in or near London, were, ambiguously, both. More fruitful lines of questioning must ask instead, how at this time were ideas for gardens and their design features understood? how imagined and thus defined? and by whom and to what conscious purpose or social effect?

More often than not, such questions have not been addressed, for few historians have chosen (or thought it possible to do so) to examine in detail the enigmatic issues of the old and the new in English gardening that London gardens can be said to reflect during this brief era. Full enquiry has largely been deferred, in part because, up to now, little evidence about actual gardens has been found, but also in part because the questions to be mooted were soon resolved (if somewhat prematurely) by the enthusiasm of Henry VIII, in his later years, for garden innovation and new horticultural ideas at Whitehall, Hampton Court, and Nonesuch in Surrey, anticipating the great changes to come a generation later in the English renaissance garden. While he lived, however, More would have understood the river gardens he and his contemporaries knew so well as timely

17

responses to a cultural world in flux, and certainly as places to confront its challenges and, finally, to affirm one's view of life.

Although later use of their sites has in almost every case destroyed the soil's palimpsest of the eight early Tudor gardens here held up to scrutiny, the records of their existence, however fragmentary, still invite further enquiry into their histories, which this study attempts to encourage. To be sure, complete understanding of each garden, in its own right, is beyond recovery. Yet studied comparatively as a group, these gardens merit attention because together they offer more information about gardening during this period than does any single garden. As a complement to London's river and garden history, moreover, such data that survive about these riverside places show us what is still possible to learn or surmise about both the pleasure and the competitive nature of Tudor gardening as More and his fellow Londoners would have understood them.

To revisit the past as revealed by London's historic gardens by the River Thames thus becomes the purpose of this book. To this end, the following chapters examine a series of related yet hitherto often unexamined issues: the history of these gardens and their owners' garden interests; the economic opportunities of the gardeners they employed, permitting the formation of a community of garden workers antedating by a century the charter of the Company of Gardeners in 1605; the efficacy of the tools the gardeners used and the demands made by new garden ideas in how they used them; the evolving features of garden design and innovation for a contemporary riverside garden; and the personal and social strategies for use of these uniquely sited garden spaces. Because More would have known all of the gardens here examined, moreover, this book looks to their histories as partially his as well, and thus explores how garden history might be used to interpret the imaginative role that gardening appears to have played in shaping his life and outlook.

In the past, few students of More have commented on his possible garden interests. He is, to the contrary, a man whom modern enquiry has studied most often in terms of intellectual history seen in a highly political context. Yet More, it must be remembered, was also a man of a practical committed life, in its later stages centered on his Chelsea home and garden. If the former, in his eyes, served as a laboratory of idealized family values, the latter also quickly became for him a valued setting both for inventive and witty social discourse

in his garden walkabouts with visitors and for personal retreat in his library and private chapel overlooking one of the garden spaces. His rural estate stands unique among the other riverside gardens here under study. It invites interest today insofar as it helps to reveal what was newest and most attractive in garden planning during the early sixteenth century. But it can tell us more. Indeed, the story of More and his garden also helps to explain why, in the final years of his life, he became a man isolated by his convictions. In the end, to study More's garden in comparison with those of his closest colleagues will inevitably serve to challenge our own historic imagination by casting a different light on this important Tudor era of cultural change and transformation.

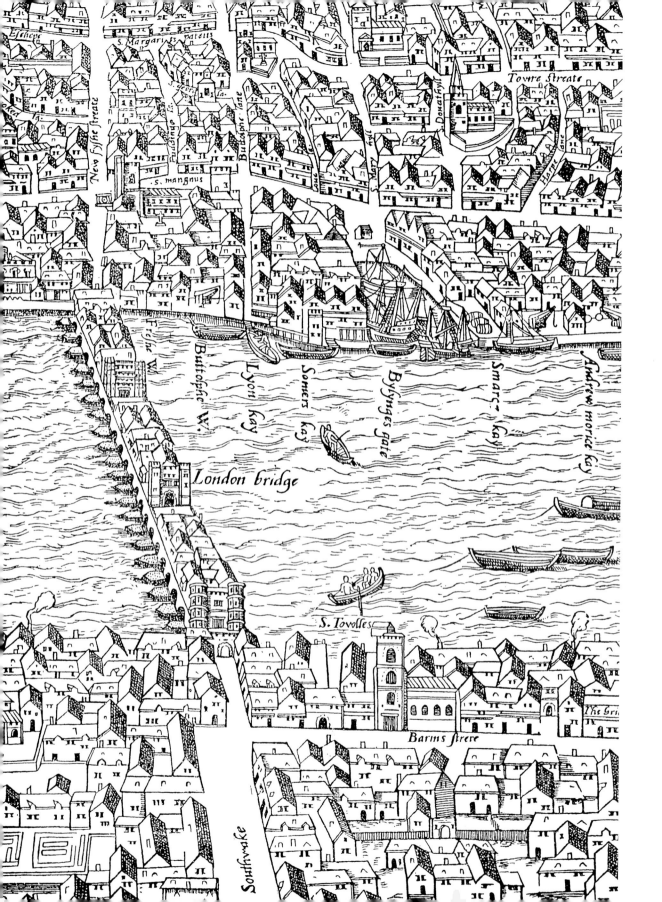

1 Eight London Gardens on the River Thames

To capture the grand panorama of the Thames as London's essential setting was a problem faced by all of the city's first map makers, beginning with the earliest depiction, created by Anthonis van den Wyngaerde early in the 1540s, and followed by the so-called Ralph Agas map of about 1560 and that of Franz Hogenberg published *circa* 1572 (see Introduction p. 3), both of which derived from an anonymous copperplate map of the late 1550s.[1] In each instance, the solution found for stressing the river's importance lay in artistic exaggeration, not only of the river's width, but also of the size of boats plying its waters, as if scale could present visually what must have been in fact the river's truer picture, that of constant motion, both in its current and tidal flow, and, more importantly, of endless human movement in its teeming boat traffic (pl. 14). William Harrison, writing in the 1570s his *Description of England* as an introduction to Ralph Holinshed's *Chronicles*, captured well some of this ever-present river dance:

> In like manner I could entreat of the infinite number of swans daily to be seen upon this river, the two thousand wherries and small boats, whereby three thousand poor watermen are maintained through the carriage and recarriage of such persons as pass or repass from time to time upon the same, beside those huge tide boats, tilt boats, and barges which either carry passengers or bring necessary provision from all quarters of Oxfordshire, Berkshire, Buckinghamshire, Bedfordshire, Hertfordshire, Middlesex, Essex, Surrey, and Kent unto the city of London.[2]

14 *Civitas Londinum* (detail), *c.*1560. Guildhall Library, Corporation of London.

A further telling indication of the Thames's importance to all of London may be found in what is now largely a forgotten vocabulary whereby London English during the late fifteenth and early sixteenth centuries was often defined as a river language. Beyond the wherries and tilt boats and tide boats and barges of Harrison's description, for example, Londoners would also have recognized "bark," "chalkboat," "cock," "cog," "crayer," "dungboat," "eelship," "farcost," "ferryboat," "flune," "galley," "hakeboat," "hookship," "hulk," "keel," "ketch," "lighter," "mangboat," "oysterboat," "piker," "rushboat," "shout," "skumer," "spindlers boat," and "whelkboat."[3] Similarly, they would have known well the numerous terms for naming those who worked on the river: "bailly," "boatman," "chalkman," "conservator," "eelman," "ferrier," "galleyman," "galliot," "garthman," "hooker," "lighterman," "mariner," "palingman," "peterman," "piledriver," "searcher," "shipcraft," "shipman," "shipwright," "shoutman," "sub-conservator," "tideman," "trinker," "waterbaillif," and "waterman." Likewise, London diners could easily have named with pleasure the foodstuff that the Thames waters made possible: "barbel," "clam," "dace," "eel," "flounder," "gudgeon," "kipper," "lampern," "lamprey," "mullet," "pike," "prawn," "roach," "salmon," "shotfish," "smelt," "sturgeon," "tench," and "trout." Seemingly without exaggeration or oversimplification, these word lists, as well as other such linguistic evidence, make abundantly clear the place that the Thames once held in London's daily life. The city and its river formed an essential equation.

Yet even though yoked together, London and the Thames were held in a defining relationship that was not necessarily a symbiotic one. Indeed, throughout their long history together, Londoners were quick to recognize that any advantages the river could provide — notably a ready supply of water and food — could never outweigh something much more fundamental to London's pride, namely the Thames as essential urban thoroughfare and port of commercial entry, and hence the City's true base of power. Thus, even before the City's official charter in 1215, Londoners had gained from King Richard I, in 1197, inalienable rights over the river, a franchise costing 1,500 marks, an immense sum that eventually, by 1285, guaranteed City control of the waterway all the way from Staines to Yantlet Creek, near Southend.[4] Established to adjudicate disputes among mill owners, bargemasters, and river-bank dwellers over levels

of the river controlled by weirs, the charter served, until the middle of the nineteenth century, to reinforce London's hegemony over the river. From the start, this was a topographical wedding not to be put asunder.

London Bridge House

Of all the historic riverside gardens here examined, the garden area established to serve the Bridge House in Southwark was most closely tied to the Thames as its *raison d'être*. To see how this is so, one must look to the history of old London Bridge itself as a structure integral to London's identity and interests. That is to say, even as the City had won rights to control the river, as granted by royal charter in 1197, it also saw as equally important the oversight of any bridge mastering these waters as a necessary extension of vested powers. Such power was essentially de facto by 1209, when London Bridge was finally completed. The structure proved to be an imposing edifice indeed. Built of stone, it spanned the Thames for 905 feet 10 inches on twenty piers of varying width, creating irregular arches from 15 to 34 feet apart. Although low and narrow in profile, only 20 feet wide, with a roadway rising little more than 30 feet above the river at low tides, the bridge gave a sense of vertical distinction created by the structures built atop it: two impressive gateways and a large two-story chapel dedicated to the City's patron saint, Thomas Becket. What lent the bridge much of its eventual fame, moreover, were its many houses with shops constructed all along the narrow roadway. By 1358, 139 such houses were already in place, with more than 30 of them built with overhanging jetties on upper stories and some cantilevered over the bridge edges, as seen in a model now in the Museum of London (pl. 15). The effect of all such building was to invite awe and to draw attention to the bridge as the principal entrance into London, announcing itself as stoutly capable of defense but also dedicated to the commercial vitality of the city (pl. 16).

Until 1750, when the first Westminster bridge was opened, London Bridge stood alone as a river structure – the sole span across the tidal Thames. Because of this, even by the fifteenth century, it had become a crucial source of the City's wealth (even as its legacies

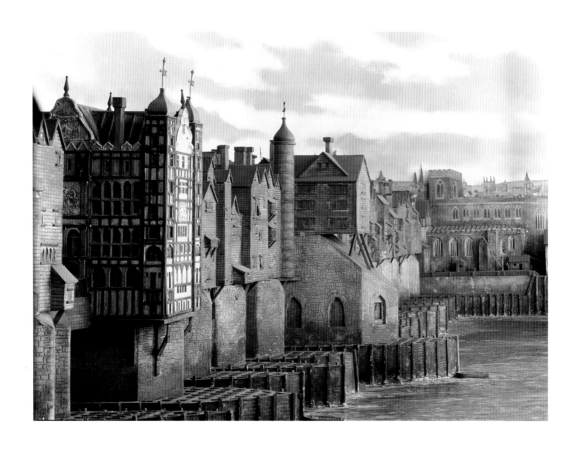

15 J. B. Thorpe, *View of
Old London Bridge*, c.1600,
1912. Museum of London.

remain so today), not only from tolls, both under and over the
bridge roadway, and from diverse property rentals, but more
importantly from more than 800 landholdings throughout the City
and metropolitan area, known collectively as the Bridge House
Estates, most of them originally given to the Bridge by gift or
bequest. As a consequence of the Estates' value to the City, therefore,
and in assertion of the Corporation's right as trustee to benefit from
the income, the Lord Mayor and Aldermen each year, from the
fifteenth century until the eighteenth, dutifully paid a ritual visit to
the Bridge House at the time of the annual audit of Bridge income
and expenditure to reinforce the City's prior claims. At these times
a meal was prepared, often served in the garden, to mark the
importance of the occasion, an event to be repeated annually in
some form for at least 330 years.[5]

 To serve as an administrative center and goods depot for the
bridge, the large building always known as the Bridge House – "the

24

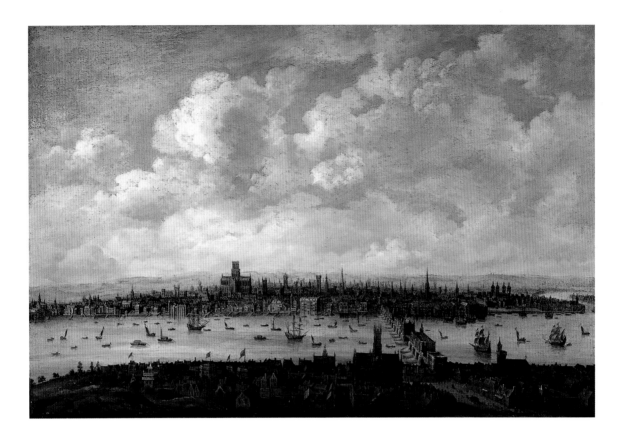

domum de Ponte" in its earliest reference in 1222/23 – had been erected along the riverside shortly after the completion of the bridge itself.[6] Its creation was fortuitous, for, with its various outbuildings and nearby workyards, the Bridge House by early in its history had become the nerve center for the many enterprises of London Bridge. As a busy place, it required a large staff. These included the chief officer working under the Bridge Wardens and known as the Clerk of the Works, whose responsibility lay in maintaining weekly accounts of receipts and expenditures, preparing engrossed copies of the accounts for the annual audit, and drawing up indentures, bonds, deeds, and other legal instruments as needed; other clerks working under his supervision; the Renter or collector of rents from tenants in the many properties owned by the Bridge; the Comptroller of the Chamber and the Bridge; the Clerk of the Chapel on the Bridge, with four assistant chaplains; and numerous workmen regularly employed by the Bridge, many on a full-time basis, for whom the

16 Anonymous, Anglo-Dutch School, seventeenth century, formerly attributed to Thomas Wyck (?1616–1677), *View of London from Southwark*, c.1650. © The Devonshire Collection, Chatsworth. Reproduced by permission of the Chatsworth Settlement Trust.

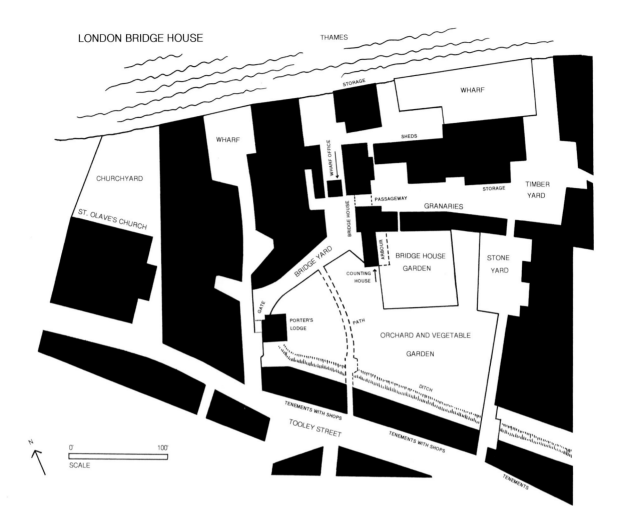

LONDON BRIDGE HOUSE

THAMES

WHARF

STORAGE

SHEDS

WHARF OFFICE

WHARF

CHURCHYARD

ST. OLAVE'S CHURCH

BRIDGE HOUSE

PASSAGEWAY

GRANARIES

STORAGE

TIMBER YARD

BRIDGE YARD

ARBOUR

BRIDGE HOUSE GARDEN

STONE YARD

COUNTING HOUSE

GATE

PORTER'S LODGE

PATH

ORCHARD AND VEGETABLE

GARDEN

DITCH

N

SCALE

0' 100'

TENEMENTS WITH SHOPS

TOOLEY STREET

TENEMENTS WITH SHOPS

TENEMENTS

17 London Bridge House and environs. Map by George Olson, 2004.

Bridge House served as a labor hall: carpenters, masons, sawyers, paviors, plasterers, solderers, glaziers, tilers, daubers, cooks, and tidemen. Because of these many employees, the existence of a garden by the Bridge House is quite understandable, its primary purpose to grow foodstuffs in quantity for the sizable Bridge House staff.

Although no plan or plat of the Bridge House and its environs survives before the eighteenth century, it is possible nonetheless to reconstruct the grounds, including the garden spaces, from the elaborate records kept by the Clerk of the Works (pl. 17).[7] Even in the earliest of these accounts, dating from 1381, costs of the garden find entry and suggest what was already a well-established enterprise.

There one discovers 2s being paid "pro emendacione et reparacione vinearum in gardino domus Pontis." References to stakes and willow rods for training and splaying, to repair and mending of these structures, and to cutting and binding the grapevines twice each year, winter and summer, run continuously thereafter in the accounts, all the way to the eighteenth century. One also finds early references to beans purchased for sowing in the garden (by the half bushel at 8d in 1382 and by the full bushel at 13d in the next two years); to a peck of "oynet sede" at 7d and garlic at 4d in 1406; to six large "Appulympes" (apple-tree grafts) at 4s 4d and six other "ympes" at 3s 4d along with their "stubbing" and "setting" in 1409 (with six more at 12d in 1412). Other expenses included wooden buckets at 10d for the well in the garden in 1382; the rebuilding of a brushwood boundary fence (with "bavin") at 2s in 1385; two spades without irons at 7½d in 1384; two forks and one iron for a certain shovel at 12d in 1382; a "reike" and "rayles" at 2s 7d to mark out planting beds in 1404; a "paryng shouel" at 12d in 1412; a "wheghelbarow" at 14d in 1421. These and other early entries of expenses thus mark out the beginning of what is surely the longest set of gardening records in London history, running continuously for 450 years, until 1831, when the Bridge House and its gardens alike were sold for development.

While other gardening records from the fifteenth century survive, notably those of the Grocers' Company,[8] what makes the Bridge House records unique is the decision of the clerks in 1461 to include in the running accounts the names of all those working in the garden, a practice that would continue until the early years of Queen Elizabeth's reign (see chapter 2). A typical example, as may be seen in the accounts for 1529/30 (pl. 18), indicates the care shown in reporting what was only an incidental entry in a long list of the Bridge House expenses.[9] However minor in importance they may have seemed at the time, such garden records are of immense value in recovering, in rich detail, gardening costs and activities in Tudor London and in providing them with a human identity.

As the Bridge House records make clear, the garden, up to the end of the fifteenth century, was very much an in-house operation, with responsibility for overseeing the garden and securing needed seeds, plants, and equipment given to the Porter at the gatehouse (located in the lane leading from Tooley Street to the Bridge House

18 Bridge House Garden Records, Corporation of London Records Office, MS BHA, vol. 6 (1525–41), fol. 93v.

environs), as was the case with William Cramond (1472–82). Throughout this period, moreover, the list of garden workers indicates that the garden was tended almost entirely by laborers drawn from the pool of Bridge workmen, each paid from 4d to 6d per day for garden work ("apparellynge the gardeyn," "making and dressing the gardeyn"). This wage was standard for most unskilled Bridge labor at the time and compares almost exactly with wages earned by building workers elsewhere.[10] Because the garden was primarily used for food, one finds these laborers growing beans and garlic, onions and parsley, leeks and peas, with rosemary as the principal herb, and doing so in orderly raised beds – long but narrow – edged with wooden railings and separated by graveled paths. Such limited gardening was typical, for as noted a century later by William Harrison in his *Description of England*, "vegetable variety in the fifteenth century was not commonly understood."[11]

Despite its workaday record as a well-tended kitchen garden, not all the garden space was devoted to homely, albeit necessary, enterprise. A portion of the garden nearest to what was called "the counting hous of the briggehous" (the office of the Clerk of the

28

Works and the place of the annual audit) also served as a green amenity both for the office staff and for visitors, boasting a framed "erber" or enclosed garden structure functioning as a summer parlor, first reference to which dates from 1426, when the Wardens entertained at a supper there the Mayor and many Aldermen. Overlooking the garden, the herber, a portion of which featured a vine trellis, continued to serve as a social setting, especially for the annual audit of the Bridge records. In some instances lavish meals were prepared to mark the event, the open-air parlor on occasion hung with tapestries. A sumptuous repast in 1438, for example, included "beef merybones [marrowbones], chinis [chines] of pork, signets, little pigs, geese, teelis [teal ducks], snyts [snipes] and ploveris [plovers]."[12]

To complete a fifteenth-century picture of the garden and its environs, one must also mention the gatehouse, which each June at the midsummer festival of the nativity of St. John the Baptist was adorned with green candles (by the 1490s, oil lamps) and great boughs of greens mixed with flowers. First recorded in 1460/61, the custom continued, with payment to the Porter for purchases of the arrangements each year, until 1543, which suggests the growing opportunity for London gardeners to supply this market demand for wild and domesticated plant materials. While it lasted, this green and floral tribute, which spread throughout the City, was noteworthy as a feature of urban life, meriting comment by John Stow:

> On the vigil of St. John the Baptist . . . every man's door [was] shadowed with green birch, long fennel, St. John's wort, orpin, white lilies, and such like, garnished upon with garlands of beautiful flowers, [and there were] also lamps of glass, with oil burning in them all the night; some hung out branches of iron curiously wrought, containing hundreds of lamps alight at once, which made a goodly show.[13]

Stow could well have been describing the Bridge House gate.

By the sixteenth century – during the period when Thomas More would have known it best – the Bridge House garden seemed set to continue in its long-established mode, that of supplying garden produce for the house kitchen. Yet this was not to remain the case. Within the first decade of Henry VIII's reign (1509–47) a number of changes began to occur in the design of the main garden spaces,

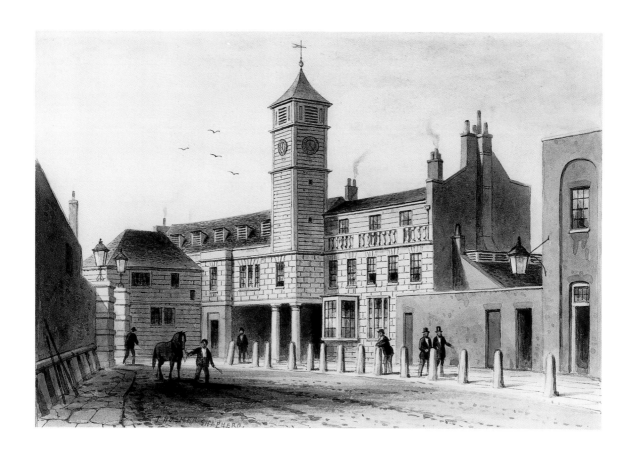

19 Thomas Hosmer Shepherd, *The Bridge House, Southwark*, 1846. Guildhall Library, Corporation of London.

some of them demanded by the disruption caused by building projects, including alterations to the Bridge House itself – the remaking of the kitchens and larder and the removal of the "olde countinghous and parlour." A watercolor made by Thomas Hosmer Shepherd in 1846 shows the main building, although much altered over the centuries, yet still reflecting the final form it achieved during the 1520s (pl. 19). His view looks to the Bridge House from the end of the lane leading from the Porter's lodge and gate as it opens out into the forecourt of the bridgeyard. The small building to the left is the wharf office and to its right stands the Bridge House itself, containing the hall and various offices. Built on two stories, with garrets, the structure had as its most distinguishing feature a clock tower, put up in 1530, when 36s 10d was paid "to a ffrenchman dwellyng in the brugh of Suthwerk for a clok and dyall and all thynges therunto belonging set wtin the briggehouse."[14] The

tower, as shown, was supported by two columns, behind which, in a set-back space to the left, a built-over gateway led to the back bridgeyard, where the Bridge House gardens had first been established. South of the main building stood the new countinghouse and parlor, completed by 1525. Glazed with "xlj fotes of new glasse," the countinghouse's windows looked into the adjacent summer parlor, a framed open structure, facing the garden, whose rooftop featured a vane painted with the arms of Henry VIII.

Other construction at the time caused severe disruption of the garden spaces, beginning in 1519, when twelve large bays for "garnardes" or granaries, ten of them with ovens, were built to store grain and provide bread for the City, as needed. Misguided in its motive, the plan soon ran afoul of London bakers and of suppliers of wheat, and eventually the structures were put to other uses (one supposedly that of barracks for Oliver Cromwell's forces). Yet they survived into the nineteenth century, as may be seen in another watercolor, one done by Edward Hassell, dating from 1830 (pl. 20). Showing the opposite side of these structures, a companion watercolor by Hassell provides the only surviving image of the Bridge House garden, here dominated by a new muniment room, completed in 1772 to a design of George Dance the Younger (pl. 21). By this date, little of the garden's layout remained, and yet planning documents for this eighteenth-century construction supply the only surviving plat drawings of the garden space and therefore are of value. One of these drawings, for example, provides accurate measurements of the garden space nearest the Bridge House, called "The Bridge Masters Gardin": from east to west on the north side, 66 feet; from east to west on the south side, 62 feet 6 inches; from north to south on the west side, 59 feet 6 inches; and from north to south on the east side, 57 feet.[15]

In the early sixteenth century land adjacent to the east of this Masters' Garden had been rented out, as indicated by various Bridge House records. Between 1515 and 1522, for example, one John Hasylfote rented a garden space there at declining rates, from 3s 4d per quarter to 8s 4d per year, with a note for 1521/22 "that John Hasylfote helde a gardeyn to fferme for viijs ivd by yere whiche gardeyn ys [now] taken in to the new ovyns in thest [the east] ende of the bakehouse."[16] Such rental indicates that even before the time that the "garnardes" were being built, the Bridge House did not

need all of its garden space for its own kitchen use. That requirement presumably was met by food crops that continued to be grown to the south of the Masters' Garden, in the orchard and vegetable garden.

The greatest horticultural changes, however, occurred in the Masters' Garden itself, beginning in the 1520s, when records suggest that the Wardens during this decade, Symond Ryce, Thomas Carter, and William Campion, made the decision to remake this defined space near the Bridge House into a more contemporary pleasure garden, a special place to be surrounded by new brick walls and featuring a fountain, brick alleys, and formal beds laid out in the latest design for knot squares (see chapter 4). To this particular end, they employed professional gardeners (see chapter 2) and expended large sums of money. Such strong garden interests, once set in play during More's later lifetime, would in fact continue for more than two centuries, transforming not only the Masters' Garden but also the other garden spaces into elaborate reflections of contemporary garden planning throughout the seventeenth and early eighteenth centuries. The Bridge House garden, indeed, was to prove to be an important mirror in the history of London gardens.[17] Only after 1750, with the construction of Westminster Bridge, did old London Bridge go into decline and with it the gardens at the Bridge House. "Seeds and roots" were still being purchased in 1786 and 1787, and one of the garden's last references, in 1797, notes payment of 3s 6d "for a Hoe, a Rake &c for the Garden." Even so, the building of the new muniment room in the middle of the Masters' Garden in 1772 could have served only to relegate much of the garden to that of a mere setting, no longer a horticultural jewel in its own right, as it had been since the sixteenth century.

Tower of London

If few people today have heard of the Bridge House, this would not be true for the Tower of London, the city's most famous medieval landmark (pl. 22). Yet during More's lifetime, the opposite would have been the case so far as gardens were concerned: any number of Londoners were quite familiar with the Bridge House, many of whom perhaps had seen its gardens, but few city residents would

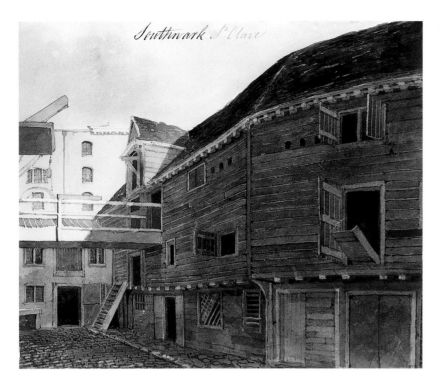

20 Edward Hassell, *The Bridge House Garnardes*, 1830. Guildhall Library, Corporation of London.

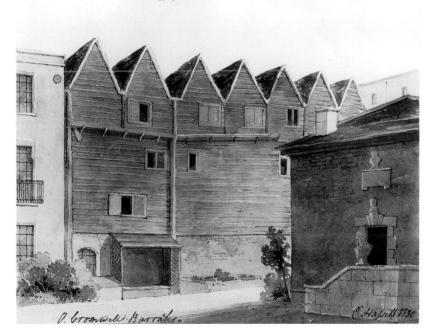

21 Edward Hassell, *The Bridge House Garden, with Muniment Room*, 1830. Guildhall Library, Corporation of London.

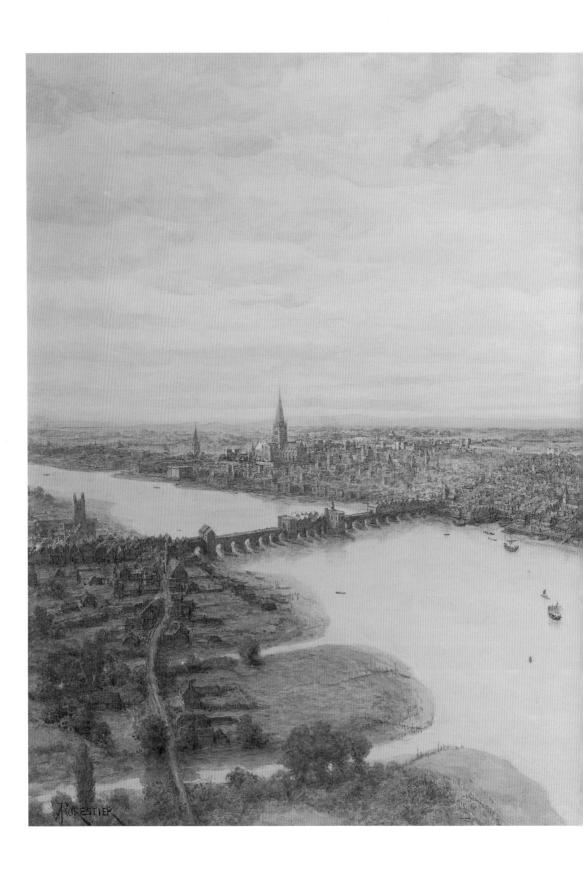

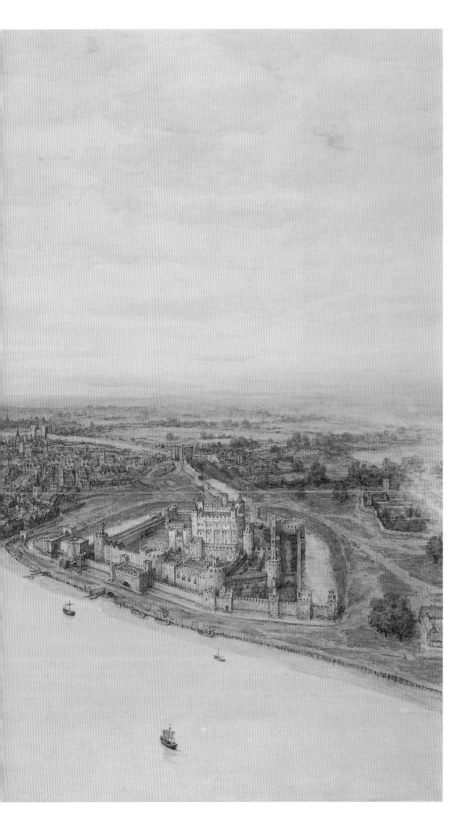

22 Amadee Forestier, *View of Medieval London*, 1912. Museum of London.

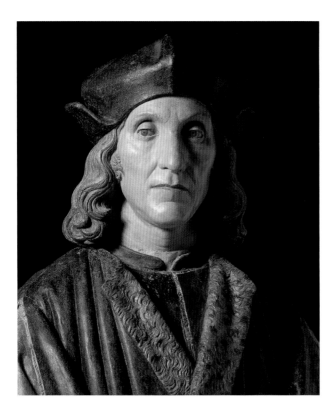

have imagined the rich garden displays to be found at the Tower, a domain where no ordinary citizen was privileged enough to enter its precincts or walk its garden spaces. These were reserved for royal use.

There had in fact been royal gardens at the Tower since at least the thirteenth century, the earliest reference dating from 1262, when Henry III ordered pear trees to be planted in the "King's garden," here referring to a walled enclosure lying to the north of the Tower. Twelve years later Edward I called for the creation of more extensive walls for this garden, running more than 280 feet, to be thatched with reed bundles. Primarily an orchard, the garden contained vines growing on trellises and in 1275 was planted with additional fruit trees and plants – cherries, peaches, quinces, and gooseberries – along with osiers, lilies,

23 Pietro Torrigiani, detail from a terracotta bust of Henry VII, 1509–11. Victoria and Albert Museum, London.

and peonies.[18] As Jeremy Ashbee has pointed out, "It seems almost certain that this extra-mural garden lay on the north side of the Tower moat on a property later to be known as the *Nine Gardens*,"[19] an area that still appears on the oldest survey of the Tower, that made in 1597 by William Haiward and John Gascoyne (pl. 24). Although little else is known about this garden space during the fourteenth and fifteenth centuries, it apparently continued under cultivation at least until 1485, when on order of Henry VII Robert Jay was named as Keeper of the gardens at Tower Hill, along with "le bulwerke" at the Tower and the houses on Tower Wharf.[20]

24 *(facing page)* William Haiward and John Gascoyne, *A True and Exact Draft of the Tower of London*, 1597. Hampton Court Palace, Surrey. Historic Royal Palaces.

Other garden areas lay within the Tower precincts, first references to which also date from the reign of Henry III, when, in 1266, he ordered the purchase of various plants, at 20s, and the repair of a wall around "the King's Garden in the Tower of London."[21] Again, little subsequent information about this garden or its location survives before the Tudor period, when Henry VII (pl. 23) began construction of new private lodgings at the Tower in 1501, consisting

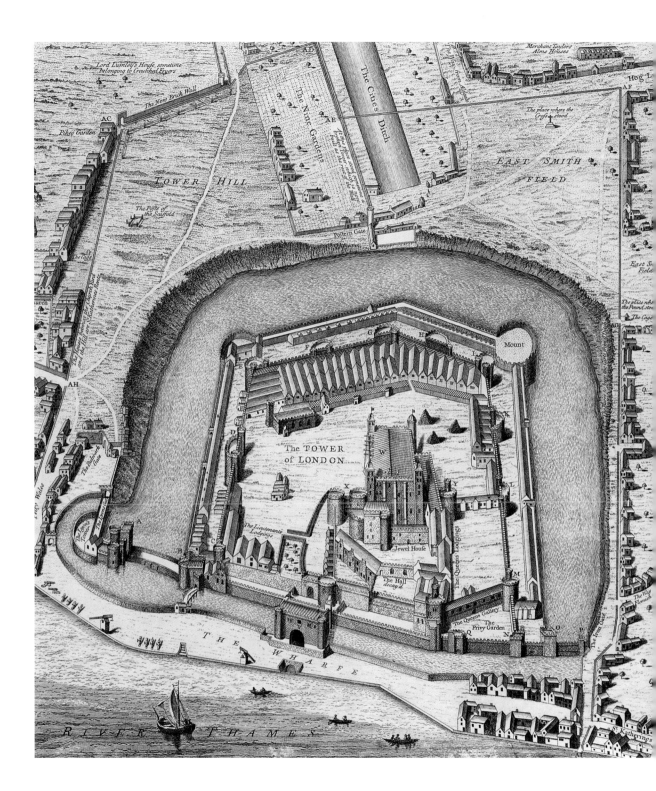

Merchant Taylors
Alms Houses

Hog L.

AF

Lord Lumley's House, sometime
belonging to Crutched Fryers

AD

The New Brick Wall

The Cities Ditch

AE

The Nine Gardens

The place where the
Crosse stood

AC

Pikes Garden

TOWER HILL

At that place stood a mane
scaffold for the execution of
greate men as the reste of the Hill

EAST SMITH
FIELD

The Posts of
the Scaffold

Postern Gate

East Sm
Field

The Cage

The place whe
the Pound sto

The Cage

church

The house joyneing to Church Yard
and the Hill neere St Katherines Roode

AH

G

H

F

I

Mount

AG

The Minoris

Hospitall of Wales

The Lyons Tower

The Bulwark Gates

The Tower

The Bulwark

D

E

The TOWER
of LONDON

K

W

The West
Element

A

C

B

The Lieutenants
Lodgings

X

Jewel House

Y

The Queens Lodgings

L

M

The Hall
decay'd

The Queens Gallery

Q

The
Privy Garden

N

O

P

The Iron Gate

St Katherines

THE WHARFE

RIVER THAMES

of a square tower structure adjacent to the Lanthorn Tower (which earlier, under Edward II, had become the king's principal lodgings). Henry VII's tower addition was also provided with a staircase consisting of twenty-three steps leading down to a new garden space, later designated as the "King's garden," located south of a curtain wall connecting the Lanthorn Tower and the Salt Tower. This wall separated a further garden to the north, probably the old "King's garden" of Henry III, but later known as the "Queen's garden." The two gardens were connected by a gate in the wall, near a council chamber facing north, overlooking the older garden space. To take advantage of these now-divided garden areas, Henry VII in 1506 had a gallery constructed atop the curtain wall, permitting garden views, less to the north perhaps, where buildings already encroached on the eastern part of the old garden, but, more importantly, to the new garden in the south (pl. 25). Built in timber and plaster, with windows, this new gallery may be seen clearly in the Haiward and Gascoyne survey. Of Henry VII's new building projects at the Tower, this gallery is of greatest interest, for, as Simon Thurley has pointed out in his study of these Tower structures, galleries overlooking gardens were at the time a novel feature in England, their introduction dating from Henry VII's remaking of the palace and gardens at Richmond in the late 1490s. There, elaborate extended galleries surrounded the Privy Garden and the Privy Orchard.[22]

Although no records survive to document the contents or layout of the privy gardens at the Tower, some sense of their appearance may be gained by imagining them in comparison with the account of the Richmond gardens made by a visitor to the palace in 1501. There, as seen from their enclosing galleries, one saw:

> moost faire and pleasaunt gardeyns with ryall knottes aleyed and herbid – many marvelous beastes, as lyons, dragons, and such othir dyvers kyndes, properly fachyoned and corved in the grownde, right well sondid and compassid in with lede – with many vynys [vines], sedis, and straunge frute right goodly besett . . . In the lougher ende of this gardeyn beth pleasaunt galerys and housis of pleasure to disporte in, at chess, tables, dice, cards, bills, bowling alleys, butts for archers and goodly tennis plays.[23]

The Tower gardens would have had only some of these features, given their smaller size compared with those at Richmond. Their

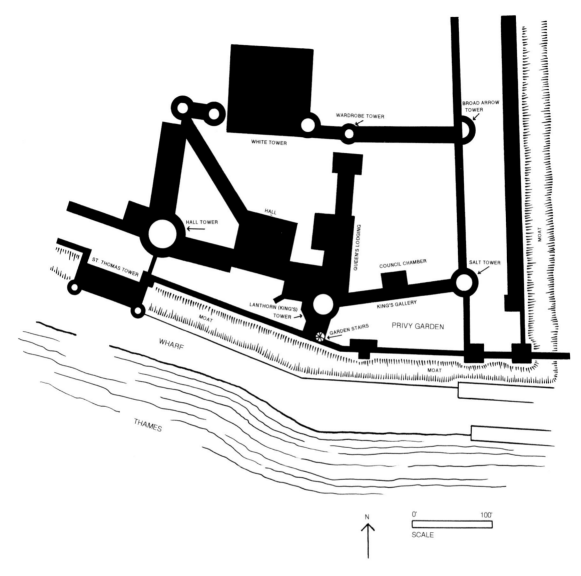

WARDROBE TOWER

BROAD ARROW
TOWER

WHITE TOWER

HALL

HALL TOWER

ST. THOMAS TOWER

QUEEN'S LODGING

COUNCIL CHAMBER

SALT TOWER

MOAT

MOAT

LANTHORN (KING'S)
TOWER

KING'S GALLERY

GARDEN STAIRS

PRIVY GARDEN

WHARF

MOAT

THAMES

N

0' 100'

SCALE

design features and execution in fact must remain conjectural (see chapter 4). Yet what is clear is that the gallery at the Tower, like its counterparts at Richmond, was designed for a specific function, to provide a vantage point from which to view the display and design of gardens below, which then were meant also to be enjoyed by a descent down steps leading into the garden expanses and then by a walk through their layouts, following a shifting perspective. Such an experience presumably was much like that described by Stephen Hawes in 1506:

25 Tower of London Gardens. Map by George Olson, 2004.

39

Than in we wente to the gardyn glorious
Like to a place of pleasure most solacyous.
With flora paynted and wrought curiously
In dyveres knottes, of mervaylous gretenes
Rampande lyons stode up wonderfly
Made all of herbes with dulcet swetnes
With many dragons of mervaylous lykenes
Of dyvers floures made full craftely
By flora coloured with colours sundry.[24]

While there is much information that does not survive about the Tower gardens, what fortunately did get recorded were the names of at least some gardeners working there. In 1496, for example, one finds Thomas Adams as Keeper of the Garden at the Tower, earning £4 11s 3d per year; in 1504 Richard Warman, earning 6d per day; from 1506 to 1511 Richard Smith (who died at Windsor later in that year), earning 6d per day; from 1511 until 1532 Robert Hasilrig, Yeoman Usher of the Queen's Chamber, earning 6d per day; and in 1532 Robert Draper, Yeoman of the King's Jewels, who, in addition to being Keeper of the Garden, was also Keeper of the Beds, Other Harness, and the Little Wardrobe, earning "6d a day for himself, and 6d a day for two pages under him."[25]

Henry VIII when king apparently showed little interest either in the Tower or its gardens (a predisposition that either heartened or dismayed the Keeper of the Garden, Robert Hasilrig), preferring instead to lavish attention on his other royal residences, first at Greenwich, but later at Wolsey's York Place and Hampton Court. Any attention to the Tower seems to have come only at the time of the coronation of his new wife Anne Boleyn in 1533, a rather frenzied period of preparation that involved rapid renovation of the queen's apartments, the Great Chamber, the Privy Chamber, the Great Hall, and the kitchens.[26] No surviving information indicates comparable attention paid to the gardens. It would seem unlikely, however, that Henry's interest would not have turned to the garden settings for Anne's grand visit. A good case can be made, in fact, that the Tower gardens would have featured displays of the rose adopted earlier as part of the royal arms, the new hybrid *Rosa damascena trigintipetala*, in shades of red and white, as shown in crowned form in the portrait of Henry found in the Plea Rolls of the Court of

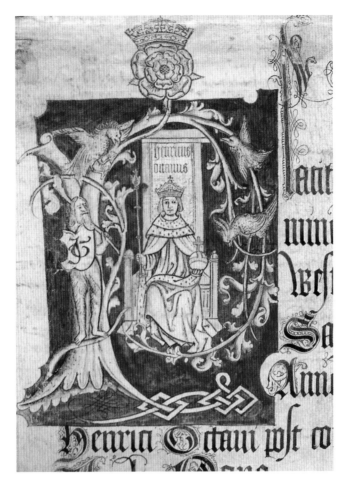

26 *Henry VII*, Public
Record Office, London,
Plea Rolls of the Court of
the King's Bench
(KB27/1024), 1517.
National Archives Image
Library,

King's Bench of 1517 (pl. 26). In anticipation of Anne's arrival, 1,800 rose roots, perhaps of this new hybrid type, had been purchased in 1532 for planting in the new Privy Garden at Hampton Court, to which 400 more were added the following year in preparation for her coronation. These many rose plants were supplied by a London gardener, John Browne, who sold from his garden premises near Clerkenwell, in St. John's Street (see chapter 5). Presumably some form of equal show would have been demanded at the Tower. Even if so, however, the display at the Tower gardens was doomed as a prognosis, for following Henry VIII little if any royal interest was shown, especially by Elizabeth I or James I. By the Restoration of 1660, the garden areas were put to other uses.

Winchester Palace

In a manuscript painting of 1575 by Richard Garth (pl. 27), a view of the Thames shows old London Bridge in one of its earliest views, here seen from its western side. Beyond it, to the left, appears the Tower of London, and in the foreground, on the right, the Augustinian priory of St. Mary Overie (now Southwark Cathedral), with the tower of St. Olave's church in the near distance (beyond which lay the Bridge House and its gardens). If one looks at this painting more closely, focusing on the river frontage standing before St. Mary Overie's, one also sees a group of clustered rooflines, and it is to these that attention must now be drawn, for behind them lay one of the oldest riverside gardens here considered in Thomas More's London, that of the Bishop of Winchester.

Today's visitor to Southwark, especially to the environs of the cathedral, can scarcely imagine what once was in this area. Nor is it of much help to walk in nearby Clink Street, which gave itself as one name for "jail" in English, to view there the ruined west wall of the bishop's palace. Yet here too the rich garden world of late medieval London once flourished, albeit in a form quite different from the royal gardens at the Tower or the civic gardens at the Bridge House. Instead, in this place, was a third type of gardening enterprise, and the one most common to the riverside at the time, that of the ecclesiastical garden, that is, a garden associated with the residence of a Church magnate.

Indeed, by the time of More's birth in 1478, residence in London or Westminster, as centers of the nation's power, had long since become requisite for the leading bishops of the Church. Eighteen of these magnates had much earlier acquired property within these locales, as had the two archbishops of the English Church, York and Canterbury. Among the ranks of these prelates none could equal in riches the Bishop of Winchester, whose immense wealth lay in landholdings scattered across his diocese, principally in Hampshire but including also the Isle of Wight and Surrey, with additional estate lands in five other southern counties (pl. 28). In all, the manors of the bishopric numbered close to sixty, more than rivaling the estate even of the Archbishop of Canterbury, giving rise to the fourteenth-century quip, "Canterbury hath the finer stable but Winchester the deeper manger."[27]

27 Richard Garth, *London Bridge with the Tower of London and Southwark*, Bodleian Library, Oxford, MS Douce 68, fol. 47r, 1575.

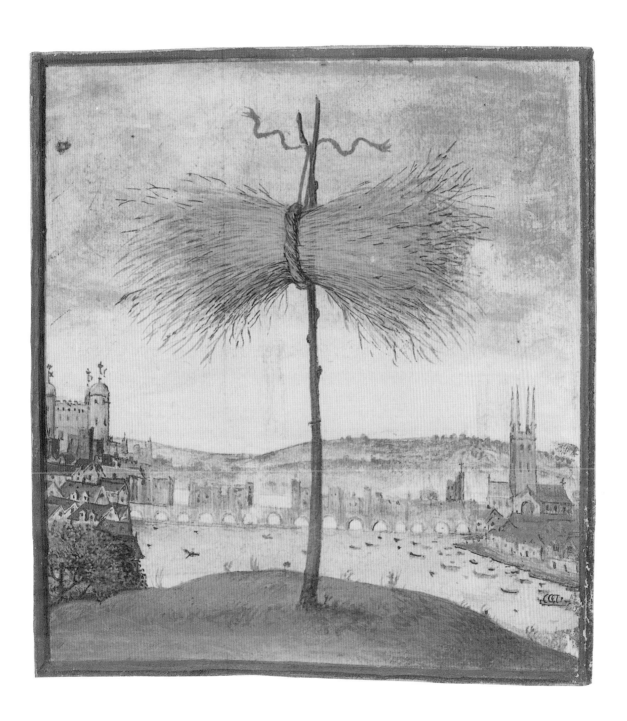

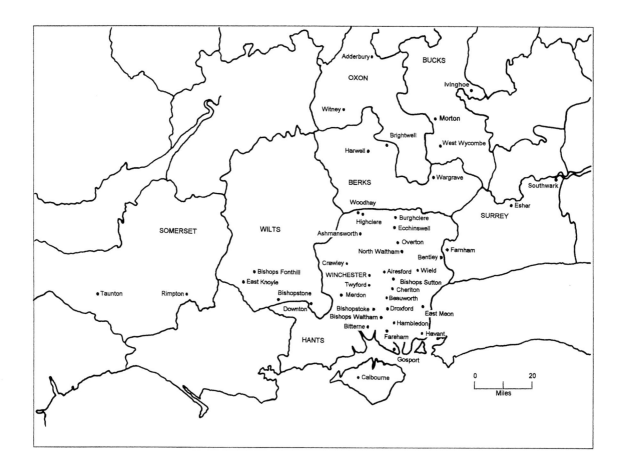

28 Winchester Estate manors. M. Page, "The Medieval Bishops of Winchester: Estate, Archive and Administration" (*Hampshire Papers*, 24, 2002).

If "first among equals" in terms of wealth, the Bishop of Winchester could also lay near claim to seniority with the Archbishop of Canterbury in terms of a London presence. The Winchester manor in Southwark in fact antedated London's official charter: the first records of the property date from the 1140s, when land in the area was purchased by Henry of Blois, brother of King Stephen, from Orgar the Rich and the monks of the soke (jurisdiction area) of Bermondsey.[28] This tract, originally encompassing about 70 acres, lay inland from the Thames, a short distance west of what was to become Borough High Street. Its land was marshy, because of which the greater portion was ditched for drainage by the thirteenth century, when the western acreage, known as the Wild, was turned into pastures, meadows, and fields where manor workers grew cereal crops of rye, barley, and wheat, as well as

44

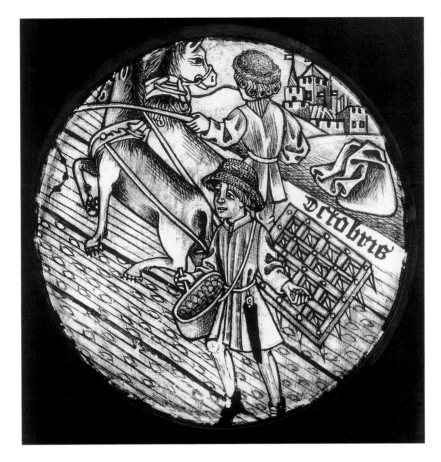

vegetable crops of beans, leeks, and peas (pl. 29). In the northeast portion of the property near the Thames, an irregular tract of about 7 acres had been set aside for the manor's buildings, including a hall and chapel, visited by Thomas Becket in 1170. Both areas of the manor remained intact into the seventeenth century, as may be seen in the map of John Norden and John Speed, dating from 1611 (pl. 30). Except for the chapel, all the original structures were replaced by new constructions in the thirteenth and fourteenth centuries, including a new hall, some 134 feet in length, the western rose window of which still survives (pl. 31).

By the early sixteenth century, at the time that More would have known the estate, the episcopal palace had achieved much of its final form, as shown in the view of the property made in about 1650 (pl. 32), with the Great Hall lying parallel to the river. The old

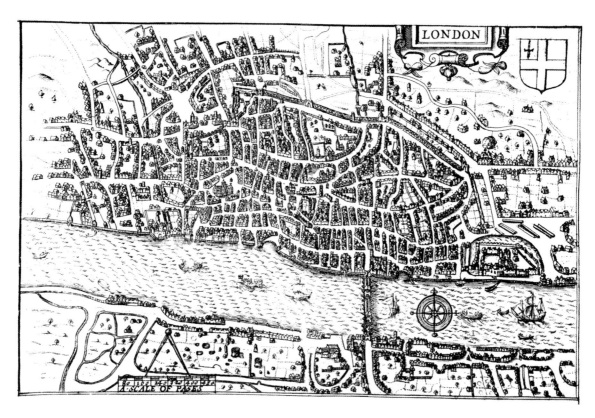

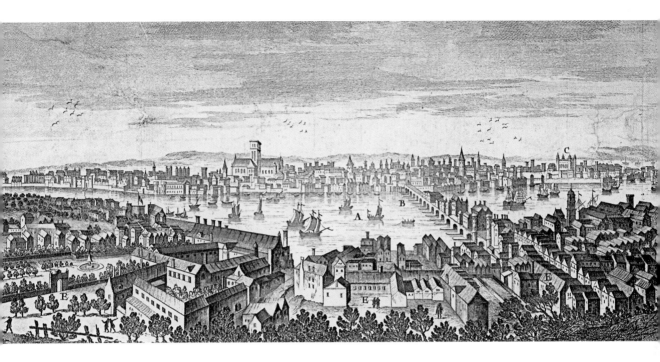

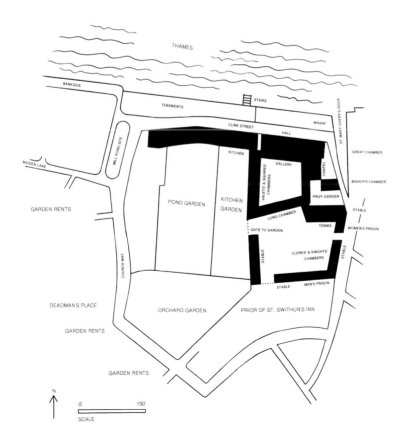

WINCHESTER PALACE

THAMES

BANKSIDE

TENEMENTS

STAIRS

WHARF

ST MARY OVERY'S DOCK

CLINK STREET

HALL

KITCHEN

GALLERY

GREAT CHAMBER

MILL POND SITE

VALETS' & SQUIRES' CHAMBERS

CHAPEL

BISHOP'S CHAMBER

MAIDEN LANE

PRIVY GARDEN

POND GARDEN

KITCHEN GARDEN

LONG CHAMBER

STABLE

GARDEN RENTS

TENNIS

WOMEN'S PRISON

GATE TO GARDEN

STABLE

CHURCH WAY

CLERKS' & KNIGHTS' CHAMBERS

STABLE

DEADMAN'S PLACE

ORCHARD GARDEN

STABLE

MEN'S PRISON

PRIOR OF ST. SWITHUN'S INN

GARDEN RENTS

GARDEN RENTS

N

0' 150'

SCALE

32 (*above*) Anon., *Winchester Palace*, *c.*1650. Guildhall Library, Corporation of London.

33 (*left*) Winchester Palace and environs. Map by George Olson, 2004.

30 (*facing page top*) John Norden and John Speed, *View of London*, 1611. Guildhall Library, Corporation of London.

31 (*facing page bottom*) John Sell Cotman, *Winchester Palace*, 1828. Guildhall Library, Corporation of London.

chapel stood by its east end, at a right angle to the south, and a new bishop's chamber, located near the chapel but built to its east at a right angle, overlooked a small privy garden. The main gardens at the palace, however, lay to the west of the palace precincts, with the kitchen and pond gardens to the north, near the domestic buildings, and the orchard and pleasure garden to the south (pl. 33). The kitchen and pond gardens may still be seen in a detail from Hollar's panoramic *Long View of London from Bankside* (also showing the nearby Globe Theatre before it was destroyed in 1644; see pl. 7). These food gardens were extensive in size, although long before More's lifetime the palace had become less dependent on produce from its own plots than would have been the case in the previous century. Indeed, the chief references to foodstuff grown on this site date from the thirteenth and fourteenth centuries, when the various plant beds ("lectulis") were seeded in vegetables ("olera") and herbs: saffron, leeks, beans, scallions, cabbage, fennel, parsley, garlic, and sage. In the orchard to the south, vines and various fruit trees were also grown, with references to pears, apples, and peaches.[29]

The fact of the matter, as pointed out by Martha Carlin, is that, by the late thirteenth century, the bishop's riverside place had altered "from its earliest character of combined mansion and farmyard into a more strictly palatial residence and administrative center, assuming the form it was to have for the next 350–400 years."[30] Such transformation affected the palace gardens themselves, particularly the orchard and pleasure garden, which, by the fifteenth century, were with increasing frequency the site of social events (see chapter v). Parallel changes also occurred in the manor's farming fields in the Wild, which from the late fifteenth century began to be leased as gardens to various Southwark market gardeners and residents. The reeves' accounts between 1509 and 1526, for example, show rents received by the Bailiff during this period, Louis Wynkefelde (or Wyngfeld), or his deputy in 1513/14, John Fryer, from gardens located to the west of Church Way and south of Maiden Lane: £6 6s from John Weston (or Merston) for two large gardens, one called "quenes garden"; £4 13s 4d from John Webster for diverse gardens below the manor ("infra manor"); 40s from Richard Danyell for diverse gardens "vocat Dedmans place situate in Churchalley"; 26s 8d and 2s from Robert Rake for "Milwardes garden" and one other garden; 3s 4d from Rouland Matson for a garden in "Mayden lane";

46s 8d from the wife of John Haydon for diverse gardens.[31] The large variations in these rents suggest gardens ranging from considerable size down to small plots. They also indicate the increased numbers of gardeners working in the Southwark area. Indeed, well into the seventeenth century, gardening enterprise near the river and southward on both sides of the Borough High Street continued to expand, as may be seen in the stylized map of 1658 by William Faithorne and Richard Newcourt, which shows numerous orchards and square-bedded gardens, some of them laid out in compartments with elaborate knot designs (pl. 34).

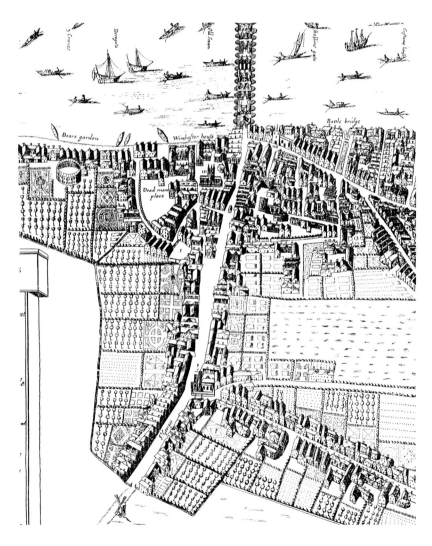

34 William Faithorne and Richard Newcourt, *Map of Southwark* (detail), 1658. Guildhall Library, Corporation of London.

As an ecclesiastical estate, the Winchester manor thus continued during the sixteenth century, the bishopric being held, after Richard Fox, by Thomas Wolsey himself in 1529/30 before his fall, then by Stephen Gardiner (1531–51, 1553–55) and a succession of lesser appointments. Yet the enterprise ultimately was to fail, in large part caused by the crowding pressure of urban development in the area. The last bishop to live in the palace was Lancelot Andrewes (d. 1626), and by the middle of the seventeenth century palace buildings, in continuous state of disrepair, were sold, to be turned to other uses, as were the complex's valuable garden spaces. Much of the palace itself was finally destroyed in a disastrous fire in 1814.

York Place and Whitehall Palace

Historically, one of the most important riverside garden projects begun during More's lifetime lay further up the Thames, in the community of Westminster. It dates from 1514, when Thomas Wolsey was made Archbishop of York and took over the see's episcopal residence, located a quarter mile north of Westminster Palace and situated near the river. During the next fifteen years he was to undertake a massive remodeling and enlargement of this fifteenth-century property, transforming it into perhaps the finest town house in the London area. As part of this expansion program, Wolsey also acquired land both to the north and the south, the latter enabling him to create new garden spaces between the house and King Street (now Whitehall). In similar but far more extravagant fashion, Henry VIII, when he acquired the property in 1529 upon Wolsey's fall from power and turned it into Whitehall Palace, was to undertake one of his grandest building schemes (superimposed both on Wolsey's house and on his gardens), rivaled only by his parallel transformation of Wolsey's country palace and gardens at Hampton Court. Both projects would consume the king's interests for the rest of his life.

To imagine these Westminster garden spaces today is a daunting task. Not only are there no clear pictorial records of Henry VIII's Whitehall gardens (completed in the 1540s), much less any image of their state under Wolsey, but their site has long since been built over, leaving only the most fragmentary green reminder of what was once

there, in the set-back lawn before a portion of the Ministry of Defence building, with its statues of military leaders, including *Field Marshall Montgomery*. Yet in this area, across busy Whitehall from the entrance to Downing Street and stretching northward nearly to the only surviving building from Whitehall Palace, Inigo Jones's Banqueting House of 1619, there were once richly elaborated gardens and orchard plantations, tantalizing records of which survive, if only in fragmentary form, supplying information chiefly of the

35 Canaletto, *Whitehall and the Privy Garden from Richmond House*, 1746–47. The Trustees of the Goodwood Collection.

51

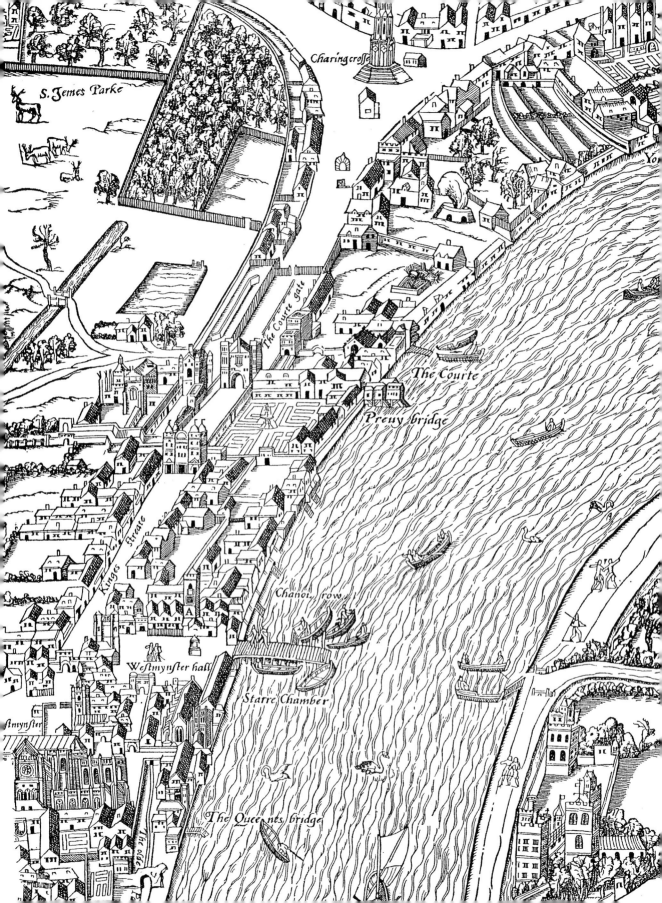

S. Iemes Parke

Charingcrofe

Yo[rke]

The Courte gate

The Courte

Preuy bridge

Chanoi, row

Kinges ftreate

Westmynfter hall

Starre Chamber

[A]mynfter

The Quee,nts bridge

beginning stages of their development, under Wolsey first, in 1515/16, and then under Henry VIII, in 1531/32.[32]

Any present-day enquiry about York Place and the Palace of Whitehall and about the location of their gardens must depend on the recent studies done by Simon Thurley.[33] There one learns, from archeological and archival data, the eventual extent and size of the palace complex, which, at the time of the disastrous fire in 1698 that was to destroy virtually all of its structures, had become the largest secular building in the country. Yet, throughout the palace's evolution, the orientation of its garden spaces remained intact, reflecting Henry VIII's vision for them at the time of his death in 1547. To see this, one can look at two maps of the area, the first the so-called Agas map of around 1560 (pl. 36). Here one sees the Great Garden in relation to the various palace buildings. It extended from a riverfront gallery on the east to a long wall on the west, running along King Street from the Great Gate over the roadway near the southwest corner of the garden (hard by the entrance today to Downing Street) to the Holbein Gate near the garden's northwest corner. The garden was further bounded all along its north side by the King's Privy Gallery, which connected Holbein Gate to the main palace buildings near the river. Not shown clearly on the map is the King's Privy Garden, lying to the north of the Gallery, which was enclosed on all four sides by an open cloister, erected *circa* 1536.[34] Also shown on the map, but only as a walled enclosure, is the new Orchard, created in 1531/32, on land acquired to the south of the Great Garden. The Holbein Gate further served as a bridge to the palace buildings and grounds extending along the west side of King Street, which had been built as the royal recreation center.

The position of the Whitehall gardens did not alter during the century and a half after Henry VIII's death, as may be seen in a second map, created for Charles II in 1670 by Ralph Greatorex (now lost, but engraved by George Vertue in 1747) (pl. 37). Again the Great Garden is the dominant feature (by that date known as the Privy Garden), with the Orchard to the south now made into a bowling green. Henry VIII's Privy Garden to the north is also now altered, reduced to an open courtyard area. The Great Garden, however, remains intact. Indeed, it was to survive the fire of 1698, remaining as an open space throughout the first half of the eighteenth century, as may be seen in one of the few remaining

36 *Civitas Londinum* (detail), *c.*1560. Guildhall Library, Corporation of London.

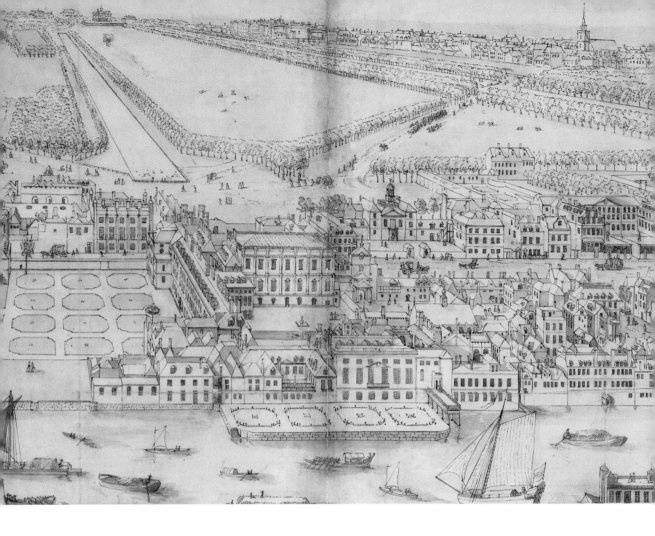

paintings to depict the garden, done by Canaletto in 1746–47 (pl. 35). This painting shows the eastern part of the garden then remaining, now simply turfed with grass beds, with Inigo Jones's Banqueting House to the north. Other details show the despoiled western part of the garden extending to the Holbein Gate, itself shortly to be torn down to enable more traffic to move in King Street.

As indicated by these maps and this painting, the *in situ* permanence of Henry VIII's Great Garden suggests that he had planted his garden ideas well – if not his notions of garden design, which did not survive him. The Greatorex map, for example, shows it as a display of square grass plats, each with a statue on a pedestal in the center and with a sundial in the center alley. Similar use of grass as a garden feature had developed at Hampton Court

38 Leonard Knyff, *Whitehall Palace* (detail), c.1695–97. City of Westminster Archives Centre.

37 *(facing page)* George Vertue after Ralph Greatorex, *Survey of Whitehall* (detail), engraving, 1747. Museum of London.

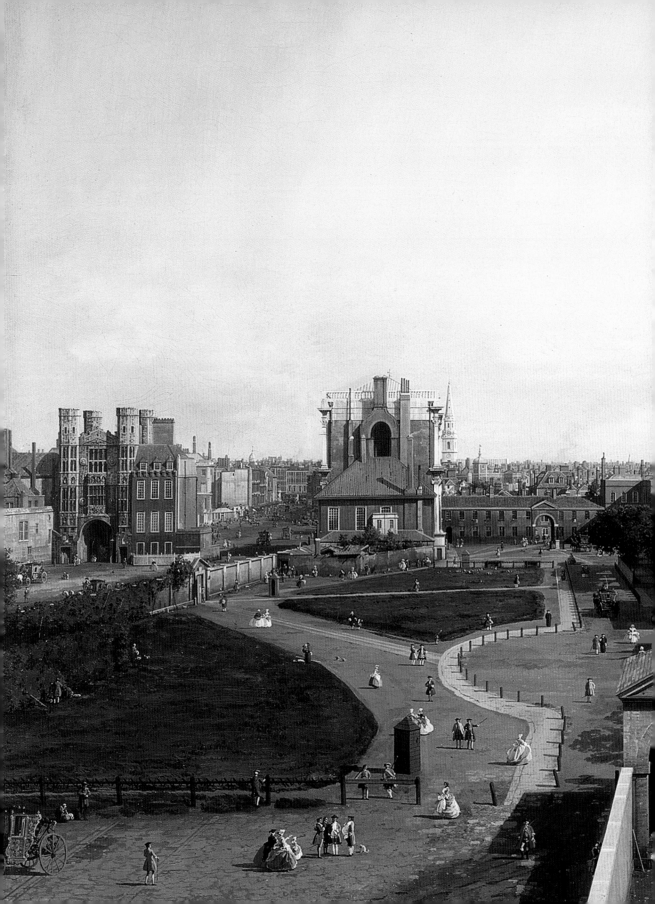

beginning in the 1640s. A drawing of the palace complex done in about 1695–97 by Leonard Knyff (pl. 38) shows the garden shortly before the fire of 1698, still composed of grass plats, but now with angled corners on the squares and with only an empty pedestal at the center of each. In addition, there is a fountain to the south. A very different picture of the garden's design appears in the Faithorne and Newcourt map of 1658 (pl. 39). Perhaps more fanciful than totally accurate, it shows small grass plats to the garden's north and south but much larger geometric beds cutting across its center.

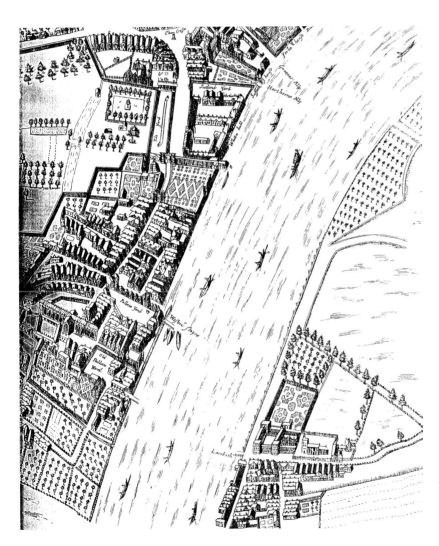

39 (*left*) William Faithorne and Richard Newcourt, *Map of Westminster*, 1658. Guildhall Library, Corporation of London.

facing page Canaletto, *Whitehall and the Privy Garden from Richmond House* (detail of pl. 35).

Henry VIII's own design for the Great Garden, as shown on the Agas map, stands in marked contrast to these later images. The garden expanse was based on squared quadrants, each laid out in different patterns of narrow beds, with a tiered fountain enjoying pride of place in the center. The configuration of the quadrants is confirmed by the earliest image of the garden, done by Wyngaerde in about 1558, and by a manuscript painting of 1588 by William Smith (pl. 40). Additional, if restricted views of the garden also appear in the now-famous painting of around 1545, *The Family of Henry VIII* (pl. 41), the figures facing north, perhaps to a view of the Privy Garden, with openings behind them looking to the south at the Great Garden. Here one sees the raised beds of the quadrants, containing low plants and edged with rails painted white and green. The painting also shows an additional feature, that of heraldic beasts

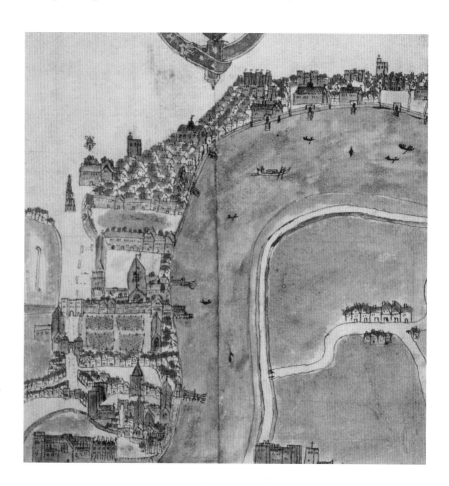

40 William Smith, *View of Westminster, London and Bankside* (detail), British Library, MS Sloane 2596, fol. 52, 1588.

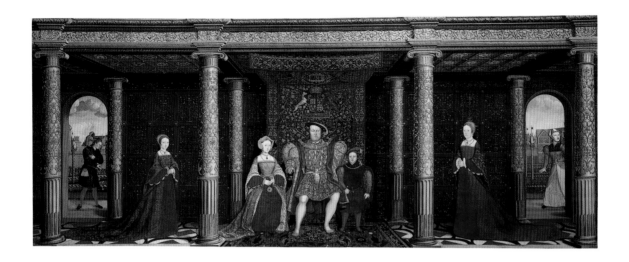

atop painted stanchions, a garden novelty that had already become a signature phenomenon in the elaborate gardens at Hampton Court. References to all these features appear in scattered records of payment between 1534/35 and the summer of 1541,[35] but it is doubtful that they could have been in place at the time of Thomas More's last visit to the garden, in May 1532, when he formally resigned his Chancellorship.

The garden that More would have seen on this occasion can remain only conjectural. It is unlikely, however, that it was the Privy Garden (north of the newly completed Privy Gallery), which was not yet fully developed. Furthermore, the Great Garden itself was still in transition through its first stages of reconstruction and enlargement. Indeed, More would have no doubt observed the raw finish both of the Great Garden and of the new Orchard layout to the south. The earliest surviving Tudor records indicate that, between August and October 1531, as many as twenty-five garden workers had been steadily employed in "levelling of a certeyne Grounde late edified, appoynted by the Kinges highnes for the enlargeing of his Orcheyerde annexid vnto his forenamed Manor." The group of workers was led by the head gardener Thomas Graunte, assisted by nine under-gardeners: John (or Thomas) Eliatte, Walter Shorlocke, William Ballewyn, Thomas Bryne, William Conweye, Patrick and William Hongle (or Hongille), Richard Kenedie, and James Mounteyn (perhaps the father of Richard Mounteyn, who was

41 Anon., *The Family of Henry VIII*, *c.*1545. The Royal Collection. © 2005, Her Majesty Queen Elizabeth II.

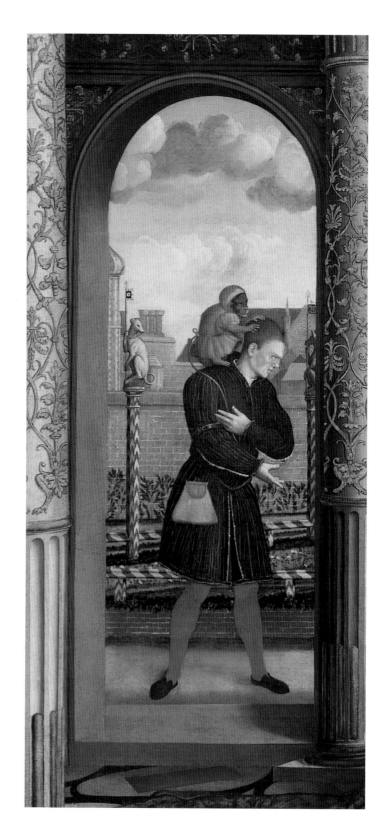

right and facing page Anon.,
The Family of Henry VIII,
(details of pl. 41).

named Keeper of the Garden at St. James in 1545).[36] These gardeners were assisted by fifteen named garden laborers (see chapter 2).[37] All of these garden workers, from the highest to the lowest status, would in turn have been under the supervision of Thomas Alvard, a former member of Wolsey's staff, who had been appointed Keeper of York Place in February 1530 and Keeper of the King's Garden and Orchard the following November. As Keeper of the Orchard, Alvard would have been entrusted with the keys "for ij plate lockes sette vpon the gate going oute of Endyve lane into the Orcherde," as noted on 7 May 1532, just nine days before More's visit.[38]

As indicated in the Introduction, the most likely setting for More's final visit with the king would have been the garden area remaining near Wolsey's Long Gallery, the fourteen windows of which had been planned during its building to overlook the river to the east and an orchard to the west, with a form of privy garden in the foreground. This configuration may be seen in a map reconstructing Wolsey's house and grounds, based on archeological records, as discussed by Thurley (pl. 42). It was in this garden gallery that More had met Wolsey in 1523, shortly after the gallery had been completed.

The extent of Wolsey's gardens as well as his gardening interests may in part be measured by the number of full-time gardeners he employed. Wolsey is well known for the extravagance of his ménage, employing more than 500 people to run his establishment, as reported by George Cavendish, one of these staff members, serving as Gentleman Usher to the great prelate. Among the list of Wolsey's Westminster employees, Cavendish made note: "in the Garden, a yeoman and two laborers."[39] All three of these people were charged only with garden responsibilities, which suggests a constant but not particularly elaborate garden scheme at the time, perhaps comparable to the garden similarly staffed at the Tower of London in 1532. Oversight of these gardeners at York Place would have been the duty of Wolsey's head gardener at Hampton Court, John Chapman, who bore final responsibility for both country and town gardens.

The size of the staff for his Westminster garden stands in contrast with the many workers that Wolsey employed at Hampton Court, and yet, when the need was there, he required and got large numbers of garden workers for short-term projects. The chief evidence for this is found in the earliest surviving records for York

42 Map of York Place in 1529. Historic Royal Palaces.

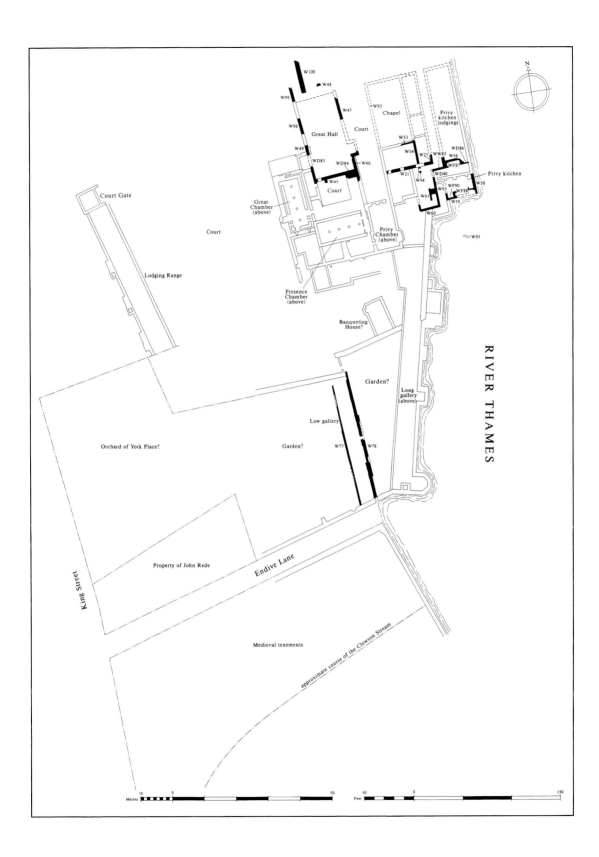

N

W100
W48
W99
W47
Chapel
W93
Privy
kitchen
lodgings
W98
Great Hall
Court
W53
WD86
W49
W54
W21
WW85
W56
WD83
WD84
W46
W21
WF87
WD40
WD84
W45
W94
WF90
Privy kitchen
Court
W61
W93
WF88
W58
Great
Chamber
(above)
W60
W59
Privy
Chamber
(above)
W95

Court Gate

Court

Lodging Range

Presence
Chamber
(above)

Banqueting
House?

Garden?

Long
gallery
(above)

Low gallery

RIVER THAMES

Orchard of York Place?

Garden?
W77
W78

Property of John Rede

Endive Lane

King Street

Medieval tenements

approximate course of the Clowson Stream

10 0 50
Metres

50 0 150
Feet

Place. Shortly after moving to the episcopal residence, for example, Wolsey had ordered a flurry of garden activity between March and July 1515, in preparation for Henry VIII's summer visit to celebrate Wolsey's election to the College of Cardinals. In anticipation "ageynst the Kings comyng," Chapman thus led teams of nineteen gardeners, sixteen laborers, and twenty-eight weeders, all of them named, to prepare and presumably to enhance the gardens that Wolsey had inherited when he took over the property. Although no further records survive, work on the gardens must have continued into the autumn, in further preparation for the grand visit by Henry VIII and Catherine of Aragon, the dukes of Norfolk and Suffolk, the archbishops of Canterbury, Armagh and Dublin, and many other distinguished guests, following the official presentation to Wolsey of his red cardinal's hat in Westminster Abbey on 18 November 1515.

It has often been assumed that Chapman came alone from Hampton Court whenever such extraordinary garden services were needed at York Place, and that the garden staffs at each place were strictly local. While this no doubt was true in general, yet in the busy preparations of the Westminster gardens in 1515, Chapman brought with him to help supervise the work at least six of his senior gardeners (whose names appear in records from both places): John Baker, Richard Brown, John Hollyer, Thomas Proud, John Randolf, and Richard Reynolds. This team from Hampton Court was joined by two other senior gardeners, presumably from Westminster: William Thomson (or John) and William Walter. Eleven under-gardeners then worked under the supervision of these eight gardeners, who in turn directed the work of the sixteen laborers and twenty-eight weeders (see chapter 2).[40]

Although we cannot reconstruct the contents of the York Place gardens, neither early nor late in Wolsey's tenure, three surviving details at least point to what once was there. In May 1515, for example, the records note payment of 13s 2d, a substantial sum, for "Erbes for my lordes gardener John Chapman." These included "Isopp and Jermander for the great garden at yorke place at Westminster."[41] Here, more than fifteen years before its use in reference to Henry VIII's garden, the term "great garden" suggests both the size and preeminence of Wolsey's enterprise. The purchase of hyssop and germander, perhaps used as edging plants for borders, a common practice at the time, further suggests a layout of well-defined long beds, similar to those later featured in Henry VIII's

Great Garden, which may therefore have had their basis in Wolsey's earlier garden format. Further note of purchase of a "paring yron" – a type of shovel used to cut soil in a sharp line – supports this conjecture.

A second detail, also recorded in 1515, points to Wolsey's garden specifically as a riverside place. In the early spring of that year, workmen were paid to build "pondes ffor the swannes," bounded by hedges secured to latticework, and to repair "the stowes [stews] att the ffysshehowse."[42] While neither of these may seem an appropriate garden feature, both were typical of larger garden establishments located near the Thames, as was the case also at Hampton Court and Lambeth Palace and even at the Bridge House garden. Finally, one can look at a detail from later in the history of York Place. Little information survives about Wolsey's Orchard, but it was presumably a source both of pleasure and produce, well established and long productive by the time that Henry VIII took over the property. In June and July 1530, in the first year of his occupation, and before his own remaking and extension of the original orchards, a record survives of payment of 4s 8d on two occasions to "the Keeper of the garden at York Place for bringing lettuce and cherries to Hampton Court" and "for bringing cherries to Hampton Court." Then, in the following month, a like sum was paid once again to the York House gardener, now "to bring fruit to Esthampstede."[43]

The newly formed gardens at York Place and Whitehall Palace thus owed their conjoined beginnings to the two most dominant leaders and friends that More had, Wolsey and the king. And as More would well have realized, these two men were much alike, sharing a competitive but finally antagonistic interest in both properties, including their garden spaces, with Henry ultimately the winner. The outcome was assured, even as noted in 1536 by official statute, which declared that the king had

> uppon the soyle of the said mansion place and howse, and uppon the grounde thereunto adioynyng, most sumptuously and curyously . . . buylded & edified many . . . beautifull, costely and pleasaunt lodgynges, buyldynges and mansions for his gracis synguler pleasure, comforte & commodite, to the great honour of his Highnes and of his Realme.[44]

Such was the rivalry that even today can still captivate interest among both social and garden historians.

Lambeth Palace, the site of the next garden upriver in More's London, is a miracle of survival. Although to most modern viewers the buildings seem a remarkable example of medieval and Tudor architecture – Morton's Gateway, the Chapel, the Lollards' Tower – yet few perhaps realize how often in its history the continued integrity of the palace complex was in serious doubt. Desecrated *circa* 1650 during the Civil War, when the Great Hall was torn down, vandalized in 1829 by well-intentioned renovation that demolished over half the medieval and Tudor structures, and nearly destroyed by German bombs during the Second World War, the palace's very existence today is a tribute to restoration and to what one might call the Church's firm foundations on this riverside spot. There in Lambeth, an identity with the long line of Canterbury archbishops has lasted for more than 900 years.

In light of this checkered history, two views of Lambeth Palace by Wenceslaus Hollar are of most use for initial enquiry into the palace's garden history. The first of these images, dating from 1647, but drawn a few years earlier, shows the palace complex from the south (pl. 44). In the foreground is Lambeth parish church (now the site of the Garden History Museum) and beyond is the palace's extensive property, a reminder that this was both a manor house and an ecclesiastical residence, comparable with Winchester Palace, only a short distance down the river. Their proximity is itself a further reminder of the long-standing rivalry between Winchester and Canterbury. This seventeenth-century view of Lambeth Palace, with Westminster across the river, would have been familiar to the two most famous resident gardeners in the area, the intrepid plantsmen John Tradescant, father (d. 1638) and son (d. 1662). To the left of the church tower is the great Morton Gatehouse, built shortly after More as a boy had left service to Cardinal Morton.

A second drawing by Hollar (pl. 43) shows a much more familiar picture of Lambeth Palace, seen here from the river, near the manor's landing quay. With the Lollards' Tower (the taller of the two adjacent towers) on the left, the Great Hall at the center, and Morton's Gateway to the right, this was still, in 1647, much like the profile of the palace that, more than a century earlier, would have been a familiar sight to More and his contemporaries, including the king and Wolsey. Wolsey, indeed, had more than a passing familiarity

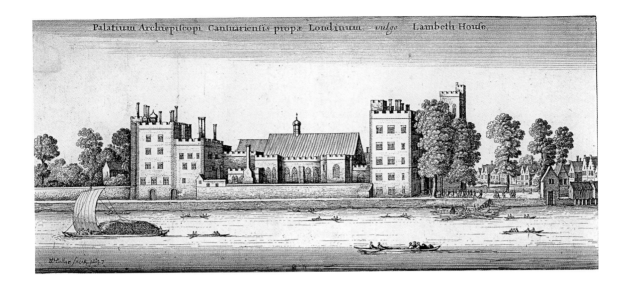

Palatium Archiepiscopi Cantuariensis propæ Londinum. vulgo Lambeth House.

with and interest in this Lambeth landmark. He would have known it even from the beginning of his career when, in 1503, as chaplain to Henry Dene, the archbishop, he had called finally at the quay to convey with due ceremony Dene's body down the Thames en route to his burial in Canterbury Cathedral. It was Dene's successor, William Warham, however, who drew his greater interest and eventually his envy. Consecrated Bishop of Lincoln by Warham in the Lambeth Chapel in 1514, Wolsey was already at the time planning to replace Warham as Lord Chancellor, forcing him from office by the following year, within a month of becoming cardinal.[45] Immediately after these events, moreover, in his elaborate reconstruction of York Place, its fifteenth-century core of chapel, hall, and cloister essentially twinned to that at Lambeth, Wolsey was driven to build a town house on an even grander scale than the palace he could see across the river, a project that may also have included an interest in out-shining the archbishop's Privy Garden. Certainly, in his exactly contemporaneous creation of Hampton Court, Wolsey was further motivated by Warham's grand new country palace at Otford, Kent, built between 1514 and 1518, with a courtyard even bigger than Wolsey's. Both of these country properties eventually attracted the covetous eye of Henry VIII.[46]

Unfortunately, no Lambeth Palace garden records survive from the period of Warham's tenure (1503–32), nor does any contemporary image of its Privy Garden, the expanse lying immediately to the

43 Wenceslaus Hollar, *View of Lambeth Palace*, 1647. Guildhall Library, Corporation of London.

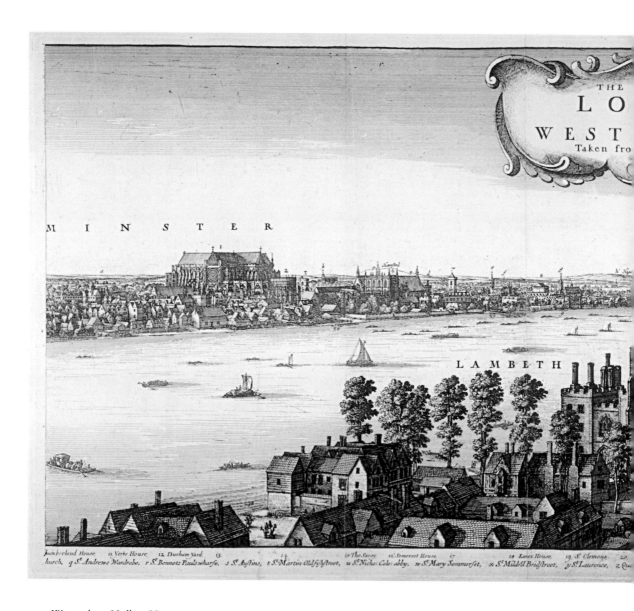

M I N S T E R

THE
LO
WEST
Taken fro

LAMBETH

Sumberland House, 11 Yorke House, 12 Durham Yard, 13. 14 15 The Savoy. 16 Somerset House, 17 18 Essex House, 19 S.ᵗ Clemens, 20.
hurch, q S.ᵗ Andrews Wardrobe, r S.ᵗ Bennets Pauls wharfe, s S.ᵗ Austins, t S.ᵗ Martin Oldfishstreet, u S.ᵗ Nicho: Cole: abby, w S.ᵗ Mary Sommerset, x S.ᵗ Mildr'd Broadstreet, y S.ᵗ Laurence, z Qu

44 Wenceslaus Hollar, *View of Lambeth, the Thames, and Westminster*, 1647. Guildhall Library, Corporation of London.

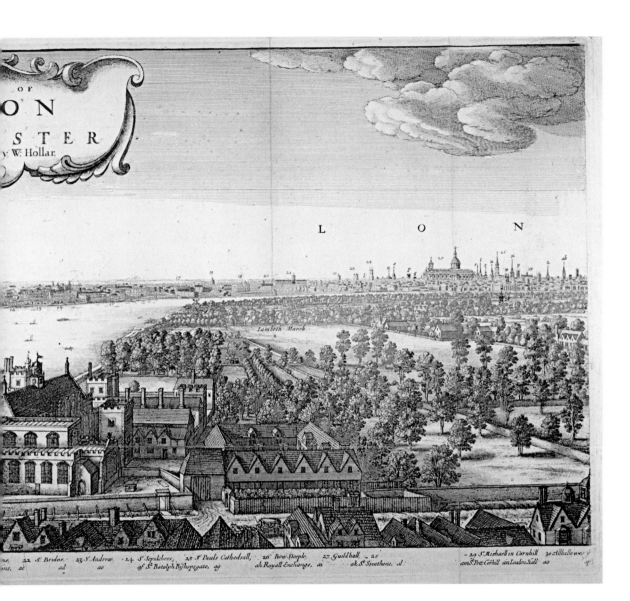

OF
ON
STER
*y W. Hollar.

L O N

Lambeth Marsh

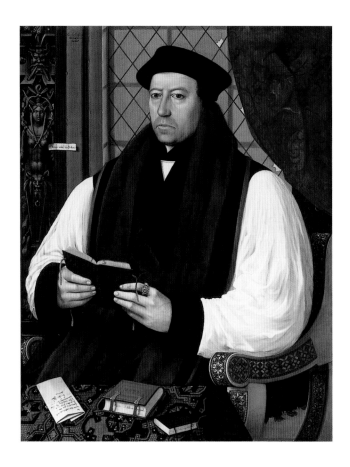

north of the palace complex that More would have known well and which he last saw in 1534, when called to appear before the Commission appointed to question his loyalty (see Introduction). Presiding at these hearings was Warham's successor, Thomas Cranmer (pl. 45). Only a short time later, within five years of More's death in 1535, however, certain events began to occur that would soon affect this garden space, the outcome of Cranmer's ambitious building projects at the palace during the 1540s. These included a new north front for the main palace wing, facing the garden, which was also overlooked by a gallery running along the upper floor. This gallery in turn connected to a new garden structure, a long two-story terrace along the garden's east side, with its lower level "paved with square tyles opening with arches to . . . the said garden," and, above, a raised walkway offering views of the garden on one side and the

orchard on the other. New garden walls around the remaining sides of the garden space were also built, as was a banqueting house at the end of the terrace walk.

The layout can be seen in a modern redrawing of details from a map of 1648 (itself surviving only in a copy of 1700) (pl. 46). The Privy Garden, it should be noted, is shown in alignment with the palace, not with the east and west garden walls, and the garden expanse itself is laid out in quadrants, an arrangement confirmed in the earliest maps of the area (see pl. 8). The map also shows the location of the palace orchard and its kitchen garden (in the Kitchen Yard), and a portion of the moat that surrounded the entire complex. The destructive occupation of the buildings during the Civil War, when the Great Hall was razed, apparently had little permanent effect on the Privy Garden or the Orchard, and their layout, as planned by Cranmer, was to survive well into the eighteenth century, as may be seen in an anonymous engraving of 1731, showing three bishops rowing on the Thames toward the palace. The Privy Garden appears immediately to the left of the palace (pl. 47).

What do not survive are the names of the gardeners who helped Cranmer to plan and re-create these garden areas, information that would have been recorded in the accounts kept by the reeves of the manor. Some of these gardeners' earlier counterparts, however, are identifiable from other such accounts kept during the long run of garden enterprise at the palace extending back for more than 200 years before the time of More and Cranmer. The earliest of these records date from 1321/22 during the tenure of Archbishop Walter Reynolds. The gardener at the time was known simply as Roger and he had working for him an unnamed laborer and a boy employed to plant flower seeds ("seminis florati") and vegetables and herbs, the last providing a unique catalogue of named plants from this period: "olearum," "fletrocilii," "shervil," "clarey," "littuse," "spynhach," "Toncressis," "Caboche," "Concomber & Gourds," "Isope," "Bourage," "Centurrage."[47] In the fifteenth century, during the tenure of Archbishop John Stafford, two more gardeners' names were recorded: in the years 1443–45, Thomas Whetele; in 1445–47, William Shippe.[48] Unfortunately, the reeves' annual reports subsequent to 1447 are now lost, and these gleanings from early records are but small compensation. Yet certainly garden staff would have been employed.

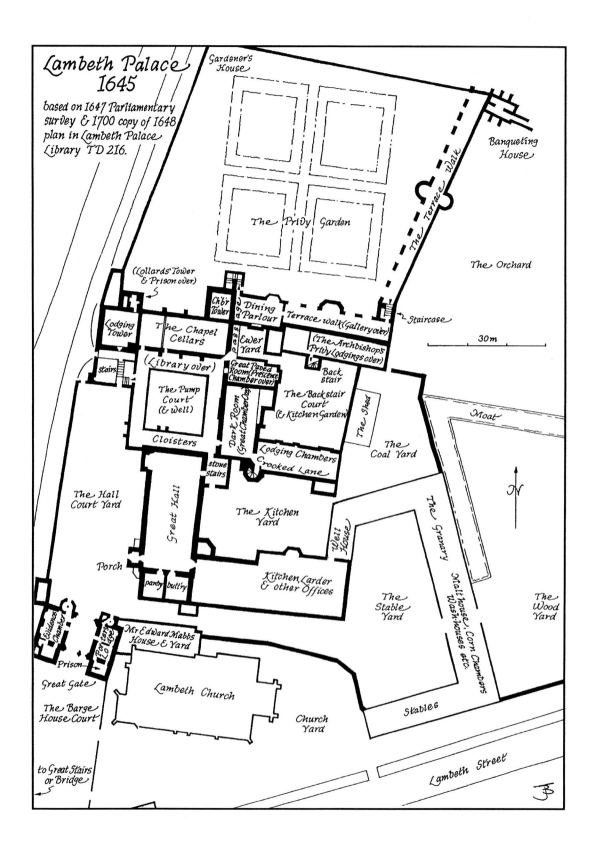

Lambeth Palace
1645

based on 1647 Parliamentary
survey & 1700 copy of 1648
plan in Lambeth Palace
Library TD 216.

Gardener's House

The Privy Garden

The Terrace Walk

Banqueting House

The Orchard

(Lollards' Tower & Prison over)

Ch'br Tower

Dining Parlour

passage

Terrace walk (Gallery over)

Staircase

30m

Lodging Tower

The Chapel Cellars

Ewer Yard

(The Archbishops Privy Lodgings over)

stairs

(Library over)

Great Paved Room (Presence Chamber over)

Back stair

The Pump Court (& Well)

Dark Room (Great Chamber Day)

The Backstair Court (& Kitchen Garden)

The Shed

Moat

Cloisters

Lodging Chambers Crooked Lane

The Coal Yard

stone stairs

The Hall Court Yard

Great Hall

The Kitchen Yard

Well House

The Granary

N

Porch

pantry

butt'ry

Kitchen, Larder & other Offices

The Stable Yard

Malt House, Corn Chambers Wash-houses etc.

The Wood Yard

Evidence Chamber

Porter's Lodge

Mr Edward Mabbs House & Yard

Prison

Lambeth Church

Great Gate

The Barge House Court

Church Yard

Stables

to Great Stairs or Bridge

Lambeth Street

JB

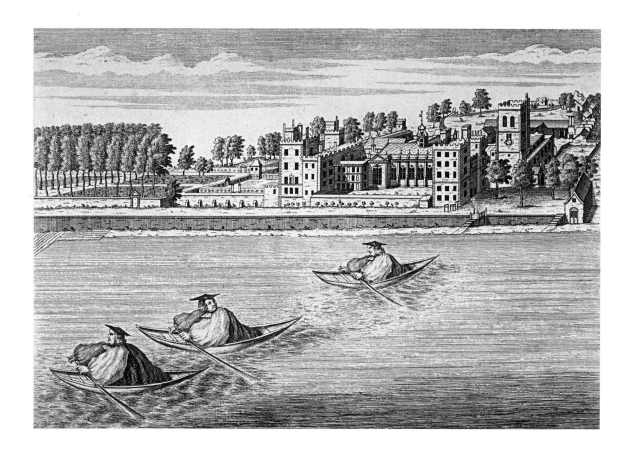

During Warham's tenure, for example, when as prelate he enjoyed a household staff numbering more than 200 people,[49] there must have been a sizable group of gardeners and garden workers.

One Lambeth Palace document from later in the sixteenth century does survive to support this assumption and deserves special notice for the picture it offers both of gardeners' responsibilities and of garden features at the time. Based on an earlier set of Cranmer's household regulations, a new set of rules governing the household staff was assembled by Margaret Parker, the wife of Archbishop Matthew Parker, at some point before her death *circa* 1572. Of the gardener's duties, she wrote:

> His office is to see the garden, orchard and walks to be kept well weeden, rould, the grasse walks and platts not suffered to be much growne but kept lowe with the sythe. To see that there be planted in the grounds flowers, hearbs and roots, both for the provision

47 Anon., *View of Lambeth Palace*, 1731. Guildhall Library, Corporation of London.

46 (*facing page*) Modern redrawing of a copy made in 1700 after the plan of Lambeth Palace grounds, 1648. Tim Tatton-Brown, *Lambeth Palace: A History of the Archbishops of Canterbury and Their Houses* (London: SPCK, 2000), by permission of SPCK.

of the kitchen and chambers; and with all sorts of good fruits, hearbs, plants and flowers for use and pleasure. That he keepe nurseries of all sorts of good plants, to supply any defect that may happen, and that he delve and manure the grounds to the best comodity of the owner.[50]

Such a regimen, written down only a generation after More's last visit, would surely not have differed appreciably from that followed even during the years of More's youth spent with Cardinal Morton or like that presumably still in operation later when More was to visit Warham, at those times the prelate was in residence. Warham's Privy Garden, moreover, was in all likelihood quite comparable in appearance with Cranmer's, both in formal layout and bed design (see chapter 4). In its privileged spaces, one can well imagine the meetings that Warham had enjoyed there, with More and with More's close circle of intellectual companions: Erasmus, the Greek scholar William Grocyn, and John Colet, Dean of St. Paul's and the founder of its school. It was an illustrious group that might have given Wolsey even more cause for envy.

More's Chelsea Manor

Proceeding a little more than two miles upriver from Lambeth Palace, one arrives at a fourth type of river garden in More's London, that of his own beloved country manor in Chelsea. Like the other riverside gardens, More's Chelsea gardens were created perhaps foremost as an appropriate reflection of social prominence. But there was one important difference. Unlike the others, whether that of king, bishop, or City organization, More's also served to mirror the personal achievement of a private, albeit highly privileged, London citizen. As such his gardens were to become famous. They also came to rival the others, both in size and orderly design.

Today, visitors traveling on the King's Road in Chelsea on a no. 23 London bus probably little appreciate the fact that, as their transport turns into Beaufort Street and heads south toward Battersea Bridge, it is taking them directly across the site of More's great country house, completed by 1525. At the time that it was built, the manor land surrounding the mansion accommodated about 37 acres,

an area bounded roughly today by the river to the south, Milman Street to the west, and Church Street to the east, with the King's Road running along the property's northern perimeter. The mansion, extending west to east for nearly 250 feet, was a free-standing structure of graceful proportions, as may be seen in a twentieth-century drawing that recreates the appearance of the house (pl. 48): the drawing is now in the possession of Allen Hall Seminary, whose main building occupies the easternmost portion of the house's original site. More's imposing residence, meant to be seen from the river, stood some 600 feet inland, separated from the bank by two walled garden courts, each bisected by a long pathway running north from the riverfront to the house's great terrace. Nearby to the west and northwest stood a number of manor outbuildings – barns, workshops, and a stable block – while to the southwest was a farmhouse where the More family had lived in 1524 while the mansion was under construction.

Although the property was to undergo many alterations in the years after More's death, eventually resulting in the mansion's destruction 200 years later, some semblance of the manor layout may be seen in a drawing done by Leonard Knyff in 1695 (pl. 49).[51] Because this drawing provides the only surviving view of the property, it is important to examine its depictions in some detail.

48 Basil Emmerson, *More's Chelsea Mansion*, 1978. Allen Hall Seminary, London.

Chief among the changes that had occurred were new houses constructed after 1535, when the manor was confiscated following More's attainder. Proceeding clockwise from the lower left corner, one sees a structure later known as the Lindsey House, first built early in the seventeenth century (and subsequently rebuilt), on the site of the original farmhouse. Above it stands a second building, called the Gorges House, erected late in the sixteenth century on space once occupied by More's farm outbuildings. Next, moving northward, is the old stable block, surviving at the time the drawing was made. Surrounded by brick walls that remain today, the space is now a Moravian cemetery. To the east of the stable area, Knyff further shows two large garden expanses, which in More's time would probably have been the family's great garden, used primarily for growing food. Then, to its east, separated by yet another brick wall, lies a configuration of smaller garden squares, which in More's day would have been laid out as fields and larger kitchen gardens. Once known as Dovecote Close, it is today the area occupied by Paulet Square.

Below this large northeast corner quadrant of the manor's lands, one next sees an elaborate garden layout extending southward toward the river. This was the former site of a third building, known as the Danvers House, put up in 1622/23 but pulled down in the 1690s, shortly before the drawing was made. This southeast quadrant of the original manor, reaching to More's parish church (now Chelsea Old Church), was originally bequeathed by More to his daughter Margaret and her husband, William Roper, when the manor lands were first purchased, and thus it escaped confiscation following More's execution. Finally, to the immediate left of this area, Knyff shows a walled orchard and, above it, a walled garden, along the northern side of which is a raised terrace extending from the mansion's eastern side to a garden structure at the terrace's end. For the decade that the Mores were in residence, this walled garden was in all likelihood the area reserved by the family as their privy garden, overlooked by the garden structure on the terrace that served as their summer or banqueting house. If this surmise is correct, then the famous Rowland Lockey miniature, *The Family of Sir Thomas More*,[52] dating from the 1590s and now on special display at the Victoria and Albert Museum, depicts this garden (pl. 50); it also shows, on the horizon to the east, a view of distant London spires.

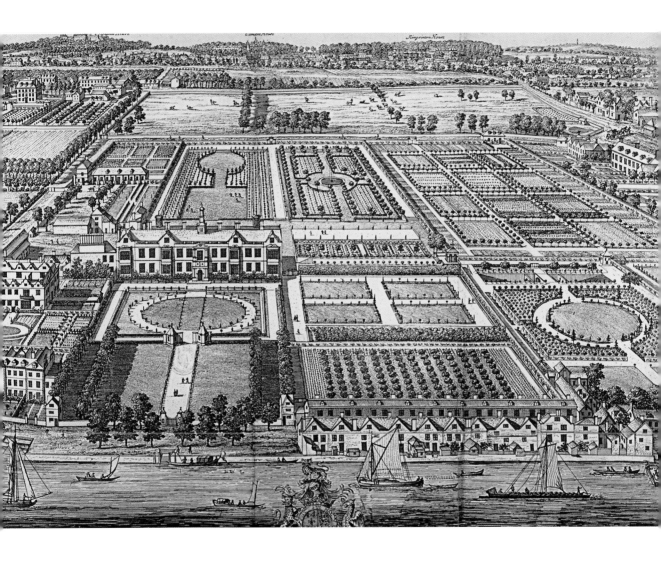

49 Johannes Kip after
Leonard Knyff, *Beaufort
House, Chelsea*, 1695,
engraving (detail), 1720.
Guildhall Library,
Corporation of London.

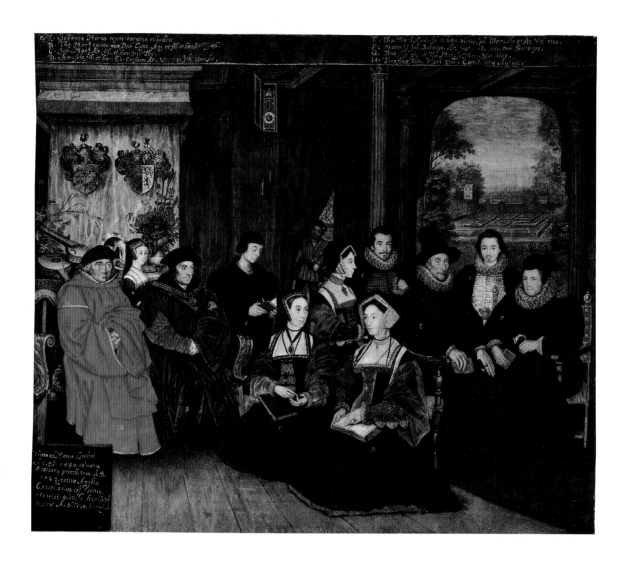

The following text appears within the painting:

A · Iohanes Morus eques auratus et iudex
B · Tho: Morus eius nur Dns Canc Ang et fil eius Diet 1595
C · Ion Mor: Ar: fil et hęr Diet Tho.
D · Anastela fil et hær: Ed: Croftare Ar: Vx: o Ioh Moro Ar:

E · Tho: Mo: Ar:nd: fil nepos diet: Ioh: Mor: Ar: et Vx eius,
F · Henric: Ioh: Scroope Ar: nat: fil: Iffr Dn̄ Scroope
G · Dns fl: diet: p Tho Mor: fil Nepo: Nepotis,
H · Cresacrq̄ Ioan. Mori Dni: Canc: arg: Ang:uc.

Thomas Morus Londini
natus Ao: 1480: Cęnatus
est: ara primū: dum: Ao: D.
1529: totius Angliæ
Cancellarius est: factus,
Henrici: 8: in: cui decessum
suscepit Ao: D.1539...

50 Rowland Lockey after
Hans Hobein the Younger,
*The Family of Sir Thomas
More*, 1593–94. Victoria and
Albert Museum, London.

51 *(facing page)* Anon., *Plan
of Chelsea Estate Prepared for
Sir Robert Cecil*, 1595.

The arrangement of original garden space within the manor's
layout, as here argued, is substantiated by a map drawn around 1595,
near the time of the Lockey miniature. Prepared for the property's
owner at the time, Sir Robert Cecil, the map shows a number of
features that appear to remain from More's tenure (pl. 51).[53] Below
the house are the two walled courtyards fronting on the river and to
their east lie the walled privy garden and, below it, the walled
orchard garden. Brick outbuildings can also be seen, to the west of
the house, with the stable block above them. To the north-northeast
of the house the configuration of various beds occupies the great

78

North

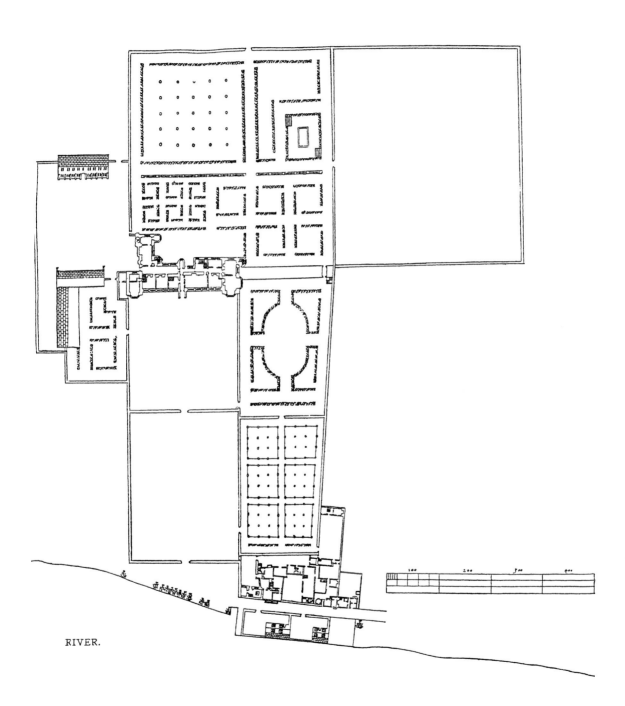

RIVER.

garden area, and to its east the blank square is that of Dovecote Close. The empty space below, to the southeast, is also pertinent, for this was the land bequeathed and reserved for the Ropers and therefore not included on this manor map. Finally, the shoreline of the river appears at the bottom, with a depiction of the wharf then still in use, dating from More's lifetime.

One additional building at the manor is important to note, for it reveals an aspect of More's Chelsea life that stands apart from his family's rural enterprise there. The structures within this building are given special notice by William Roper:

> As Sir Thomas More's custom was daily, if he were at home, besides his private prayers, with his children to say the seven psalms, litany and suffrages following, so was his guise nightly, before he went to bed, with his wife, children and household to go to his chapel and there upon his knees ordinarily to say certain psalms and collects with them. And because he was desirous for godly purposes sometime to be solitary, and sequester himself from worldly company, a good distance from his mansion house builded he a place called the New Building, wherein there was a chapel, a library and a gallery. In which, as his use was upon other days to occupy himself in prayer and study together, so on the Friday there usually continued he from morning till evening, spending his time only in devout prayers and spiritual exercises.[54]

The location of this place of daily retreat, in the general layout of the manor, has been the subject of frequent debate.

The most recent argument over the site of the New Building is that of Roy Strong, who presumes that the view presented in the Lockey miniature is looking southeast from the More mansion, to a walled garden running down toward the Thames on the quadrant of property outside the manor that was owned by William and Margaret Roper (later the site of the Danvers House).[55] He is almost certainly correct in assuming that this is the probable area where the New Building, with its chapel, gallery and library, once stood. This reflects Walter Godfrey's findings of 1911.[56] But on topographical grounds, the garden could not be the one depicted by Lockey, which looks to the east and the city's distant horizon, not to the south towards the Thames. A much clearer estimate of the miniature would see it as the mansion's nearby privy garden, as noted earlier,

with its raised terrace culminating in a banqueting house. The gate in the garden's far (eastern) wall, moreover, would have opened not to the Thames, but rather to a lane leading south to the Thames (now Danvers Street). Near the bottom of this lane was the more probable site of the New Building, enlarged by the Ropers as a house after 1535 and called by them "Moorhouse," which in turn was destroyed when Danvers House was built.[57] But no image survives of the original place of More's retreat.

If these conjectures about the garden spaces of More's manor are correct, then it was probably the privy garden where More so frequently walked with visitors (see chapter 5). But this was not the only place for such entertainment. One of the earliest accounts of such meetings is that written by More's grand-nephew Ellis Heywood, who in his book *Il Moro* of 1556 constructed an imaginary meeting in Chelsea between More and six visitors. In Roger Deakins's translation of the work from the Italian, the passage introducing this scene begins as follows:

Among the many delightful estates that grace the River Thames, there is one, quite close to London, where Sir Thomas More (a man well known for his virtue) had a beautiful and commodious home where it was his custom to withdraw when he tired of the city. The house was so close by and the owner so excellent a man that the rarest and finest intellects of the city gathered there.

Next, after introducing the visitors who once paid More a visit, the passage continues:

These gentlemen, as I have said, came to More's house to dine. After the meal they went to walk in a garden that was about two stone's throws from the house. On a small meadow (in the middle of the garden and at the crest of a little hill) [*in un pratello posto in mezzo il giardino sopra un uerdo monticello*], they stopped to look around. The spot pleased them greatly, both for its comfort and for its beauty. On one side stood the noble City of London; on the other, the beautiful Thames with green gardens and wooded hills all around. The meadow, beautiful in itself, was almost completely covered with green and flowers in bloom, and tender branches of fruit trees were interwoven in such beautiful order that they seemed, to the guests, to resemble an animated tapestry

made by Nature herself. And yet this garden was more noble than any tapestry, which leaves more desirous than content the soul of him who beholds the images painted on cloth.[58]

While this passage may describe More's privy garden, its references to espaliered fruit trees also suggest the possibility of the walled orchard near the river or even the southern or outer courtyard, which in an early drawing of the mansion's floor plan done by John Thorpe is identified as an "Orchard or garden Yarde."[59] Heywood's emphasis on a small hill providing a vantage point for seeing both the City and the Thames also suggests that More may have had some form of mount as a garden feature (see chapter 4). Yet any such pleasure-garden areas, with their attendant intellectual or political drama played out when visitors were walking with More in these places, formed only one part of the manor. This was also a working place, with large plots devoted to the growing of food.

The question of gardening staff for all such manor enterprise thus must follow. How many people did More employ and how many of them worked primarily in the gardens? One answer lies in a surviving document dating from 1528, when Wolsey had ordered a census of population and grain stocks, a result of the plague as well as harvest failures. More contributed to this investigation for Chelsea, and when the report was made it noted that there were 2,090 people in the borough and that "More hath in his house daily" 100 persons.[60] Aside from family members and personal servants, perhaps as many as fifty others served domestic duties, of which garden staff would have made up a sizable part, assisted by upper servants of More's household who, when free of other duties, were assigned their own garden plots to tend.

The manor, it should also be remembered, had field crops, as did neighboring farms, and this too formed part of the manor's enterprise, which in addition to the home place included land elsewhere in Chelsea and across the river in Battersea. Some indication of the care that More took both for his neighbors and for his own farming staff may be seen in the only surviving letter from More to Dame Alice, his wife. Written on 3 September 1529, upon report of a fire that had damaged a portion of the house as well as the barns (shared with neighbors to store grain), More's letter concludes:

I pray you to make some good ensearch what my poor neighbors have lost and bid them take no thought therefor, for and I should not leave myself a spoon there shall no poor neighbor of mine bear no loss by any chance happened in my house. I pray you be with my children and your household merry in God and devise somewhat with your friends what way were the best to take for provision to be made for corn for our household and for seed this year coming, if ye think it good that we keep the ground still in our hands, and whether ye think it good that we so shall do or not, yet I think it were not best suddenly thus to leave it all up and put away our folk off our farm, till we have somewhat advised us thereon; howbeit if we have more now than ye shall need and which can get them other masters, ye may then discharge us of them, but I would not that any man were suddenly sent away he wot nere whither [knows not where]. At my coming hither . . . shall we further devise together upon all things what order shall be best to take.[61]

Although Dame Alice has frequently been depicted in terms of her personal limitations – and often was so by More himself – what this letter makes clear is the trust he placed in her and the responsibility she routinely must have taken in the management of the manor. It was she, one must recall, who saw most clearly what her husband was prepared to give up when, at the end, he was imprisoned. One can imagine her voice, at a time of severe provocation, asking him sternly if he realized what was at stake in Chelsea: "a right fair house, your library, your books, your gallery, your garden, your orchard and all other necessaries so handsome about you." Summarized in these words, More's manor indeed stood as a place apart, distinctive among the other riverside gardens here visited.

★ ★ ★

Fulham Palace

If More's Chelsea manor represents all that was new in early sixteenth-century riverside gardens, the next garden here considered, that of the Bishop of London's Fulham Palace, located upriver only a few miles distant, was its exact antithesis, so far as its ancient origins were concerned. Indeed, when land for the Southwark manor of Winchester was purchased in the 1140s, Fulham had already existed as a residence for the head of the Church in London for more than 400 years. When More would have visited the palace in the sixteenth century, the site had been continuously occupied by its long line of bishops for 800 years.

Such numbers defy any easy accommodation, and yet modern visitors to the palace are apt to find their imaginations fired by the extensive grounds lying alongside the river, the route of its ancient moat, more than a mile in length, still marked by paths that finally reach the palace, which even today stands surrounded by 13 of the 36 acres originally comprising the manor.

The portion of the palace remaining that More would have known is the Tudor gatehouse and western service court (pl. 52).

52 Fulham Palace, gatehouse.

Completed about 1500, these structures, built in brick, would have represented the newest of architectural design at the time, the gatehouse comparable with those at Lambeth Palace and at Lincoln's Inn (facing Chancery Lane).[62] Although altered in later years, the court lying beyond the gatehouse (pl. 53), even today, also retains its Tudor appearance, reminiscent of its much larger counterpart at Hampton Court, soon to be built by Wolsey.

Although the Fulham gateway and tower are now what one first sees upon entering the palace grounds, this would not have been the entry point for More and his contemporaries. As was the case at Hampton Court, Fulham Palace was meant to be seen from the river, with a pathway leading northward from the manor's barge landing (eventually crossing a bridge over the moat) by which a visitor came finally to the eastern wing of the complex, with its kitchen gardens lying to the left and a walled garden orchard, to the right. One might well imagine the widowed Catherine of Aragon, perhaps in 1507–08, traversing such a route of arrival when paying a visit to Fulham before her marriage to Henry VIII was eventually

53 James Peller Malcolm, *Fulham Palace*, 1798. Guildhall Library, Corporation of London.

54 John Rocque, *Fulham Palace, Surveyed between 1741 and 1745* (detail), 1746. Guildhall Library, Corporation of London.

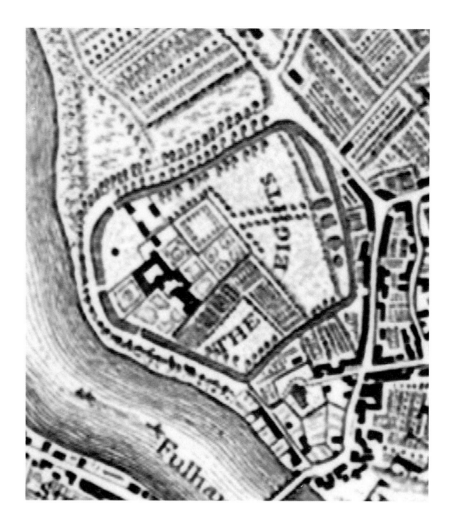

settled. Nearly destitute at the time, she was to spend a period of retreat at the palace under the protection of Bishop Robert Fitzjames.

Although no map or image of Fulham Palace survives from More's lifetime, some sense of its location within the grounds of the manor and of its garden layouts may be seen in John Rocque's survey, published in 1746 (pl. 54). The gardens, here shown in outline and design, appear much more elaborate than would have been the case 200 years earlier, but the general sense of location would not have altered. Rocque's survey still reflects the gardens' most celebrated development, late in the seventeenth century, under

Bishop Henry Compton. Between 1683, when shipments of plants first arrived, until his death in 1713, Compton indulged his passion for botany, introducing new plant species into England, creating thereby at Fulham perhaps the most extravagant display of foreign plant material assembled at the time. He was aided in this enterprise chiefly by the missionary he had sent to the Virginia colony, John Banister, who was instructed always to be on the lookout for whatever was new, exotic, or different among plants found there, particularly trees and shrubs. As a result, the plantations of New World flora at Fulham were to achieve a good deal of contemporary fame, and Compton's legacy still attracts serious interest among garden historians.[63]

To the extent that good things can be said to have come from the English Civil War, one of these was the decision (never implemented) made by Parliament in 1647 to confiscate and sell Fulham Palace in its entirety. To that end a survey of the property was ordered, carried out by William Dickes, whose report still survives, rediscovered by Simon Thurley among archival documents at the Guildhall Library.[64] Outlining in detail the layout of the palace's gardens, the report offers a unique opportunity to assess what was there at the time. It also forms the basis for enquiry into the garden plans of a century or more earlier, as discussed below.

The portion of the report dealing with the gardens begins with the location of the kitchen garden, "lying between the mote and the backside of the south buildings." Next listed is "a square garden called the plumb garden walled with brick adjoining the said kitchen garden on the east part thereof." To its east, in turn, lay "a large orchard called the walled orchard walled about with brick," while to the north lay "the little orchard adjoining." The report then turns to gardens north of the palace complex itself. First mentioned is a "stone gallery garden"

> in which said garden is a stone gallery on the south side thereof and a fair summer parlour, wainscotted, on the west part therof . . . [with a] terras chamber over the summer parlour [and] a great gallery matted and wainscotted over the stone gallery.

Such description is reminiscent of other galleries and summer houses, meant to overlook choice garden displays, as noted above in connection with the Tower of London, the Bridge House, York

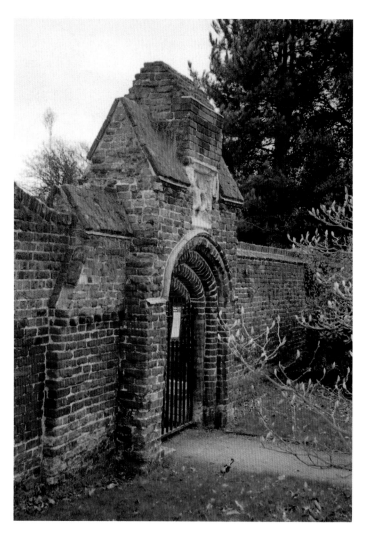

55 Fulham Palace, garden
gate.

Place, and Lambeth Palace (see also
chapter 5). Finally, the survey ends
by listing such privileged expanses
at Fulham: "the great garden and
the rose garden to the west of [the
stone gallery] on the north part of
the manor house and adjoining the
warren."

One sees from these
topographical descriptions that
already by 1647 the orientation of
the "best" or privy gardens had
begun to shift to a north–south
axis, an elaboration of which would
be completed later, presumably
under Compton, as shown on the
Rocque map. By then the kitchen
garden on the south had been
replaced by formal compartments,
while the ranges of the great
garden and the rose garden had
been extended by new
compartments to the north. Yet
very little of this axis shift would
have characterized the gardens in
the sixteenth century, where
emphasis seems still to have lain on
gardens to the east of the palace.

Such argument is based on the
findings of an archeological survey of the grounds conducted in the
1980s. This useful report, based on ground surveys made at the time
and on the Parliamentary Survey of 1647, concludes with a series of
maps visualizing the garden plans at various times, including one
from the sixteenth century (pl. 56).[65] Of particular interest is
discussion of the Large Orchard, a portion of whose walls still
survive, as does a gateway bearing the arms of Bishop Fitzjames
(pl. 55), a contemporary of More. The repositioning of these arms
from the eastern side of the gate to its western side (and thus
signaling an entrance to a new garden area) suggests that, perhaps

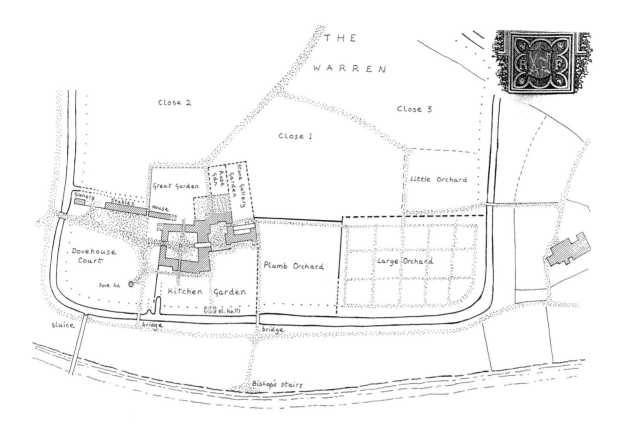

The following labels appear on the map:

THE WARREN

Close 2

Close 3

Close 1

Little Orchard

Granary

Stables

Great Garden

House

Stone Gallery

Rose gdn.

Garden

Dovehouse Court

Dove ho.

Plumb Orchard

Large Orchard

Kitchen Garden

sl. ho.(?)

sluice

bridge

bridge

Bishop's stairs

during his tenure (1506–22), the Large Orchard was first being developed, laid out in fifteen squared plots, the demarcations of which can still be seen in the paths used in the expanse.

It was Fitzjames's successor, Cuthbert Tunstall, who was perhaps the closest friend More had among the bishops at Fulham during his lifetime (see Introduction). More would have remembered him most as an honorable man. Today, however, Tunstall is most often remembered as the man who turned down William Tyndale's request for a job. Having come to London in 1523 to begin serious work on a translation of the New Testament, Tyndale had approached Tunstall as a possible patron for such a task: "Whereupon my lord answered me, his house was full, he had more than he could well find, and advised me to seek in London, where he said I could not lack a service . . . I . . . understood at the last . . . that there was no room in my lord of London's palace to translate the new testament."[66]

56 Warwick Rodwell, *Reconstruction of Fulham Palace Gardens*, 1987 (with, inserted, the arms of Bishop Fitzjames from over the garden gate, as recorded in 1813). London Borough of Hammersmith and Fulham.

How different might have run the course of history had Tunstall taken Tyndale into his household, earning him a place both at his residence near St. Paul's and at Fulham Palace and thereby offering in effect, and perhaps finally in fact, his support of an official English translation of the Bible. Had this happened – and Tyndale's bitter exchanges with More thus not having occurred (see p. 189) – how different too might be the way one now reads Tyndale's garden rhetoric, as reflected in his translations and still so strongly echoed in the King James Bible. A passage from Tyndale's Gospel of St. Matthew comes to mind in this context. Its irony would not have been lost on More's own sense of his personal destiny.

> No man can serve two masters. For either he shall hate the one and love the other: or else he shall lean to the one and despise the other: ye cannot serve God and mammon. Therefore I say unto you, be not careful for your life . . . Behold the fowls of the air: for they sow not, neither reap, nor yet carry into the barns: and yet your heavenly father feedeth them. Are ye not much better than they? . . . Wherefore if God so clothe the grass, which is today in the field, and tomorrow shall be cast into the furnace: shall he not much more do the same unto you, o ye of little faith?[67]

Such are the vagaries of garden history speculation.

Hampton Court

Because of its distance upriver from London, Hampton Court was, in the sixteenth century, and still is today, clearly a destination and not merely a Thames address. As a destination in history it stands even farther away, separated from us by its centuries of continuous fame. Indeed, to reach the Tudor origins both for Hampton Court and for its gardens, one inevitably must look beyond and around their subsequent development.

As a case in point, one can begin with perhaps the most famous of Hampton Court's many depictions, that done by Leonard Knyff, which shows the palace complex as it would have appeared in 1700, upon completion by William III (pl. 57). One value of this spectacular painting lies in its clear presentation of the entire area

surrounding the palace, a panorama that, however aggrandized, still shows much of the original layout. Yet here one must pause to reflect on what was not in this scene when the place was dominated by Henry VIII, or earlier by Wolsey. At the least, one must erase mentally the formal design of the great park in the foreground, the Wren construction of the palace's east face, the elaborate gardens lying to the north, and the intricate Privy Garden laid out between the palace and the river, to the south. In contrast, the origins of Hampton Court were far more humble. One must try to imagine instead a small moated manor house, with hall, chapel, and lodgings surrounding a central court, the property of the Knights Hospitallers of St. John of Jerusalem, which Wolsey had leased in 1514, with the right "at all tymes" to "take down, alter, transpose, change, make new byeld at theire propre costs any houses, walles, mootes, diches, warkis, or other things within or about the said manor."[68] None of this late medieval foundation was to survive what was to follow.

Wolsey's creation on this site of the grandest new palace of his day – eventually covering more than 6 acres – took place during the course of the next ten years. Yet, ironically, this massive building project can be reconstructed only in its earliest stages, insofar as account records survive. This is no less true for the palace's gardens, the main documentation for which dates from 1515/16. Even so, to revisit the gardens' beginnings as recorded in these few documents is to gain new insight into what they initiated as probably the most important garden venture in early Tudor history.[69]

Wolsey began construction at Hampton Court almost immediately, beginning in January 1515. By then, John Chapman from nearby Kingston had already been appointed "my lordes gardyner," at an annual salary of £12, with duties in Westminster as well. In this new position, one of Chapman's first responsibilities, beginning on 20 January, was to put together a staff of gardeners and garden workers and to purchase or repair tools for them to use. Among these latter, money was spent for "iij spades," "xiij showeles" (shovels), "ij yron Rakes," "ij lynes" (measuring cords), "iiij Debelles" (dibbles), "an hand bill" (billhook), "mendyng of heyforkes," "mendyng of an old hand bill haftyng and grindyng," "a wheyll barowe," "a tubb to water therbes." As for gardeners, his main team, many of them perhaps previously in his employ, consisted of Richard Baker, Richard Brown, John Hollyer, Thomas Proud, John Randolf, and Richard

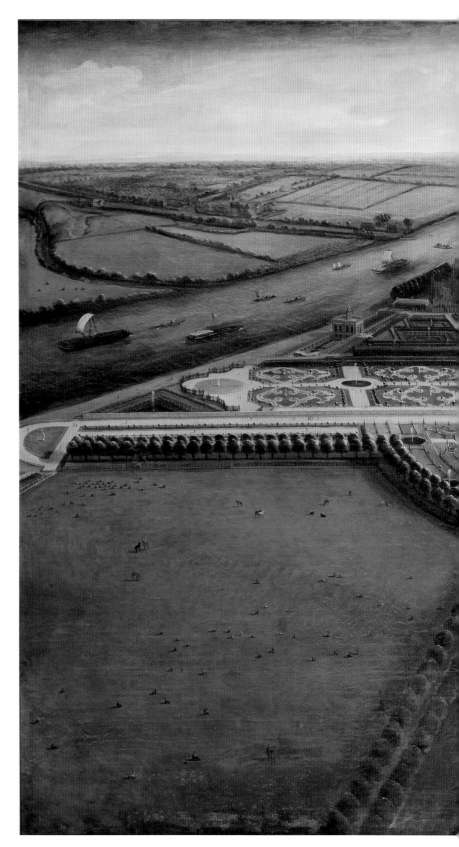

57 Leonard Knyff, *Hampton Court from the East*, *c.*1712–13. The Royal Collection, © 2005, Her Majesty Queen Elizabeth II.

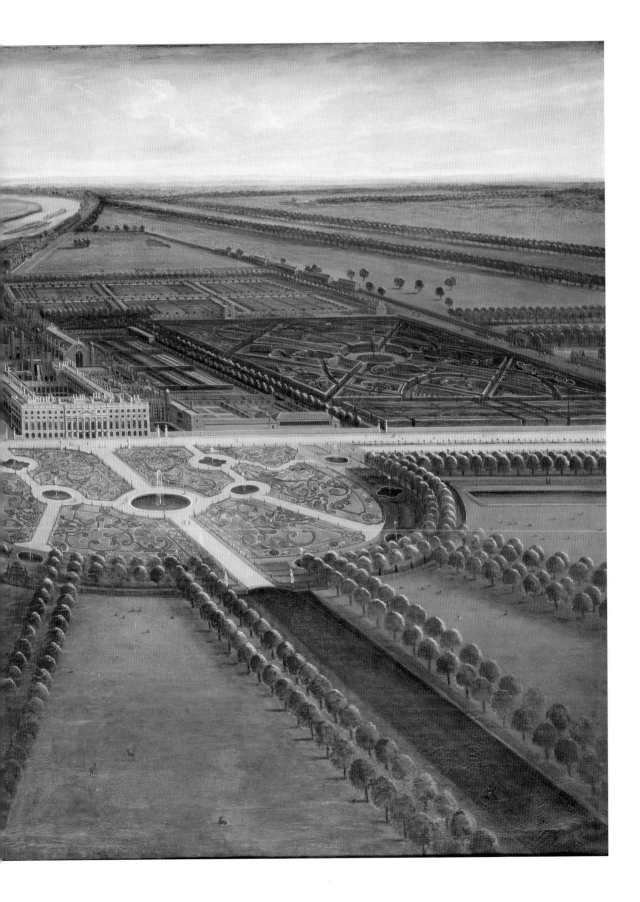

Reynolds, all of whom, as noted above, also worked with Chapman in Westminster. By February, these men, working with five other gardeners, Reynold Miller, Thomas Sharpe, Richard Smith, Richard Fuller, and Thomas Parson, were preparing beds and planting crops in "my lordes garth" as well as in "thorchard." The location of these garden areas was presumably to the immediate north of the old manor complex at the original site of the manor's adjoining kitchen garden and orchard, now kept for similar use by Wolsey. There the gardeners also worked to set up a fence, with 100 "iiij penny naylls fixed upon the pale in thorchard for twyggis to bynd tharbor."

In preparation for the garden's plantation, Chapman had purchased large quantities of seed as well as a few plant materials late in January. These included "ij lb of lekesed," "ij lb of parsely sed," "iij lb of Anittes sede" (aniseed), other "dyuers sede that is to wit levewirtes sede, carrott sede, tyme seed, parsely sed, caryway [caraway] sed, millyans [melon], dyderus [?], collyandre [coriander] sede," plus "iij fruyt treys." A month later, more purchases included "vij baskettes of Strawberes" and "vj baskettes of prymroses." In addition, there were "vj burthages [i.e., loads] of pottes for the herbys" and "twyste to bynd therbes." By early March, the new garden regimen was presumably well under way.

The gardening season in 1515 was to prove a busy one for Chapman, for as head gardener he had many other duties. From March until July he, along with his main Hampton Court team, Baker, Brown, Hollyer, Proud, Reynolds, and Randolf, were back in Westminster, overseeing work on the renovation of Wolsey's "great garden," in anticipation of the king's forthcoming visits. Yet during this period Chapman would also, presumably, be making many trips back up the Thames to supervise the major construction of new brick walls for the Hampton Court orchard. During July alone, the records indicate that Thomas Abraham, John Swallow, and John Snow, "bricklayers," were paid for laying 158 "poll of Bricke in thorchard at vjd the poll" (representing more than 2,775 running feet of brick courses).[70] On 16 July, Garret Lyte was paid "for xij lodes of trees wt dygging & cariage for thorchard at vjd of the lod." Meanwhile, sixteen men and women were at work from then into the autumn "weding in my lordes garthinges & orchard at iijd the day" (see chapter 2).

One additional record of Chapman's busy year dates from September, when he purchased, yet again, more tools for the garden. The list is an interesting one, some of the pieces suggesting the needs of a now enlarged orchard enterprise: "iiij paryng yrons," "ij pare of cherys [shears]," "ij long billys," "iij small hokes," "an Awgere," "j whele Barrow," "j bayl hoke," "j male Spaid," "ij Graftyng sawes," "j gret chesell and j small," "j graftyng knyff" (see chapter 3). Clearly, something was under way.

Although it is not possible to reconstruct the subsequent years of Chapman's tenure at Hampton Court, various other data further suggest creation during this period of gardens other than the walled orchard and kitchen garden. By 1518, for example, many stretches of the new moat surrounding the palace complex were now complete and fish ponds had also been constructed, presumably between the palace and the river (within the area later to become Henry VIII's Pond Garden).[71] These years, perhaps even to Thomas More's eyes, must also have seen the creation of Wolsey's famous knot garden, which was situated to the east side of the palace, between a new gallery wing and the chapel. This garden was still in existence at this location in 1534, when £2 was allocated for a stone sculpture bearing the king's arms for the "Knott garden":

Payd to Ed[mun]d More Kyngston ffremason for makyng carving
intayllyng of Kynges Armes in a table of freston conteynyng vij
fote one waye and iiij fote the other waye wyth borders of antyk
worke and serten of the Kynges bestes holdyng up in a shilde the
Kynges Armes with the garter poises [poesies, i.e., mottoes] and
Scrypture in gravid and Also the Crowne imperiall wrought after
the best facion to stande of[f] the northe syde of the Kynges great
galary In the Knott garden.[72]

Some semblance of this large tablet, presumably placed at the center
of the garden's knot design, may still be seen today in another
rendition of the arms also by Edmund More, positioned over the
eastern gateway leading from the Base Court to the Clock Court
(pl. 58),[73] one of three such created by him.

Other features of the knot garden have often been inferred from
the lines that George Cavendish wrote in comment on Wolsey's
garden, including floral design and "exedra" (as they were later
called), that is, turf-covered garden benches, as well as arbors and
alley paths:

My garden sweet, enclosed with walles strong,
Embanked with benches to sytt and take my rest
The Knotts so enknotted, it cannot be exprest,
With arbors and alys so plesaunt and so dulce,
The pestylynt ayers with flouers to repulse.[74]

But some of these garden features could well have figured in other garden areas that Wolsey had established, one of them perhaps lying south of the palace's Great Court and north of what later was to become Henry VIII's Pond Garden (pl. 59). There low brick walls along a walkway, perhaps antedating Henry VIII's development in this area,[75] still mark out a garden boundary, today the site of the Orangery green (pl. 60). Another area suitable for a garden lay further to the east, south of Wolsey's gallery wing (which to its north also overlooked the knot garden).

A case might be made that either or both of these sites served as an additional privy garden for Wolsey. As early as the spring of 1530, for example, only a few months after Henry VIII had eventually taken over Hampton Court, surviving records indicate payment for eighteen carved wooden heraldic beasts bearing the king's arms that by summer were erected in a garden space called, alternately, "the privy orcherd" and "the lytill orchard":

Emp. of the Kynges Bestes holding Armys in the privey orcherd. Item – to John Ripley [of London] wt other Joyners for xviij of the Kinges bestes by them made viz iiij lyons iij Antylopes iiij hertes thre hyndes oon dragon & thre grey howndes at xviijs the pece. £16 4s.

Also noted was payment of £13 16s to Henry Blankston for gilding and painting the figures and painting bases for them in green and white. In addition, he was paid 8s "for the hyre of ij bargys at ij tymys to Carie the said Bestes from London to hampton court." The following January Ripley was to supply seven more "bestes" for the "privey orchard."

Since this garden/orchard is never mentioned again, one can guess that the reference might be to a Wolsey garden sited to the south of the palace, but later destroyed. If so, it indicates Henry VIII's wish, in a most visible way, to mark immediately the palace's new ownership (and doing so by using, for the first time, dynastic heraldry as a garden feature).[76] Certainly a southern garden would have appeared

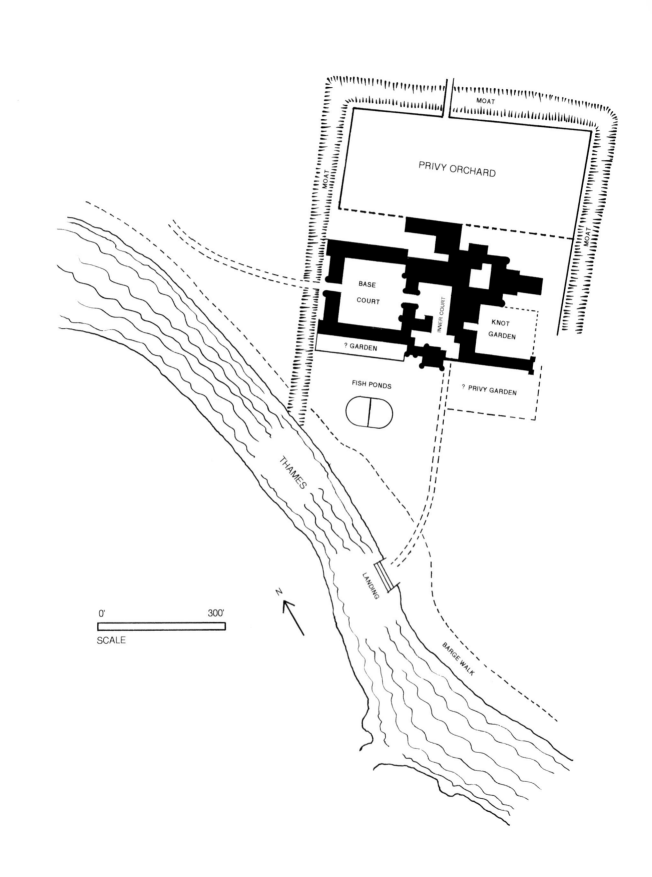

MOAT

MOAT

PRIVY ORCHARD

MOAT

BASE
COURT

INNER COURT

KNOT
GARDEN

? GARDEN

? PRIVY GARDEN

FISH PONDS

THAMES

LANDING

BARGE WALK

0'　　　　　　　　　300'

SCALE

N

60 Hampton Court,
Orangery garden wall.

prominently to visitors arriving by boat as they walked along a
pathway north from the river's edge (following the west side of the
present Privy Garden) to the palace's southern entrance, located
between these two garden areas (see pl. 59).

59 (*facing page*) Wolsey's
Hampton Court and
environs. Map by George
Olson, 2004.

In the absence of further evidence, any such suggestions for identifying Wolsey's putative gardens can only be conjectural. But in light of his enormous annual expenditures at Hampton Court, estimated at more than £5 million ($9 million) in modern currency,[77] it would seem unlikely that his garden ambitions would not also have found an outlet south of the palace complex. Even if so, however, as was the case at York Place, here at Hampton Court whatever lead Wolsey had first established was soon to be overtaken by the ambitions of Henry VIII.

Those ambitions were turned to actions by 1531, when the entire 6-acre tract south of the palace was disturbed by major garden projects, frequently referred to in the records as the making of "the Kings new garden." The first part of this massive undertaking involved the creation of two of the final three gardens eventually to occupy the space. These first two occupied land lying immediately to the west of "a long dytch" or moat extension running between the eastern wing of the palace ("the Kings galary") and the river, laid out to form a long rectangular and artfully lowered garden space, approximately 200 by 300 feet, adjoining a triangle of land below it, created by the angle of the river. The triangle soon became the setting for a large round garden mount, on which a three-story banqueting house was erected offering views of the gardens and of the surrounding country and riverside. Eventually known as the Privy Garden and the Mount Garden, these discrete areas were defined by the construction of brick walls, one of which ran parallel to the river and culminated at its eastern end in a large tower. From the angle of this wall two parallel walls were also built, to the east and west sides of the Privy Garden, with its eastern wall also extending toward the river along the side of the Mount Garden triangle. Finally, a further wall was put up to mark the southern boundary of the Privy Garden, and each end of this divider featured additional towers (pl. 61).

To build such structures was a monumental task. In payments for labor just from September to October 1531, for example, the London "bryklayer" John Dallyn earned a handsome sum of £28 13s for having laid "by taske worke" more than 306,000 bricks "vppon the garden wall betwyxt the Kinges lodgyng and the Teemes dockyng," as well as on "the foundacion of the mownt standyng by the see-Teemys."[78] Yet even as these walls were rising, site work on the

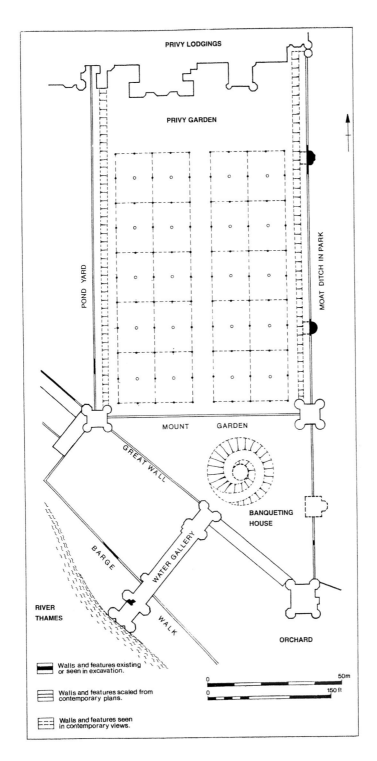

PRIVY LODGINGS

PRIVY GARDEN

POND YARD

MOAT DITCH IN PARK

MOUNT GARDEN

GREAT WALL

BANQUETING HOUSE

WATER GALLERY

BARGE

WALK

RIVER THAMES

ORCHARD

Walls and features existing or seen in excavation.

Walls and features scaled from contemporary plans.

Walls and features seen in contemporary views.

0 50m
0 150 ft

61 Privy and Mount
Gardens, Henry VIII's
Hampton Court. Historic
Royal Palaces.

interiors of the gardens was also going on, so much so that, on many working days, the scene must have presented an extraordinary spectacle, perhaps not as dramatic as an Amish barn-raising, but one equally busy, with a swarm of laborers at work on the gardens' infrastructure and design. One can only guess what was going through the mind of John Chapman, still in charge of the gardens under Henry VIII as he had been for Wolsey. The prospect of once again facing new garden ventures may have taken its toll, for in 1532 he was succeeded as "the King's Gardener at Hampton Court" by Edmund Gryffith.[79] By then, however, he had overseen much of the initial planning – quite literally the groundwork – that would give the Privy Garden and the Mount Garden their distinctive layouts.

The third of Henry VIII's new riverside gardens consisted of another triangle of land defined by the river wall, the west Privy Garden wall, and the western wing of the palace. Begun only when the other two gardens were well under way, this garden area involved extensive excavation in order to create three ponds, each surrounded by low walls, their purpose to house fresh fish for use at the palace. This was presumably the same area where earlier Wolsey had his fish ponds. Yet the Pond Garden, as it was later called, served more than a practical purpose. It also was meant to complement the neighboring Privy and Mount gardens. It did so by using displays of twenty heraldic beasts (which would also become featured in these neighboring gardens), but here executed in stone, not wood, with the king's beasts set on stone-topped brick walls.

At this point, one must pause to note that almost all discussion of these three gardens has been influenced by their earliest depiction, done by Wyngaerde *circa* 1558 and now frequently reprinted (see pl. 13). Inevitably, viewers' attention has been drawn to what appears to be the gardens' most distinguishing feature, the profusion of symbolic animals that stand in geometric order so as to outline garden beds or emphasize garden structures such as walls or the mount. Roy Strong's persuasive arguments in *The Renaissance Garden in England* are surely right in suggesting that the choice of such heraldic garden displays by Henry VIII, both at Whitehall and here at Hampton Court, was intentional, meant to be seen as "outward signals of royal magnificence" in assertion of "royal power and omnipotence."[80] Certainly Wyngaerde was perceptive in stressing such a garden feature: 159 stood in the Privy Garden (aligned with 960

yards of rails painted white and green surrounding the twenty garden beds), 16 in the Mount Garden (flanking the path spiraling the mount), and 20 in the Pond Garden,[81] all of them successors to the original 25 in the "privy orchard" noted earlier (records of their making, decorating, and installation survive for almost all of the 220). Similar display of twenty sundials in the Privy Garden, not depicted by Wyngaerde but noted in the account records, can be said to have offered further symbolic emphasis on the sovereign's tie to scientific knowledge and hence his preeminence.

All of this is surely important. Yet to the gardeners who made them, these gardens at Hampton Court must have meant more than the symbolism of garden ornaments. While highly skilled in the practical engineering of garden layouts, such as creating steep earthen banks against garden walls or leveling large expanses of uneven ground, as was the case in the Privy Garden (see chapter 4), their trade also was in plant material. The challenge for them was to select and arrange flowering plants that would complement the symbolic emphases of such gardens. Given the size of the Privy Garden, this would have presented an unusual problem. How does one conceive of garden beds that are not long and narrow but rather are each 45 feet wide and 60 feet long?

Insofar as this problem has been addressed by garden historians, most have simply noted the variety of plant material purchased for the garden. "Small settes" of "whit thorn," "woodbyne," "prevett," and "hasell" were acquired in massive quantities, yet these materials were used primarily "to quick set" the garden embankments abutting the walls, some of which at first collapsed and had to be reinforced with poles to hold the plants in place. Other plants purchased in quantity (measured by the bushel and gathered in the wild) were "strawbery rotes," "violettes," "primerose rotes," and "mynte," as well as "swete williams" and "gillavers flarris." Some of these were presumably used as borders at the base of the planted embankments, but others may also have been deployed to fill the large expanses of the main beds, thinly spread out in a setting of grass, which would have been a typical plantation at the time. To keep these beds level and intact, even a mole catcher was employed.[82] The purchase of fruit trees (in one such order, fourteen "Damson Trees" and thirty-two "appul trees and payrtrees . . . from Braynford hownslo and Heston") suggests perimeter plantings, as appear on the Wyngaerde drawing.

All such data would seem to indicate that plant materials were used primarily as an unobtrusive setting for the garden's heraldic structures. A problem remains, however. In such a highly symbolic garden plan, were there not also appropriate flowers or flowering plants selected for display that in their own right had symbolic value? One answer lies in a frequently overlooked plant purchase for the Privy Garden, namely, that made from the London gardener John Browne of 1,800 "Rosiars for to sett in the Kynges new garden," soon followed by purchase of 400 more.[83] Although the records do not indicate the type of rose that Browne supplied, a good case can be made for identifying them as the red and white *Rosa damascena trigintipetala*, the official flower featured in the royal arms (see the discussion of the Tower of London, pp. 40–41 above). Low growing in nature and close planted around the perimeters of each garden bed, they would in their large number have offered a striking linear effect against the green and white rails and would have lent further symbolic emphasis to the heraldic beasts that towered above.

Henry VIII's vaulting ambitions for his gardens were not restricted to the south of the palace. About the time of More's death, gardeners' attention was soon directed to land north of the moat and the walls surrounding the kitchen garden and orchard. There, in what quickly became named "the Kings new orchard," trees in great numbers were planted: 200 "yowng trees of oke and Elms," 400 "apple trees," 600 "chery tres," 6 "lodes of appell trees and payr trees and chere trees and mayddeler trees and crabbe stockes from Charsey Abbey," 5 "seruys treys," 4 "holuff [holly] treys." Open spaces remaining were planted in grain, for which "moers" were hired at harvest. Other areas of the expanse soon were also laid out as a pleasure garden, with an ornamental garden pond near a "Round house in the grate orchard," a large new banqueting house (equipped with its own kitchen) located "next from the herber [arbor] in the grete orchard." Henry Blankston of London was even hired "for payntyng of a But in the great orchard for the King to shote pellettes at."[84]

These and other records go on to show the king's garden interests for the rest of his life. Of all this activity More would have been witness only to the beginning stages, his last visit to Hampton Court occurring in 1531. Yet before his death and perhaps even in prison,

he might have heard more of Henry VIII's transformation of Wolsey's palace and grounds, especially the gardens lying along the river. From the time of their creation they were to become, quite literally one might argue, the crowning achievement of their royal owner. Compared with the other riverside gardens of More's London here examined, moreover, those at Hampton Court represent a crowning achievement in garden history as well.

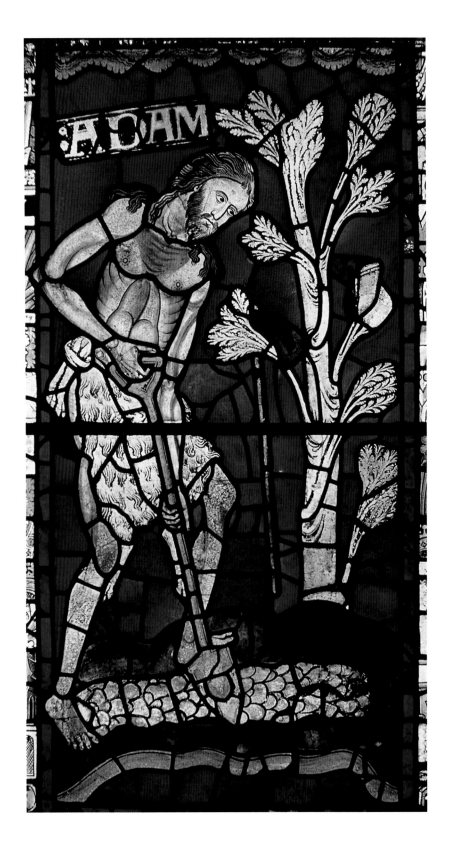

2 The London Gardeners

ALASTING IMPRESSION GAINED from even a brief survey of the riverside gardens of Thomas More's London is that these were places of immense privilege. In each instance, be it royal, ecclesiastic, civic, or private, a garden by the Thames, while seeming to exist for functional use and personal pleasure, also served to announce quite publicly by its prominent river site the owner's exalted social position. Not everyone in town could afford to live in such style on this watery Main Street. Yet what of the people who made these garden tracts possible? Who were these gardeners and garden workers? How did they view their work or the employment opportunities that gave them such work? In a larger sense, how should the typical London gardener of the day be defined? In the past, only a few answers to such questions have been thought possible, and issues of identity, economic opportunity, organization, and expertise among London gardeners in general have remained largely unresolved. Indeed, their history has often seemed no clearer than that of their mythical prototype, Adam himself (pl. 62).

Certainly the world of gardeners in Tudor London was not that of the commonwealth envisioned by More in his *Utopia*. Far from it. One might recall here Ralph Hythloday's comments in Book II:

> In other places men talk very liberally of the common wealth, but what they mean is simply their own wealth; in Utopia, where there is no private business, every man zealously pursues the public business. And in both places, men are right to act as they do. For among us, even though the state may flourish, each man knows that unless he makes separate provision for himself, he may perfectly well die of hunger. Bitter necessity, then, forces men to

62 *Adam Delving*, stained glass, twelfth century, detail from the West Window, Canterbury cathedral. Dean and Chapter, Canterbury Cathedral.

look out for themselves rather than for others, that is, for the people. But in Utopia, where everything belongs to everybody, no man need fear that, so long as the public warehouses are filled, he will ever lack for anything he needs. Distribution is simply not one of their problems; in Utopia no men are poor, no men are beggars. Though no man owns anything, everyone is rich. For what can be greater riches than for a man to live joyfully and peacefully, free from all anxieties, and without worries about making a living.[1]

For More, the ironic point of the contrast was intentional, meant to be clearly seen.

Perhaps closer to More's own practical idealism about economic reality was the statement he made late in his life, in *A Dialogue of Comfort against Tribulation*:

Men cannot, you wot well, live here in this world, but if that some one man provide a means of living for some other many. Every man cannot have a ship of his own, not every man be a merchant without a stock. And these things, you wot well, must needs be had. Nor every man cannot have a plough by himself. And who might live by the tailor's craft if no man were able to put a gown to make? Who by the masonry, or who could live a carpenter, if no man were able to build neither church nor house? Who should be the makers of any manner cloth, if there lacked men of substance to set sundry sorts awork . . . surely the rich man's substance is the well-spring of the poor man's living.[2]

As noted above in the context of More's letter to Dame Alice, his attitude toward his own staff, especially at a time of need, might be termed one of benevolent paternalism. Even so, one can only guess what his garden workers, or indeed other London gardeners, might have thought of employment seen as largesse offered by the privileged. Nonetheless, all of them might well have agreed that garden owners mattered insofar as they offered jobs. Perhaps equally important, however, some may also have seen such work as an opportunity, not only to succeed in a livelihood, but also to show off one's horticultural skills, in which enterprise pride was presumably no small factor.

In partial answer to any such questions concerning the *modus operandi* among London gardeners, the accounts of three of the

riverside gardens invite further attention, for in each case the records offer a variety of information about their respective garden staffs. That these gardens should be those at Hampton Court, York Place, and the Bridge House is fortunate in one other sense, for their histories, by telling the fullest documented story of three very different types of sixteenth-century gardens – the royal, the ecclesiastic, and the civic – offer additional insight into their gardeners' sense of enterprise.

Henry VIII's Garden Staff

Before turning to Henry VIII's gardeners at Hampton Court and York Place, one should note that these two properties, newly acquired from Wolsey by 1529, were only the latest in a series of more than sixty residences eventually held by the king. In several instances, names of those appointed to oversee gardens at other royal sites also became a matter of fugitive record.[3] As a matter both of respect and reference, all such surviving gardeners' names thus deserve a memorial in a single listing, with dates of their recorded service (Appendix A).

Among these names, that of John Chapman must stand preeminent so far as Hampton Court is concerned. Continuing work he had begun there as head gardener under Wolsey, Chapman now bore chief responsibility for executing Henry VIII's ambitious new garden schemes, beginning in 1529. This list of royal gardeners, however, contains names of some who may have offered advice and counsel in these undertakings. Stephen Jasper from Beaulieu, for example, one of the king's favored master gardeners (earning even more than Chapman at £15 0s 4d per year), is known to have visited Hampton Court at least three times between 1529 and 1531, on two occasions delivering to the king the new delicacy "archecokkes" (artichokes).[4] His successor, John Rede, also visited during this period. Another visitor was the even more distinguished king's gardener John Lovell from the palace at Richmond, who appears to have been a welcomed supplier of garden delicacies, such as filberts, damsons, grapes, pears, and other fruit, as well as sweet water. A fourth visitor during Chapman's tenure was the gardener at the palace in Greenwich, a man named Welshe. Although the visits

of these fellow head gardeners to Hampton Court during its gardens' most formative period cannot be reconstructed, one must assume their keen interest in such an undertaking as well as presume the debates with Chapman that probably occurred during walkabouts at the garden sites.

As noted above, it had been Chapman's apparent custom to employ large gangs of gardeners and laborers when undertaking major work, as was the case both at Hampton Court and York Place in 1515. Once Henry VIII had taken over the latter in 1529, a similar arrangement was put in place by Chapman's successor, Thomas Alvard. By 1531, working under the supervision of Alvard's head gardener Thomas Graunte, a team of nine under-gardeners and fifteen garden laborers, all of them named, were put to work "enlargeing of [the Kinges] Orcheyarde." Unfortunately, surviving records for Hampton Court during this period do not include the names of comparable gangs employed for the complex creation of the Privy, the Mount, and the Pond gardens. Perhaps of greater interest, however, is the record of specific work done by named garden staff during these undertakings. One such gardener, Roger Down, for example, had the special task of overseeing the building of the terrace-walk embankments put up against the inner sides of the Privy Garden walls and repairing them if they fell. Additionally, he worked at leveling and making the garden borders, as well as helping to make the garden beds. In these tasks he was assisted by Thomas and Richard Down, perhaps his sons, and seven other named laborers. Another gardener, John Hutton, was brought in from London specifically to work on the design of the Privy Garden's main beds (see chapter 4). Hutton also brought with him and set the three-year-old rosemary plants alongside the pathway to the Mount, with record of an Agnes Hutton, presumably his wife, further supplying "Gillavers mynte and other swete flowres" for the Privy Garden.

Chapman employed a Kingston gardener, Matthew Garrett, to do much of the actual planting in the Privy Garden, the work mostly involving root setting of strawberries, violets, primroses, and gillyflowers. What is of great interest is the degree to which Chapman also relied on the gardening skills of a group of women who worked alongside Garrett in such plantation. The records make note of four in particular: Ales Swallow, Agnes Leighton, Elisabeth

Allen, and Jane Oker. Of these, Swallow and Oker appear to have taken the lead (even as they most often appear elsewhere in the records at the head of the large group of women employed as weeders and waterers). Other women also supplied the strawberry and flower roots, gathering them in great quantities in the wild, for which they earned 3d to 4d per bushel. These independent gatherers, who evidently made a specialty of supplying such plant materials, were Agnes Brewer, Margaret Rogers, Agnes More, Jane Downer, Agnes Pounche, and Margaret Flowre.

The most strenuously intensive garden labor, that of planting small quicksets, the slips or plant cuttings used for hedges or for the prevention of soil erosion on sloping ground, was reserved for male gardeners. Purchased in enormous number (records noting multiples in staggering quantities of 300, 600, 900, 1,000, 4,700, 6,000, 12,900), sets of whitethorn, hazel, woodbyne, privet, and "stokkes of crabbe" were planted not only on the wall embankments of the Privy Garden and the pond embankments of the Pond Garden but also on the moat edges ("the park dyches"), first using the special "knyfes" required and hence purchased "to shred the quyksettes" in their tangled roots. The records also list suppliers of these plant materials, chief among them Lawrence Vincent, who lived in nearby Kingston. Other frequent suppliers were John Gaddisbe, Thomas Hobard, and John Faryngton, also from Kingston; Edward Vincent from Westminster (perhaps a relative of Lawrence); William Shore, John Hasyll, John Shepherd, and John Dory. To work at some of this quickset plantation a gardener was even brought in all the way from the riverside town of Dartford in Kent: William Baldwyn (Ballewyn), a man whose name also appears among the gardeners at York Place, where he may have had similar duties.

The purchase of trees for the Hampton Court gardens and orchards has been noted above (see chapter 1), but some sense of what it took to find and secure plant materials such as these is also part of the body of records. Chapman's successor, Edmund Gryffyn (Gryffith), to cite but one example, eventually purchased sixty-seven "appultrees" in December 1532, but the record of his payment discloses a much fuller picture: "xs viijd paid to Edd Gryffith for hys costes and Expenses Rydyng to sondry place in bukkshire in providyng of sayd trees by the space of viij days at xvjd of the day for hym self and hys horse."[5] Gryffith finally resorted to an agent for

the purchase, as the records go on to note: "Also payd to William Gardener of London marchaunte for lxvij appultrees of hym bought and delyvered at growe place in bukyngham shire at vjd the pece xxxiijs vjd." "Growe place," as Mollie Sands has noted, was "probably Grove Place, Langrove, which was owned by a Roger Grove as early as 1496, and remained in the Grove family until 1559." Only a few years later, in 1536, Gryffith would undertake another such venture to secure trees for Hampton Court, traveling with fellow gardeners John Bridgeman and John Maybank as far as Sion (the Briggintine abbey at Brentford), the Charterhouse (the Carthusian monastery in London), and Richmond Palace to select "yow [yews], sypers [cypress] and bayes for the Mount."[6] No matter at what cost or effort expended, it would seem, demand would finally find supply for whatever choice plants were needed for the king's new garden ventures.

Again, although the roster is a long one, the names of all such people involved in making the gardens at Hampton Court and York Place (soon to be named Whitehall) under Henry VIII deserve to be preserved, at least those who were working there during the final years of More's life, some of whom he may have known (Appendix B).

Wolsey's Garden Staff

Mention has already been made of John Chapman's busy year of 1515, when he undertook not one but two major garden projects for Cardinal Wolsey. Traveling back and forth on the Thames from Hampton Court to York Place, he must have welcomed the ride insofar as it gave him time to plan his strategies for the next stages of these gardens' creation, however divided his attention may have been. For those who knew him or at least knew his reputation, Chapman was probably the subject of envy or awe, and certainly a topic of discussion in the gardeners' London world at the time. That such a gardeners' world was then already in existence is now beyond question, for at least two reasons.

First, had there not been a well-established community of gardeners, it is unlikely that Chapman could have assembled so quickly a large staff of gardeners and garden laborers. As noted

above, at both sites he had little trouble in finding the people he must have needed. Presumably this would have been the easier task at Hampton Court, with its rural setting and population used to agricultural labor. But Westminster appears to have presented no greater challenge, despite the fact that he brought with him from the country six of his main garden staff. But to find in town thirteen additional gardeners and under-gardeners ready for employment at short notice suggests a presence of trained workers already in place. Perhaps equally revealing of this urban gardening establishment is the fact that Chapman was also able to hire no fewer than twenty-five women for garden duties. Albeit their work consisted primarily of weeding, it has been too easy thus to dismiss female gardeners simply as unskilled labor. The later reports of those working at Hampton Court under Henry VIII show that women were in their own right crucial workers both in planting and in tending gardens (see pp. 110–11 above). This must have been an extension of the traditional garden labor that women often provided, but not thereby an indication of lesser abilities or more limited gardening knowledge. Indeed, both for these women and for their male counterparts hired as gardeners, and even for Chapman himself, where had such expertise come from if not from regular employment in the past?

It is tempting, for example, to identify the John Gardener who was employed by Chapman as a garden laborer at Hampton Court in 1515 with the later John Gardener, who was Keeper of the King's Garden at West Horsley in 1546. Could not the latter have gained part of his expertise while working at Hampton Court as a young man? In the gardens he oversaw at West Horsley, for example, his garden workers were employed in mowing grass alleys and orchard grounds, "picking and weeding out leaves out of the knottes of the privy garden and of the mounte garden and out of strawberry borders and roseers [roses] borders."[7] Such garden layouts could well have been learned earlier at Hampton Court.

Although not named among Chapman's York Place staff in 1515, Henry Russell of Westminster offers a parallel example of extended garden employment during this period. Working both as plant supplier and gardener, Russell was well established in business by 1539, when, in writing his will (proved in 1549), he identified himself as "gardiner and servaunte vnto the Kinges majestie." Earlier, in 1531, his credentials as an experienced gardener had enabled him

to be hired at the highest pay to work for seven days at the Bridge House garden. Presumably he would have been acquainted with other prominent Bridge House gardeners during this period, one of whom was William Bawdewyn (Baldwyn), the Dartford gardener previously employed both at Hampton Court and York Place, who was head gardener at the Bridge House in 1533/34.[8] Russell's work for Henry VIII, in turn, is documented from a later date, in 1543, when account records note payment to "Henry Russell of Westminster, for 2 banks of Rosemary by him bought to be set in the King's Garden at his manor at Chelsea price 13s 4d; for 6 borders of lavender price 26s 8d. And to him for 3 load of Calesse sand for the great bowling alley."[9] Russell had other ties to London's world of professional gardeners, as indicated by the man he named as supervisor of his will, Thomas Cawsway (Causy/Casy), the Houndsditch gardener who made his living selling herbs, seeds, and roots to other gardeners (including those at the Bridge House), and to whom Russell owed the substantial sum of £4. Indeed, London gardeners, it would thus seem, shared a mutual world, often of joined enterprise.

Beyond respect for the large number of gardeners' names that fortunately survive in the accounts of York Place and Hampton Court, a further reason to assume a workforce of a critical size lies in the very gardens these people created. Although those at the Bridge House, at More's Chelsea manor, and at the ecclesiastic palaces of Winchester, Lambeth, and Fulham could never match the gardens being created by Wolsey at York Place and at Hampton Court, much less those under Henry VIII's ambitious purview, there is every reason to imagine all of them as stylish adaptations of a long-standing horticultural tradition, particularly in their creation of new privy or private gardens. The surviving evidence of all such garden enterprise, as characterized in the preceding discussions, warrants a conclusion that, by early in the sixteenth century, the craft of gardening in London was not practiced intermittently or in isolation, tied solely to individual talent and enterprise (see chapter 4). To the contrary, as the records of these riverside gardens seem clearly to indicate, More's London, even though a small city of perhaps 55,000 people, had nonetheless come to include a viable gardeners' community often working in cooperative venture.

Although the membership census of that community is far from complete, and doubtless can never be fully discovered, the names of

Wolsey's garden workers, both at York Place and Hampton Court, surely form one important part and therefore, as with Henry VIII's gardeners, deserve here a memorial (Appendix C).

The Bridge House Garden Staff

The third and perhaps most unusual source of names of gardeners working in More's London is that found among the Bridge House records.[10] While the Exchequer Accounts for Hampton Court and York Place supply such names in great number, they do so for only certain specific years and therefore are incomplete. What makes the Bridge House records extraordinary, as noted above, was the decision by the Bridge clerks in 1461 to include the names of all those who worked in the Bridge House gardens. As a consequence, for more than a century a complete picture of the garden workforce became a matter of careful record, highly interesting in its own right for showing how these gardens developed (see chapter 4). Because of this lengthy coverage, moreover, it is possible to use these data as the basis for making certain comparisons with garden workers elsewhere during this period, particularly one tracing the shifting history of wages or job payment for garden work in Tudor London. To these ends, a roster naming the Bridge House garden staff as well as their plant and seed suppliers between 1406 and 1567 is presented below, not in alphabetical but in chronological order (Appendix D).

As this listing shows, the gardens at the Bridge House until the end of the fifteenth century were tended not by gardeners but by garden laborers, all of them workmen already in the employ of the Bridge House Wardens. Furthermore, these laborers were paid on a daily basis, as needed, for work done in garden space devoted primarily to the production of food. By the end of the century, however, this was all to change, for the Bridge House increasingly thereafter relied upon independent gardeners hired to tend the gardens. Thus, beginning in 1498, John Dawle, who heads the list, was first employed to cut the vines, but then by 1505 was given complete oversight "by the advice of the bridgemaisters for new delving of the said garden making the beddis, sowing of sedes and setting of erbes and plants in the same beddis wt iijd for a pecke of benes." For this undertaking, "letten to him at taxe," that is, for the specific task rather than as a wage, he was paid a substantial sum,

27s 3d.[11] A similar agreement was made the following year with the gardener Nicholas Melton. But the arrangement for contracting the garden for a whole year at a set fee soon was altered, and gardeners were hired instead either at day wages for seasonal work or for special projects or at quarterly wages if working on a year-round basis.

Thus, for more than a century, beginning in 1461, payment for garden work, as revealed in these records, provides a unique record, week by week and year by year, of contemporary economic history, so far as gardening is concerned. Care and cutting of the vines, for example, were always listed separately "at taxe" in the accounts, with payment of 12d per year in 1461/62 rising to 16d or 18d in the 1490s and to 24d by 1504/05. On the other hand, pay for garden labor, such as "delvyng settyng and sowyng" or more generally "kepyng of the garden," continued at a daily rate, as it had in the past. Originally, there had been no pay differential by status among the workforce. In 1461/62, for example, the laborer James Baas worked thirty-two days at 4d per day; in 1466/67 the laborer William Bachile earned 5d daily for fifteen days; in 1478/79 the per diem was 6d. By comparison, the Grocers' Company did make distinctions, paying its gardener 8d per day from 1452 to 1454 and a garden laborer 5d.[12]

In the Bridge House gardens, differential payment between a gardener and a garden laborer also became common in the sixteenth century. In 1524/25, for example, the gardeners involved with the Privy Garden's renovation, James Kettill, Robert Freman, and Roger Middelton, each earned daily 8d, their "seruauntes" John Sparrow and Rauf Collyns 6d. The next year Collyns had risen in status, earning 8d. These day wages were to remain steady for the next forty years. As for other gardeners hired to work throughout the year, they were paid a flat quarterly wage, 6s 8d, as in the case of William Bawdewyn in 1533/34 or William Johnson in 1552/53 or John Roche in 1558/59. In comparison, the Drapers' Company paid their head gardener, Robert Ratford, a yearly wage much higher, £3 6s 8d in 1548.[13]

At this point it is useful to ask how these pay scales compared with those for garden staff at the royal establishments. As mentioned above, at Hampton Court John Chapman was paid £12 per year (the same wage he had earned under Wolsey), but even that did

not match the payment to Stephen Jasper from Beaulieu, £15 0s 4d. These wages were top of the scale, however, and other royal gardeners earned varying lesser amounts. John Whitwell, with joint appointments at Langley and Woodstock, for example, earned 10 marks (a mark equal to 13s 4d) per year, John Gardener at West Horsley, £7 0s 4d. William Rutter at Windsor earned £4, as did Robert Pury at Wanstede. Other gardeners were paid a per diem rate: 6d for Robert Hasilrig at the Tower of London, 4d plus board for Philip Enys at Greenwich, and only 3d for John Bryket at Eltham. If one turns to York Place, there the surviving records for 1531 note the standard daily rate for a gardener as 7d, with only Thomas Graunte the head gardener earning 8d. Garden laborers were paid 6d. At Hampton Court, however, the pay scale at the same time stood much lower, with Edmund Gryffith as top gardener earning only 6d and under-gardeners such as Roger Down, or the London gardener John Hutton, only 4d.

Presumably there was such a disparity between town and country because of differing wage expectations among gardeners working in Westminster and those employed in a more rural economy. This difference is reinforced when one looks at Wolsey's pay scales in 1515. At York Place, Chapman worked for the same per diem as his main garden staff, 6d, with garden laborers earning 3d. At Hampton Court, however, Chapman's main staff earned less than they had in town, only 4d. Clearly, the wages paid to gardeners at the Bridge House in both comparable periods, 1515 and 1531, outdistanced those in the king's employ, although the total amount a gardener might earn in a year may have been greater at York Place and even at Hampton Court, given the likelihood of more days of employment.

All such measures of money earned must also be compared with the pay that other London laborers were receiving at the time. How did garden work stack up against other sorts of work? As an answer, one can cite the study that the City Aldermen made in 1564 of wages paid for sixty crafts and trades. Although gardeners are not among the groups listed, the survey found that the average pay for skilled laborers, such as bricklayers, carpenters, plasterers, etc., was 13d per day, or 9d if fed by the employer. In contrast, a century earlier, similar skilled labor averaged 8d and unskilled, 5d.[14] Compared with these data, the records of payment for garden work, as revealed above, show it as an underpaid craft in terms of financial reward.

To return to the list of the Bridge House garden staff, one further fact to note is that between 1498 and 1560 as many as fifty-four men are identified as gardeners, out of a total of ninety-four. In economic terms, what do these numbers suggest? Perhaps most apparent is that while some of these men held longer tenure as a Bridge House gardener, notably John Dawle (1498–1505), Nicholas Melton (1506–08, 1515–16), Richard Saddeler (1509–11), Richard Savell (1522–23, 1526–27), James Kettill (1523–25), Rauf Collyns (1524–31, 1543–44), John Blakeman (1525–27), Tey Kellet (1531–33), Symond Holden (1534–36), Henry Myllis (1536–40), John Collyns (1540–41), and William Johnson (1552–58), the greater number of gardeners worked for only a single year or a portion of one. This disparity in length of employment suggests somewhat ad hoc garden planning by the Bridge Wardens, but also, and more importantly, it would seem to offer further proof that, by the opening decades of the sixteenth century, independent gardeners in the area could – and did – find ready employment as well as a growing demand for their services. Opportunities would seem to have extended far beyond the Southwark boundaries.

Frequent payment to a number of these gardeners for "sundry plantes and sedes" also suggests that some of them almost certainly had gardens of their own from which they sold. In 1503/04, for example, the Bridge records note payment to John Hely for "sundry seeds" at 8d; in 1515/16, Nicholas Melton for "tyme plants and sedes" at 7d; in 1522/23, Richard Savell for "herbis, plantes, and sedes" at 18d; in 1524/25, James Kettill for 200 "Rosiars & for laieng of them wtyn the saide gardeyn" at 12d; in 1515/16, Rauf Collyns for "tyme plantes and sedes & plants" at 10d and in 1525/26, for "plantes of lavender and Roddys for the vyne" at 5s; in 1534/35, Peter Tyrrell for "tyme plantes and sage" at 4d; in 1535/36, Roger Roberts for "gelefloore-rootes for to set" at 4d; in 1551/52, Harry Stoke and Hugh Lewis, for "plantes & sedes," at xiijs xjd; in 1552/53, Thomas Bowman for "sedes" at xiijd; and in 1555–57, William Johnson for "seedes" and "Rowtes to set," both at 4d.

Purchases of seeds and plants from gardeners not employed by the Bridge House Wardens further suggest that even by this period at least a few worked primarily as seed and plant merchants, which appears to have been the case in the years 1502–04, when John Arnold, the Porter, purchased "dyuers sedes erbes and plantes sett

and occupied in the same gardeyn" at 2s and at 2s 2d; or in 1506/07, when he paid for "ij lbs of oynett sede and for a busshell and a pecke of spered onyons sowen and set wtin the bridgehous gardein this yere" at 2s 2d. Those suppliers are named in 1508/09 and again the following year when Arnold purchased "oon pounde of oynet sede" at 6d from John Bekyngham and "ij libr. of oynet seed" for 12d from William Bekyngham. A similar instance occurred in 1529/30 when seed was purchased from the Houndsditch gardener Thomas Cawsway for 20d (see pl. 18). Cawsway's colleague Henry Russell of Westminster, as noted above, may also have supplied seeds and plant materials when he was employed in the Bridge House gardens in 1531. Clearly, a commercial world of nurserymen and seed sellers was already under way.[15]

To complete this composite picture of gardeners employed at the Bridge House, one must turn finally to a group of workers not yet mentioned, namely, the women who formed part of this Southwark workforce. There were large numbers of female garden staff both at York Place and Hampton Court (see pp. 110–11, 113 above). To a certain degree their counterparts were also participants in the Bridge House enterprise, most of them involved with the homeliest of gardening tasks, that of weeding. Although men also were involved with such necessary garden care, it was chiefly women, often at first noted in the accounts simply as "a weding woman" or "a pore widow to wede the gardeyn," who were thus employed. Eventually, although not consistently, a number of these women, some of whom did gardening as well as weeding, got named in the records, as was the case of the wife of John Marlow in the years 1511–13, Agnes Kendall in 1515/16, the wife of John Collyns in 1540/41 ("to John Collyns Gardyner and his wyf for workyng in the garden in the makyng of a knott there and sowyng of all the reste of the garden and for mendyng of the same knott at dyuers & sondry tymes he by xij days at viiijd . . . and his wiffe by vij dayes at vjd"), and Katheryn Sherman, who in 1552/53 was also paid 6d daily "for a weekes wages to make the gardeyn." Such pay was not the case earlier when, during the 1510s and 1520s, weeding could earn a woman a per diem income varying from only 2d to 4d. Here as elsewhere, the rate of pay for women's work clearly was on the increase, more than favorably comparable with rates paid both at Hampton Court and York Place.

The grete herball

whiche geueth parfyt knowlege and vnd[er]
standyng of all maner of herbes ther gracyous vertues whiche god ha[th]
ordeyned for our prosperous welfare and helth/forthey hele cure all man[er]
of dyseases and sekenesses that fall or mysfortune to all maner of creatou[re]
of god created/practysed by many expert and wyse maysters/as Auicenna [and]
other. c. Also it geueth full parfyte vnderstandynge of the booke lately p[rin]
tyd by me(Peter treueris)named the noble experiens of the vertuous ha[nd]
warke of surgery.

The most interesting of these weeders at the Bridge House gardens is a woman regularly employed from the year 1524/25 named "Modor Tubbys" (see pl. 18). The wife of a bridge laborer, John Tubbys, she was widowed by the late 1520s but continued to work as a weeder, joined in 1529/30 by William Hewett, at which time romance appears to have flourished. Hewett had earlier, in 1525/26, been appointed "vnder baylyf of the Guyldeable [the king's manor land near the foot of the bridge] in Suthwerk" and for his services was allowed "the Rent of a tenement nexxt vnto the Briggehowse gate of viijs by yere." He held this post until 1528, then returned to work as a laborer for the Bridge, both in the stone yard and the garden, finally in 1530/31 attaining the position of Bridge House Porter upon the death of Thomas Chylde. At exactly this time, the entry for "Modor Tubbys" is replaced by "the wyf of William Hewett," with a rise in wages from 6s 8d to 8s per year, which was paid annually until 1550, occasionally supplemented by the sale of seeds. It would appear that Mother Tubbys (now Hewett) had become a fixture in the garden, lasting a quarter of a century.

The Southwark printer Peter Treveris, whose *The Grete Herball* of 1526 was the second earliest herbal printed in London, chose for the title page a woodcut image of a man and a woman in a garden (pl. 63). Although no evidence survives of his ever having visited the Bridge House gardens, yet had he done so, one likes to think, he was inspired by the sight of Mother Tubbys when planning the picture.

Any answer to the question of who was the gardener in Thomas More's London, of course, remains elusive. Yet in the surviving records of Henry VIII's, Wolsey's, and the Bridge House's gardens, the names of their garden workers, as here reported numbering 318 persons, were carefully recorded, which seems a sign that these were people to be valued and respected, much as were More's farming and garden staff in 1529, at the time of the Chelsea manor fire (see chapter 1). Although most of these garden people are now almost lost to view, yet they, too, were no less a part of More's riverside London than the garden owners he knew intimately. Those gardens quite literally could not have existed without them.

63 Title page, from Peter Treveris, *The Grete Herball*, 1526. British Library, London.

THE
HERBALL
OR GENERALL
Historie of
Plantes.

Gathered by John Gerarde
of London Master in
CHIRVRGERIE.

Imprinted at London by
John Norton.
1597

3 Tools of the Gardeners' Trade

ALTHOUGH ALL HISTORICAL ENQUIRY may be said to be an exercise in imagination, it is perhaps nowhere truer than when such enquiry turns to historic gardens, which inevitably are tied to the passing seasons of their own eras. Yet how to imagine the riverside gardens in Thomas More's London is a particular challenge, for no images survive of these once-flourishing places, and even a likely sense of their contents and layouts is a matter of almost pure speculation. All such aid thus failing, imagination must turn to whatever else might be useful. One, as just explored above, lies in the reconstruction of the community of the makers of these gardens in the early sixteenth century, populated by discernible people with specific names and histories. To the extent that this gardening world now comes into view, a related line of enquiry thus becomes possible, whether a sense of these gardens can be gained by studying the tools that their gardeners used to make them.

Among students of garden history, it should be noted, there has been recurring interest in the variety of equipment once available for garden use.[1] Although few gardening tools and implements survive from London's earlier periods, there are fortunate survivals among the fifteenth- and sixteenth-century artefacts collected by the Museum of London. Complementing a study of such historic garden objects, the records of the riverside gardens here under scrutiny offer documentation, in many instances, of actual use of similar equipment at the time. Such objects and documents, especially when combined with coincidental artistic representation, allow one's imagination at least a glimpse of gardeners at work. To such an end, garden and art historians as well as museum curators might agree, there is no tool like an old tool for helping to overcome the barriers of time.

64 Title page, from John Gerard, *The Herball, or Generall Historie of Plantes* (London, 1597). Bodleian Library, Oxford, L.L.5 Med.

As an orientation to enquiry about the tools and equipment available to the gardeners in More's London, I begin with the beautiful title page of John Gerard's *The Herball, or Generall Historie of Plantes* of 1597 (pl. 64). At the bottom of the page a cartouche presents an image of a walled garden, tended by gardeners and enjoyed by the owners walking among the small raised beds. Although the picture is of no specific garden, its features nonetheless capture what was probably the look of many gardens earlier in the century, including those at Winchester Palace, Fulham Palace, Lambeth Palace, and More's own Chelsea manor. The depiction is based on a drawing of 1590 by Hans Bol, engraved by A. Collaert, which shows in even clearer details a number of the garden's features (pl. 65). These include a walkway around the perimeter, opening along the hedged wall on the right to a series of indented garden seats, later called exedra, as further places to view the garden layout. The tall tree to the rear is surrounded by yet another raised garden seat, set off by four geometric beds that frame the feature. To the right, between the garden and the large building, is a large walled pond, on which ducks are swimming, presumably serving both as an amenity and a source for plant watering, as the woman is doing in one of the geometric beds. The other garden staff, made up of both men and women, is involved with raking, weeding, spading, and planting. And to the far right near the pond another gardener is carrying a small tree in a pot, similar to those in the garden beds. Other pots in the central alley contain flowers supported by frames.

Such an image is useful here for raising three important questions about garden tools and equipment. First, how was garden space like this created, that is to say, what tools were necessary for the engineering groundwork that preceded what is shown here? Second, what sort of equipment was used in tending such a garden in order to keep its appearance intact and its plants at appropriate display? Finally, how were garden objects, such as pots, used, both to decorate and also to keep plants at their peak during the growing season? Revisiting the surviving riverside garden records examined here and taking a closer look at surviving late-medieval tools from the London area help to supply a number of answers.

Visitors to the Museum of London may find themselves initially puzzled by some of the garden tools in the late-medieval collection. The implement illustrated in plate 66 is an example of an "yron,"

65 A. Collaert after Hans Bol, *April*, engraving, *c.*1590.

66 Garden spade iron, late fifteenth century. Museum of London.

that is, a metal tool edge for a wooden garden spade. Throughout the earliest Bridge House garden accounts, one finds frequent record of expenditure for just such "yrons," whether for forks, shovels, or spades – a reminder that wooden tools and metal tool fittings needed replacement at different times. Among early references, as mentioned in chapter 1, one finds, in 1382/83, payment of 12d for "two yrons for two fforks & one yron for a certeyn shouel"; in 1384/85, 7½d for "two spades wtout yrons"; in 1397/98, 7d for "two

126

shouelyrons"; in 1417, 12d for "ij paringshoueles" and "j fforke ferr [iron]." At other times, new tools, with both wooden and metal parts, were purchased, as was the case in 1524, with payment of 6d "for a spade shodde wt Iron for the gardeyn wtyn the Briggehouse."

The antiquity of such records must serve as a reminder of how little the technology of tool production had changed during the centuries preceding the sixteenth. Most tools that gardeners were using in More's London were those available to gardeners at much earlier dates. In the context of the Museum of London example, a wooden form, usually cut from ashwood and made with a D- or T-shaped handle, a straight shaft, and, in this case, a single-sided footrest, would have been inserted into the iron to create a one-sided spade. A useful illustration of this tool may be seen in a Bodleian Library manuscript from the late fourteenth century, showing a gardener holding such an iron-shod implement, a variant of the more familiar two-sided shovel or spade, which was also common (pl. 67). A further illustration, showing how the tool was

67 (*above left*) *Gardener with Watering Pot and Spade*, late fourteenth century, Bodleian Library, Oxford, MS Rawl. D939, part 2.

68 (*above right*) The Holkham Bible, *c*.1320–30, British Library, MS 47682, fol. 4v.

used, is found in the Holkham Bible, datable to about 1320–30, now in the British Library, depicting the *Expulsion of Adam and Eve from the Garden of Eden* (pl. 68). The image, focused on Eve with a spindle and on Adam with a one-sided shovel, calls to mind the contemporary fourteenth-century doggerel made popular by the priest John Ball:

> When Adam delf [dug] and Eve span,
> Who was then the gentilman?

Some sense of the immense amount of physical labor involved while using such tools to create a garden space in the first place is clearly evident in the records of Hampton Court, particularly in 1531, when noting the massive groundwork needed to create the Privy Garden. One recalls, too, Chapman's initial tool purchases in 1515, including "iiij spades xiij showeles." Under Henry VIII, multiples were also needed: "for a dosen of shodde showelles for the newe garden deliuered to John Chapman Gardener." Of equal importance were heavy iron rakes to help break down soil, as may be seen in an image from Thomas Hill's *The Gardeners Labyrinth* from later in the century (pl. 69). Again, at Hampton Court these were frequent purchases: "for iiij yron Rakes for the Kynges new garden"; "for ij Rakes to Rake and Levell the grownde in the new garden."

Even more basic than spade, shovel, and rake was another tool, the mattock, used to break up turf and soil initially. The use of such a tool represented hard labor, some sense of which is indicated at Hampton Court in 1531: "to Robert Bedene of Kyngston Smeth for vj mattokkes for to Dygge Erth in the foundacion of the warkke goyng about the Kynges new garden." Such tools were apparently purchased by weight, as noted at York Place in 1515: "for j mattock for the garden waying viij lib. at ijd the lib." Also useful in cutting turf in straight lines was the "paring yron." Additionally, wheelbarrows at Hampton Court were a frequent purchase, for moving earth as it was dug: "to William Amer of Rislip for iiij Whele barrows to Cary Erthe to levell the Ales in the Kynges new garden."

That all what might be called topographical engineering was arduous work, it must be noted, was common knowledge at the time. Here one might recall Ralph Hythloday's comments in Book I of *Utopia* when reporting a debate he once had when visiting John, Cardinal Morton, at Lambeth Palace:

69 "Gardeners," from Thomas Hill, *The Gardeners Labyrinth* (London, 1577, 1586). Royal Horticultural Society.

There are a great many noblemen who live idly like drones, off the labors of others, their tenants whom they bleed white by constantly raising their rents . . . These noblemen drag around with them a great train of idle servants, who have never learned any trade by which they could earn a living. As soon as their master dies, or they themselves fall ill, they are promptly turned out of doors . . . Those who are turned off soon set about starving, unless they set about stealing . . . Then when a wandering life has taken the edge off their health and their clothes . . . men of rank will not want to engage them. And country people dare not do so, for they don't have to be told that one who has been raised softly to idle pleasure . . . is likely to look down on a whole neighborhood, and despise everybody as beneath him. Such a man can't be put to work with spade and mattock; he will not serve a poor man laboriously for scant wages and sparse diet.[2]

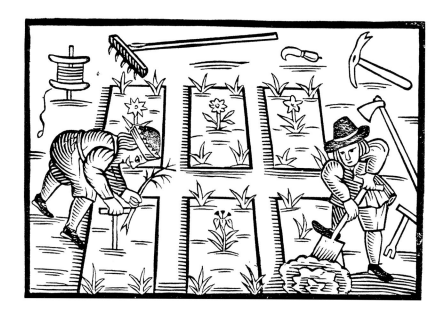

Whether or not scant wages and sparse diet were the lot of the
gardeners here under study, their hard labor is a more secure
assumption.

Once the earth was broken, smoothed, and leveled, the next step
was to lay out the garden beds to whatever overall design was
intended. To do this reels of cord were staked to align the bed
circumferences, as seen in the Hampton Court records: "for vj peces
of rownde lyne to mesure and sett forth the newe Garden" (see
chapter 4). An image of such cord reels appears in another
illustration from *The Gardeners Labyrinth* (pl. 70). Once measured, the
beds were then ready for the construction of low frames to raise
their level, sometimes further emphasized by rails or hedges. A
record of this complete process survives in the Bridge House records
dating from the years 1474–76, when the garden appears to have
been remade:

> And to William Fishburn, ditcher, for clearing out a ditch between
> the garden of the house of the bridge on the northern side and
> the tenements of the same bridge on the southern side, containing
> in length xv perches [a measuring rod 5½ yards in length], for
> each perch ijs and this was paid by the tenants of the same tene-
> ments xijs vjd & by the said Wardens xvijs vjd . . . And to a

130

laborer working in digging and shaping the garden within the house of the bridge working for viij days taking vd per day iijs ivd . . . And for rayles, thorns, and the making of a hedge in the garden of the bridge house vjd.[3]

Such groundwork preparation and space allotment for garden beds would have differed little in the other riverside gardens of the day.

But such work did not end with the transformation of land into garden space. A next step, that of plantation, thus also became a matter of record. Seeded areas, for example, were prepared by using a form of harrow, called a "setting drag," presumably a heavy metal frame pulled over prepared beds to loosen the soil evenly before sowing by hand (see pl. 29). The purchase of such equipment is carefully noted at Hampton Court in 1531: "to Roger Burdoyes . . . smeth for ij settyng drags at ijd the pece." Already established plants, in contrast, including the quicksets as well as the roots of strawberries, violets, primroses, and gillyflowers in the Privy Garden, were set by hand, frequently using "dibbers," the short digging tools used to make an opening in the soil (see pl. 70). As noted above, four such "dibbers," or "debelles" (dibbles) as they also were called, were among the first tools purchased by Chapman at Hampton Court in 1515. Again, such methods of planting a garden would have been common at the time.

Another tool from the Museum of London collection serves to introduce the second topic for enquiry, the equipment needed to care for plants once in the ground. Perhaps the most basic personal tool for the gardener was a small knife, as in the late fifteenth-century example illustrated in plate 71. In this instance, the knife, measuring only 7 inches in length, with its top rounded into a bill-like hook, offers a tangible reminder of the hand work involved in garden husbandry. The tool had a variety of uses, one of which involved seasonal pruning and planting of grapevines. Records of such viniculture survive for many of the riverside gardens of More's London, including Winchester Palace, Lambeth Palace, Fulham Palace, and Hampton Court.

Indeed, the cultivation of grapes was de rigueur for any garden at the time, large or small, the fruit being valued foremost for supplying the vinegar-like "verjuice" essential to cookery and food preservation. The Bridge House garden was no exception, and the first surviving record of its existence, dating from as early as 1381, as

cited above, notes the care given to the vines: "Item solutum pro emendacione et reparacione vinearum in gardino domus Pontis ijs." Because of its importance, such amendment and repair of the grapevines by cutting and binding them twice each year, winter and summer, became the gardening task most consistently noted thereafter, with annual payments for this labor running throughout the Bridge House records for more than three centuries.

The use of the garden knife was particularly suited to the winter cutting and planting of vines, a task commonly represented in medieval manuscripts depicting monthly occupations of the seasons, typically shown for February. A clear example of these activities may be seen in a Book of Hours now in the Pierpont Morgan Library, in a painting by Simon Bening of about 1515 (pl. 72). The gardener at the left is using the small knife to cut a vine while the adjacent gardener holds a similar knife in his teeth as he ties a vine to a stake. At every stage in the Bridge House garden's long history, as would have been the case elsewhere, the use of such a tool in viniculture differed little from the method for "cutting and setting of vynes" found in the earliest gardening treatise, that of John the Gardener, which survives in a fifteenth-century translation:

Of settyng of vynys we most have yn mynde
How thay schal be sette al yn here kynde.
Whyle hit ys estern wynde
Thu schalt kytte nother [neither cut nor] sette nor bynde.
When the wynde ys yn the west
To kutte & to sett ys al-ther best [best of all].
Yn thys maner thu schalt kytte the vyne-tre.
To be sette hit schal have knottys thre.
Too [two] schal be sette yn the grownd
And one above for growynde [growing].
Yn the lond [soil] where hit schalle growe ynne
Hit wolde aske to be dyte [dressed] wt dynge [dung].
Every yere wt-ougt [without] drede [fail]
They wold ask dyng abougt ham [them] sprede.
[Then] grow they will sone and long be.⁴

Other tools needed for the care of plants also became part of the record, especially at Hampton Court. As noted in chapter 1, among the tools purchased by Chapman in 1515 were those used for

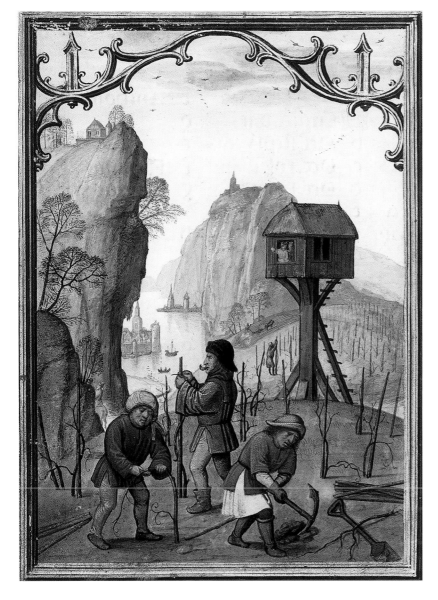

72 Simon Bening, illustration in a Book of Hours, *c.*1515, Pierpont Morgan Library, New York, MS M399, fol. 3v.

purposes of grafting: "ij Graftyng sawes," "j gret chesell and j small," "j graftyng knyff." These and other such orchard tools may be seen in an illustration in Leonard Mascall's *Art of Planting and Grafting*, first published in 1599 (pl. 73). Purchases of additional targeted garden tools by Chapman also got recorded, such as "ij pare cherys" (shears), "ij long billys" (billhooks), and "iij small hokes," these last

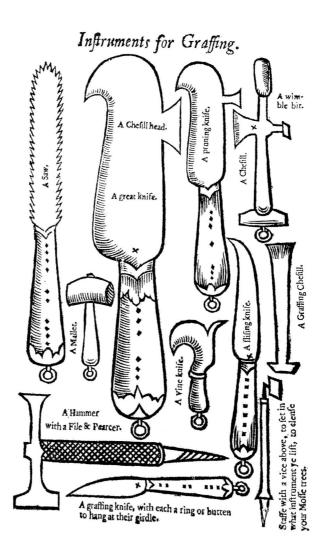

Instruments for Graffing.

presumably the same as "a hooke to cutt herbys in the gardeyn wtin
the briggehouse," recorded among the Bridge House records in
1526/27 when bought from the London "smyth" Thomas Gold.
Hooks of larger size were used as scythes for mowing, again as
noted in the Bridge House records: "for a hooke to cutt grass in the
garden." Another frequently noted purchase there was "wyre," its
purpose occasionally noted: "wyre to Bynd the Roosemyre vnto the
wall."

As for garden weeding, much of this was done laboriously by
hand, with the Bridge House records making periodic note of

payment for "a basket & bromes for the gardeyn" for plant debris and also on one occasion "a paire of Sleeves for the gardyner." As for weeding tools, the main implement used for such work was the garden hoe, one version of which, unlike its modern equivalent, was equipped with a long thin blade for precise address. This prototype may be seen in Titian's painting of around 1512, *Noli me tangere*, depicting the Risen Christ's appearance to Mary Magdalene, as reported in the Gospel of John: at first she does not recognize him and thinks him to be a mere gardener (pl. 74).

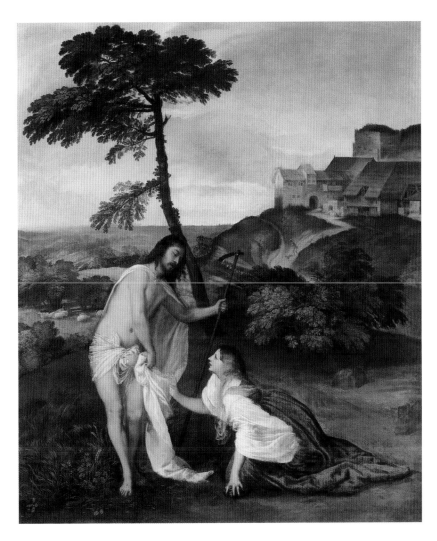

74 Titian, *Noli me tangere*, National Gallery, London, *c.*1512.

75 Garden watering pot, mid- to late fifteenth century. Museum of London.

More than incidental to the care of gardens were the various implements used to water plants. Among other necessary equipment for gardeners, for example, were wooden tubs used for storing water, usually drawn from a garden well. Such a container was noted in 1515 at Hampton Court: "a tubb to water therbes" (the herbs), as was also the case at the Bridge House in 1541: "to a Cooper for foure hoopes sett vpon a tubbe in the garden" and "for a watering tub for the garden." More significant was the purchase of the ceramic pots used in actual watering, as recorded in 1524 at the Bridge House: "to Thomas Childe for iiij water pottis for the gardeyn wtin the Briggehous ivd." One such sprinkler, an excellent fifteenth-century example of which is to be found in the Museum of London collection (pl. 75), merits special notice because of its shape and use. Unlike modern watering cans (and virtually unknown today), this pot had neither handle nor rose, but instead was a bulbous-shaped pot with holes in its bottom through which water

was released by control of the thumb held over the small aperture at the pot's neck. The process of watering by use of such a pot is well illustrated in a woodcut showing four nuns gardening, from the Nuremberg edition of 1512 of the *Hortulus* of Walahfrid Strabo (d. 849), now in the Hunt Botanical Library, Pittsburgh (pl. 76; see also pl. 67). This form of watering pot was common in the sixteenth century and was described by Thomas Hill in *The Gardeners Labyrinth*:

> The common watering pot for the Garden beddes with vs hath a narrow neck, bigge belly, somewhat large bottome, and full of litle holes, with a proper hole formed on the head, to take in the water, which filled full, and the thombe laide on the hole to keep

76 Title page, Walahfrid Strabo, *Hortulus* (Nuremberg: Joannis Weyssenburger, 1512). Hunt Institute for Botanical Documentation, Carnegie Mellon University, Pittsburgh, PA.

in the aire, may on such wise be carried in handsome maner to those places by a better help ayding, in the turning and bearing vpright of the bottom of this pot, which needfully require watering.[5]

Watering pots in various forms were also being manufactured at the time. One had the familiar sprinkling head, as may be seen in an example from the Museum of London (pl. 77), while another featured a straight pipe spout for watering in a stream. The sprinkling pot is clearly depicted in the title page of Gerard's *Herball*, where two putti at the top of the cartouche are watering the garden below (see pl. 64). Even in the seventeenth century, all three pot forms were still in use, although these last two were now often made of metal. Their different purposes are well described in John Rea's *Flora* of 1665:

You should have three Watering Pots, one of the ordinary fashion, of Tin, of white Iron, with a Head full of small holes; another with a Pipe onely, to let out the water; a third of Earth, with a small neck, and many small holes in the bottom. The first is to water Plants in Summer; the second, to water Pots with rank water, wherein the dung of Sheep, Pigeons, or Poultrey hath been imbibed, that it may be put to the roots of July-flowers, and other housed Plants, without wetting or staining the leaves or branches. The third being put into water, will fill from the bottom, which will stay in so long as you stop out the air with your Thumb at the top; this fitly serveth to water young and tender Seedlings of Auricula, and such like, without washing the Earth from them; for by the motion of your Thumb, you may cause the water to fall gently upon them, more or less, as you shall desire.[6]

77 Watering pot, sixteenth century. Museum of London.

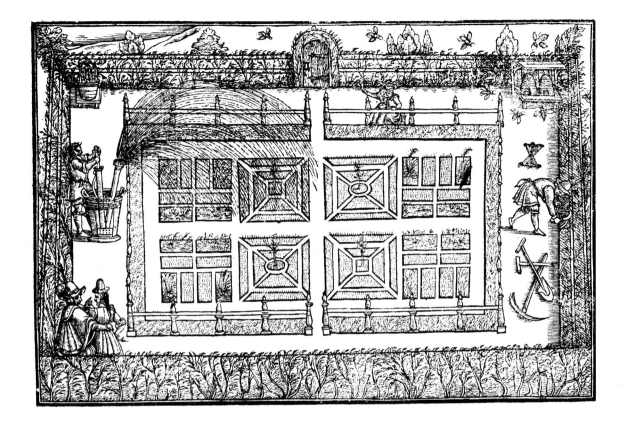

The watering of larger garden expanses required additional equipment, as may be seen in two further illustrations from *The Gardeners Labyrinth*. The first of these involved a sprinkling system, with water being forced by a stirrup pump from a large standing tub (pl. 78). Hill describes this process:

> There be some which use to water their beds with great Squirts, made of Tin, in drawing up the water, and setting the Squirt to the brest, that by force squirted upward, the water in the breaking may fall as drops of raine on the plants, which sundry times like squirted on the beds, doth sufficiently feed the plants with moisture.

A second system involved a form of irrigation, with shallow ditches filled by pumping a feeding shaft connected to a similar standing tub (pl. 79). Hill comments:

78 "The maner of watering with a Pumpe in a Tubbe," from Thomas Hill, *The Gardeners Labyrinth* (London, 1577, 1586). Royal Horticultural Society.

139

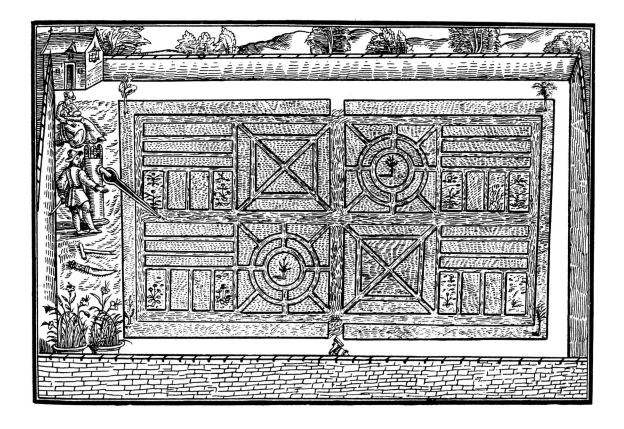

79 "Watering by Irrigation," from Thomas Hill, *The Gardeners Labyrinth* (London, 1577, 1586).

The Gardener possessing a Pump in his ground, or fast by, may with long and narrow troughes wel direct the water unto all beds of the Garden, by the pathes between, in watering sufficiently the roots of all such herbs, which require much moisture.[7]

Even this would not have been sufficient for the Privy Garden at Hampton Court. When it was finally planted in full, with its numerous quicksets, flower roots, rose bushes, and fruit trees, Chapman hired waterers, as many as thirty people at a time, most of them women, many of whom were also weeders, to keep the massive plantation alive. For purposes of this labor, the records also note payment in 1531 "to John Ryley of Kyngston for iiij Colis with Tyris for to watter the new Garden withe ivs viijd" and "to Thomas Ryley of Kyngston for a new Tubbe withe ij Tyres to cary watter in to water the said garden." Equipped with "tyres," that is, metal-rimmed wheels, such a "Cole" could be rolled around the large

140

garden spaces to transport water where needed. The term comes from the Middle English "cowl" or "coul," referring to an eared water tub or vessel, carried by two people by means of a pole inserted in the ears.

A water tub equipped with wheels has hitherto been thought to date only from the seventeenth century. One of its earliest descriptions is that supplied by John Evelyn in his *Elysium Britannicum*, written around 1665. His term for the implement is "foixt":

> The Foixt is to be made of a Barill of what capacity you thinke fit, so as it may be either transported by wheels, or otherwise borne: let this vessel be lined with sheete lead exquisitely sothered [soldered], well and strongly hooped with 4 yron circles; to this let there be contrived one pipe of leade or brasse of halfe inch diameter, reaching from the head of the vessel to within a quarter of an inch of the bottome, & [let] the upper part of this pipe rise halfe a foote above the head, to which it is fixed, & crosse the top of the pipe place to [two] plyable spoutes which may move upon a skrue [screw], having a stop-cock underneath; these spouts perforate to the boare [bore] of a gooses quill. Moreover, at convenient distance let there be fixed a dubble pumpe with their suckers, and handles of brasse and yron; these must be contrived within the body of the Vessell, and made to worke at the same tyme, the one drawing in water through a neck or pipe of coach leather skrued with a soccket to the bottome edge of the Barill, & extending to the fountaine or well, the other drawing in the Aire and compressing the Water, till, being no longer moveable, another stop-cock passing through the lower socckett afore sayd [must] be immediately shutt.

Evelyn then goes on to describe the watering process:

> Let the Gardiner direct the Spoute to the height, or place requisite. It is hardly imaginable, how effectuall, easie, expeditious and naturall this watering, resembling Raine, is, for being directed at the farther part of a Bed or Garden and the Spout fixed to a poynt, it will (without any further attendance) according as the aire dilates, refresh and water the whole bed regularly, and with great delight to the beholder. Besides this, it will also reach the

topps of the highest trees, destroy Caterpillars, and other noxious
Insects: In summ, of all the Gardiners Instruments, this is the most
elegant, usefull, and Philosophicall.[8]

Beyond this description, Evelyn also presents a drawing of a "foixt"
(pl. 80). Noted more than a century earlier, Hampton Court's "Cole"
would seem to represent an unusual prototype of this piece of
equipment, certainly providing one of its first references.

Large storage containers for the water itself would also have been
a necessity for an expanse as large as Hampton Court. Perhaps the
most intriguing of these garden records is a rare entry from 1533,
noting payment "to William Gwen of London tyner [tinner] for a
new Cokke for the sestrene standyng in the Kynges new Garden
price iijs iiijd." Although the size or shape of this standing cistern is
not further recorded, it may have been a very early prototype of the
ornate lead garden cisterns that came into vogue a century later,
some of the earliest surviving examples of which date from only
after 1650. Evelyn draws an image of one on which the date 1660
appears (see pl. 80).[9] If this Hampton Court reference was in fact to
such a metal cistern, it shows, once again, how Henry VIII could
command the latest and the finest in garden equipment. Kept full

142

both by rainwater and by piped water as needed, the cistern would have turned a necessity into a handsome garden amenity.

Up to this point, the tools and equipment examined here are those that served primarily for creating garden spaces and for giving attendant care to plants grown in the ground. Yet equal in importance for all these riverside gardens would have been plants grown in containers, such as urns and pots, ranging in size from small to large. Both flowers and trees could thus be accommodated, as shown by Hans Bol (see pl. 65). A number of such containers survive in the form of redware pots dating from the fifteenth and sixteenth centuries, as may be seen in examples in the Museum of London, some of which are prototypes of pots still common in Evelyn's time (pl. 81).

Although the use or deployment of container plants is seldom noted in any detail, we learn, for example, in a surviving Bridge

81 "Flower Pots," from John Evelyn, *Elysium Britannicum*, c.1665. The British Library.

House record from 1511/12 that 9d was paid to the "talughchaundler" John Wylcokes "for x bassell [basil] pottes and ix gyllover [gillyflower] pottes for the gardeyn." As mentioned above, John Chapman at Hampton Court also purchased shortly thereafter six loads "of pottes for the herbys" as well as "twyste to bynd therbes," the latter a reminder of the common use of frame insertions to support the plants in such containers. A clear illustration of this kind of small-scale gardening may be seen in a painting of around 1640 by David Teniers the Younger (pl. 82). Trees and larger plants also would have been grown in containers, some of them often trimmed into pyramid tiers. At the Bridge House garden there was even a topiary rendering of a ship, made of wired rosemary, for which a mariner was hired in 1532/33 to deploy small lines for trimming the riggings, as noted in the payment to William Hewett, the Porter, "for small lynes for the rosemary . . . for a maryner . . . trymmyng of a shippe." Only a few years later, Henry VIII could also boast a similar topiary at York Place, much grander than this one at the Bridge House garden, for which even canvas was purchased "for the Shippe of Rosemarye in the Gardeyne."[10]

The question remains, however, whether all such containers were used solely for plant display at appropriate sites in a garden space, or whether pots were also used to grow plants in volume at some removed garden area, from which replacements could be brought into the main garden as needed for spent container plants. Even more intriguing is the record of payment at Hampton Court in 1531 for 130 "pottes for the hott howse bought from John Paulmer [Palmer] of Stoke in Essex."[11] Paulmer's venue on the east coast suggests that these may have been imported pots, perhaps from the Low Countries. Reference to "the hott howse" is more problematic, for the first records of a building used to shelter plant material by means of some form of heating date only from later in the century, when the growing of tender plants, such as orange and lemon trees, jasmine and oleander, became fashionable. Thus, if this is in fact a reference to a hothouse for plants, it suggests how innovative Hampton Court was for its day.[12]

The final Museum of London artefact examined here is not a tool but a garden implement, and is perhaps the most unusual appurtenance for any garden from this period (pl. 83). The object, in appearance a ceramic bottle with a fairly large aperture at the top

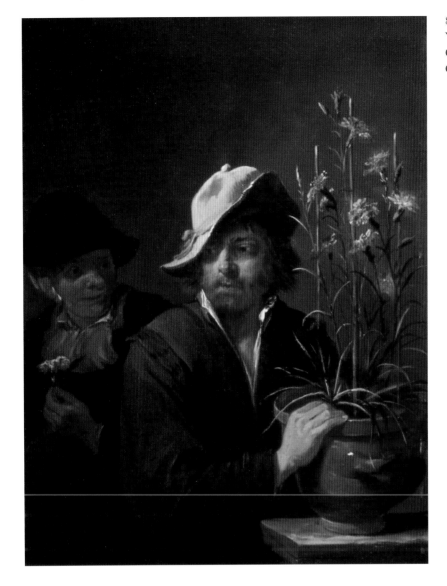

of its neck, measuring some 8 inches in length and 5½ inches in
breadth at its widest point, is a rare survival of what is known as a
ceramic bird pot; in sixteenth-century London it was called a
"sparrow pot." Such vessels were used as nesting boxes and placed
on garden walls or under the eaves of buildings to prevent birds
from dirtying walls or damaging thatch or to encourage them to
control flying insects. The device may also have made it possible to

83 Ceramic sparrow pot, mid- to late sixteenth century. Museum of London.

destroy eggs or fledgling birds.[13] In the Museum's example, the pot, its base secured against a wall by a bracket, would have enabled a bird to enter through the neck aperture or to perch on a stick put through the holes in its neck stub and main chamber.

Images of similar implements survive in a number of sixteenth- and seventeenth-century paintings and drawings from the Low Countries which illustrate the pots' use and placement in an urban setting. This is seen, for example, in details from the *Winter Landscape with Iceskaters*, by Hendrik Avercamp (1585–1634) (pls. 84 and 85), here showing pots located on the gable of a large building or on the

wall of a privy. A closer view of a bird pot is found in a painting by Carel de Moor (1655–1738) (pl. 86). In this painting, a boy is holding what is a Continental form of the London pot, flattened on one side, with an opening (for removal of eggs or fledgling birds) that would have been concealed when the pot was hung by its handle against a wall.

Intact bird pots survive from a number of Low Countries sites, some from the beginning of the fifteenth century,[14] but no English examples date from earlier than the sixteenth century. Because of their rarity, an early reference in the Bridge House accounts to

84 and 85 Hendrik Avercamp (1585–1634), *Winter Landscape with Iceskaters* (details). Rijksmuseum, Amsterdam.

147

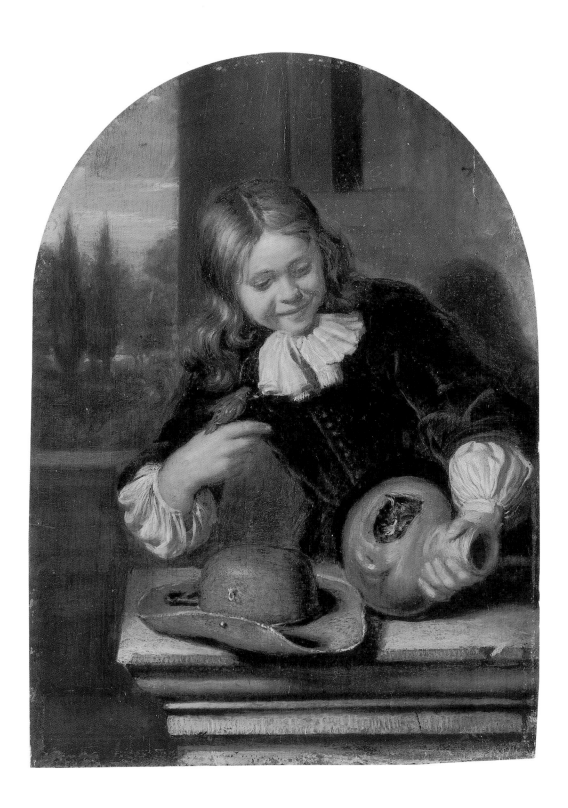

purchase such pots for the garden thus merits special attention. In March 1527 payment is noted "for v sparrow pottys for the gardeyn iijd" and is again noted in parallel accounts: "To William Snethe for a spade for the same gardeyn ijd To the said Raufe for a Buckett polys and roddys for the said gardeyn xvjd To hym for pakthrede jd To hym for sparrowe pottes iijd." No other documentary evidence for such bird pots has yet come to light for London. It is clear from archeological excavations, however, that bird pots continued to be used well into the eighteenth century in London and beyond, even as far away as America, in Williamsburg, where they were called "bird bottles" in an inventory of 1739, and "Martin pots" in an advertisement in 1752. A modern reproduction of a mid-eighteenth-century Williamsburg bird pot found in 1966 (pl. 87) shows a marked similarity to the sixteenth-century prototype in the Museum of London.[15]

Although the records of tools and pieces of garden equipment summarized here are indeed remarkable, given the distance of time since they were first noted, the objects they report nonetheless remain ultimately only material for an inventory. In themselves implements could not guarantee success for a gardener in More's London. But to the extent that they did serve as an efficacious extension of some garden workers' eyes or hands or minds, they remain for us a useful memento, a reminder that the riverside gardens in early sixteenth-century London were the expressions of human labor in a particular place and at a particular time. Even garden tools thus become part of the city's social history.

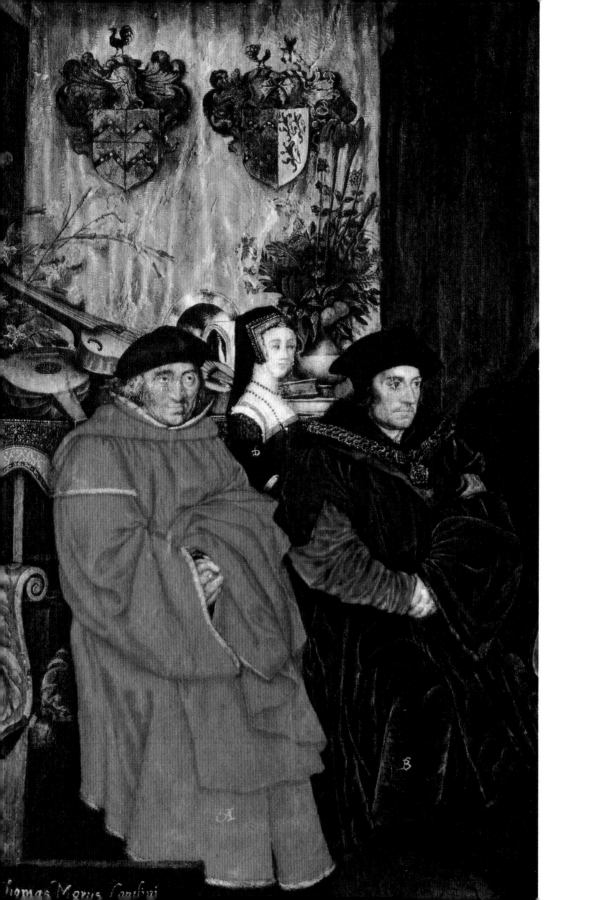

Thomas Morus Cancellari

4 Garden Design and Innovation

IN 1521 THOMAS MORE AND HIS FATHER, JOHN, served as joint counsel to the Bridge Wardens Symond Ryce and William Campyon "for sundry causes concernyng the lybertyes of the Citye wyth[in] the baroughe of Suthwerk" (pl. 88).[1] Although both men had done similar legal work for the Wardens before, at this date it would have been highly unusual for them to continue in such service. Indeed, John More had for a number of years already been sitting on the King's Council, and just the year before, in 1520, had been named a judge in the Court of King's Bench. Thomas's star, in turn, had by this time risen even higher. A King's Councillor since 1518 and de facto chief personal secretary to the king, he was in 1521 shortly to be appointed Under-Treasurer of the Exchequer and given a knighthood. Within two more years, he would be elected Speaker of the House of Commons.

But serve they did, as the Bridge records make clear. There is also the likelihood that the two of them, in connection with this investigation, paid a visit to the Bridge House, perhaps on more than one occasion. If so, they would have been welcomed as most distinguished visitors. While there in 1521, moreover, they could not have escaped noticing the upheaval, both in the Bridge House itself and in the adjoining garden and backyards. As noted above, a new countinghouse and adjacent summer parlor were under construction at the time. Beyond the house to its east, the great "garnardes" or granaries had already been completed, but the Wardens' garden area, so severely disrupted, was still under major renovation. Talk among the Mores and Campyon and Ryce may well have turned to discussion of the Wardens' vision for the garden, with their plans for

88 Rowland Lockey, *The Family of Sir Thomas More* (detail of fig. 50).

new walls, a fountain, paved alleys, and new formal beds. In such parley, More might well have talked about all the great garden changes and innovations he had seen at York Place and at Hampton Court, at both of which he was a frequent visitor. He also may have been thinking ahead to a time when he could remove his family from Bucklersbury to some place in the country where he too could build a garden estate.

Within four years that dream would become reality for More. Because of generous remuneration for his prominent positions in the government, he was able to purchase land in rural Chelsea in 1524 for £30 and begin construction of his house the next year. At the same time, the grounds of the manor were being laid out. The questions one must ask today do not deal solely with what the garden settings for the mansion may have been (see chapter 1), but also with a more difficult enquiry. Where did the ideas for an integral match of house and grounds come from? Who envisioned a large house, approached through two great garden courts and framed by outbuildings, food gardens, a privy garden, and an orchard garden? Unfortunately, all such information is now lost. Yet More's own role in such plans would seem warranted, with ideas for the grounds and gardens perhaps influenced by his familiarity with various river properties, including the riverside estates here under study.

Gardens fronting the Thames, for example, would have been common sights for a river traveler like More, such as those lying between the river and the Strand at the Bishop of Exeter's Inn (known after 1549 as Paget's Place), the Bishop of Bath's Inn (after 1549 called Arundel House), or at the Bishop of Norwich's Inn (acquired by the Archbishop of York in 1557 and thereafter named the new York Place, see pl. 36).[2] The idea for a house facing but set back from the river and approached by traversing the long formal perspective of enclosed garden courts also may have occurred to More from visits to Fulham Palace and to Wolsey's Hampton Court, although in neither of these places had a plan for such an entrance from a river landing yet been fully implemented (as it soon would be under Henry VIII at Hampton Court). Closer to the City, More would have witnessed Wolsey's and Henry VIII's earlier tryout of such an arrangement in the construction of Bridewell Palace between 1510 and 1523 (pl. 89).[3] Whatever its source, More's site

89 Bridewell Palace,
copperplate map (detail),
c.1553–59. Museum of
London.

planning at Chelsea proved to be highly successful, as attested by his
visitors. It may, in turn, have been influential on others, such as Lord
Protector Somerset, who built a mansion on the Strand in the years
1547–50, with formal gardens leading down to the river.[4]

The use of brick, increasingly since the turn of the century the
building material of choice, is another idea that More may have
been attracted to from seeing its effective use in new constructions
at the time: in Bridewell Palace, completely built of brick, or in
Morton's gateway at Lambeth Palace, the more recent gateways and
courts at Lincoln's Inn and at Fulham Palace (pl. 90), or the even
grander gateway and base court at Wolsey's Hampton Court (pl. 91).[5]
More also would have seen at first-hand the suitability of brick for
garden walls, particularly those built as orchard surrounds by Bishop

90 (*above left*) Fulham Palace, gatehouse.

91 (*above right*) Hampton Court, Great Court.

Fitzjames at Fulham Palace (pl. 92) and by Wolsey at Hampton Court. For More at Chelsea, this meant a most lavish investment both of money and interest, with every major garden area defined by sturdy brick perimeters. Certain stretches of sixteenth-century walls, presumably built by More, still survive, as may be seen in the nineteenth-century Moravian Burial Ground, located on the site of More's stable block (pl. 94), and in a portion directly to the east of his mansion house site, behind today's Allen Hall Seminary, near an

ancient mulberry tree by some still claimed to have been planted by
More (pl. 93). One must recall here More's own words about such
walls:

> As for rosemary,
> I let it run all over my garden walls
> Not only because my bees love it
> But because 'tis the herb
> Sacred to remembrance

92 (*above left*) Fulham
Palace, brick garden wall.

93 (*above right*) Allen Hall
Seminary, Chelsea, brick
garden wall.

94 Moravian Burial Ground, Chelsea, brick garden wall.

> And therefore to friendship,
> Whence a sprig of it hath a dumb language.[6]

More's interest in brick for garden walls may also have dated from 1509, when at the Bridge House first reference is made to their construction, the "bryklayers" Robert Bylby, William Bulloke, and Richard Haydon working for forty-five days at the task. Had he visited the garden again in 1522, he would have seen these walls being demolished, the bricks carefully cleaned and saved for the walls' remaking, now that the granaries encroaching on the garden space were completed. Payment in that year is noted to Robert Shugesby for "taking doone" 10,000 bricks "from the old wall in the gardeyn wtin the brigehouse and making clene of the same." Further records note payment to John Russhe, "laborar," for "casting of fundacionis for wallys in the gardeyn." Soon thereafter 19,000 additional bricks were also "conveyed in to the gardeyn," and construction began, with "pareling [square-cutting] asshelar" stone both for the walls' "fundacion" and for capping. Once the walls were completed, rosemary was planted at their base, trained by wire to grow up to the top, as was becoming the current fashion. More's rosemary-covered walls would have been little different from these.

Brick continued to be used in other ways in the Bridge House garden in 1523, and such deployment would also have been a matter

of interest to More. Jeffrey Tull, "bryklayer," for example, was paid 5s, "at tax," that is, for the task of "making and workmanship of a new ffountayne of bryk wtin the gardeyn," perhaps one similar in appearance to the brick fountain later built in the Tudor courtyard at Fulham Palace (see pl. 90). At the same time, other bricklayers and laborers were paid for "making of a new well in the gardeyn" and for "paving of an alley wt bryk wtin the brigehous gardeyn." While such evident zeal for brickwork thus appears almost a contagion in the garden design for the Bridge House, it could not compare with More's own large-scale use of such materials only two years later in Chelsea. As noted in chapter 1, wall construction there even included, along the north side of the Privy Garden, a raised terrace overlooking the garden, leading from the main house to a banqueting house in the far corner, an arrangement still apparent in the Lockey miniature showing the garden (pl. 95). Such terrace features, only a few years after their appearance in Chelsea, would be incorporated at Hampton Court and Lambeth Palace, again as noted above.

Perhaps the greatest influence on More's interest in his garden estate came from the people who had most at stake in such an enterprise, from his gardeners themselves. Conceivably, More might have consulted John Chapman to discuss plans for his new manor gardens. Certainly his access both to York Place and to Hampton Court would have made such meetings possible. But a more likely scenario was the advice given by the ordinary gardeners he employed in Chelsea, beginning in 1525. Although surviving records name no such garden staff, any number of the gardeners he may have employed, if drawn from the community of such people as described above, would have had the expertise to suggest a variety of ideas for use of existing garden spaces and for features that might be developed in them.

A useful reminder of that world of garden labor may be seen in the drawing *Ver* (*Spring*), done in 1565 by Pieter Bruegel the Elder, engraved in 1570 by Pieter van der Heyden (pl. 96). Although depicting a Netherlands garden, the image nonetheless captures well the sort of garden work being done a generation or more earlier in England, as might have been the case at More's Chelsea manor, or indeed at places like the Tower of London, Lambeth Palace, and Fulham Palace. Bruegel's picture is worth examining in detail, for it

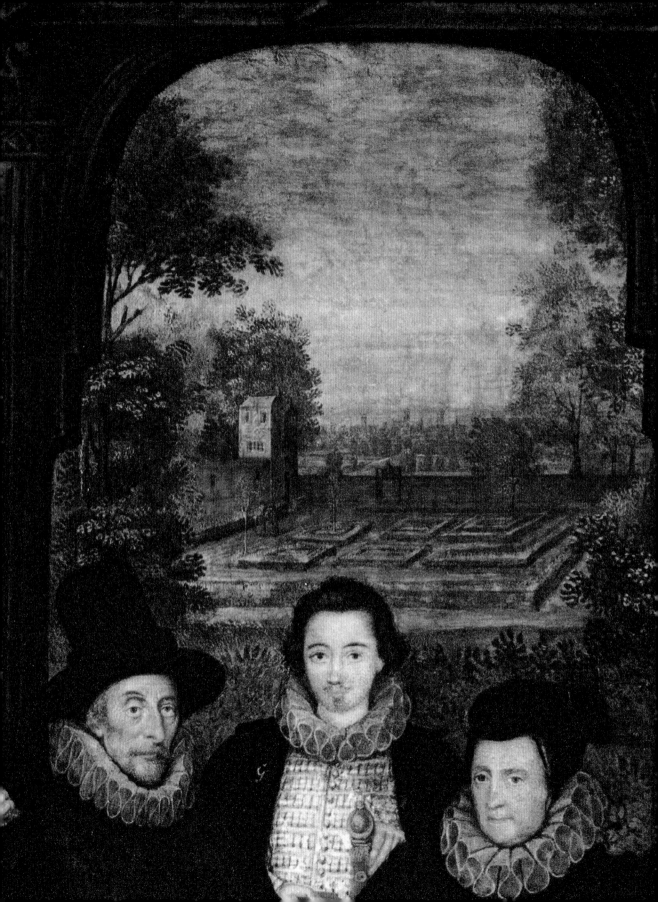

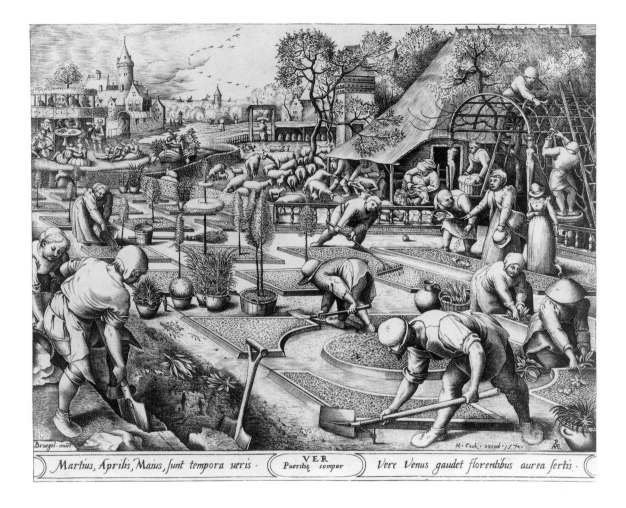

Martius, Aprilis, Maius, sunt tempora ueris · | VER Puerit̨ compar | Vere Venus gaudet florentibus aurea sertis ·

summarizes the gardeners' expertise, showing different phases of garden construction as well as the planting, care, and management of garden materials. To the left, for example, one sees the use of a paring spade to cut straight lines in the soil. The gardener in the foreground further shows the careful construction of low edging for raised beds, aligned by measures of cord staked in the ground. Other laborers demonstrate the preparations for planting: raking a bed smooth, sowing seed by broadcasting, and planting roots by hand. And to the right, other gardeners undertake the trimming of grapevines growing on an arbor frame, while to the rear a woman is watering.

The picture is also useful for showing the deployment of small trees, some of them planted in the center of a raised bed (including

96 Pieter van der Heyden after Pieter Bruegel the Elder, *Ver (Spring)*, 1565, engraving, 1570. The Metropolitan Museum of Art, New York, Harris Brisbane Dick Fund, 1926. (26.72.57)

95 (*facing page*) Rowland Lockey, *The Family of Sir Thomas More* (detail of fig. 50).

one topiary tree in a tiered fountain shape) and others grown in containers. Other pots, none of them yet placed for decorative effect, contain low-growing flower plants or taller ones supported by frames. Even a broom for sweeping the alleys of debris lies waiting for use. All such activity and management would have been quite familiar to the gardeners in More's employ.

One other feature of the drawing deserves to be noticed, for it forms part of what appears to be Bruegel's intended social comment. Gardeners and their labor are given prominence here so as to mark a contrast with those who owned or enjoyed such a garden, as may be seen only in small scale in the background, where couples row on a stream, sit drinking on the grass, or enjoy the food on offer in a tree arbor (built around its trunk), topped by a covered platform in

right Pieter van der Heyden after Pieter Bruegel the Elder, *Ver (Spring)* (detail of pl. 96)

the branches for others viewing the garden expanse from above.[7] Certainly, in More's day tree arbors were not yet part of the vocabulary of London gardeners, and the idea of a special structure built to provide the amenity of a viewing platform for overlooking a garden would have first entered the ken of most of them only with the Mount construction at Hampton Court in the years 1532–34.

The question has been raised already, however, whether a modest version of such a viewing structure might have figured in More's plans for his garden. It would seem highly unlikely, and certainly no direct evidence survives that this might have been the case. Yet, as noted in chapter 1, in Ellis Heywood's *Il Moro* of 1556 he makes reference to "un pratello posto in mezzo il giardino sopra un uerdo monticello," that is (in Roger Deakins's translation), "a small meadow (in the middle of the garden and at the crest of a little hill)" where More's imaginary visitors "stopped to look around":

> The spot pleased them greatly, both for its comfort and for its beauty. On one side stood the noble City of London; on the other, the beautiful Thames with green gardens and wooded hills all around.

Could More have had, in some form, an artificial hill or small rise made, perhaps with a viewing platform atop it, as one of his garden features?[8] Perhaps more importantly, would the gardeners he employed have known how to construct such a raised area? If so, what might it have looked like?

One possible answer to such questions lies in another manor house, nearly contemporary with More's, located in another part of rural London. In 1540 two Spanish merchants named Balm (or Baum) had constructed a mansion in Hackney, close to the Shoreditch boundary. Like More's house, it was approached by formal courtyards leading from a gatehouse, with the house further framed by surrounding orchards and other formal garden expanses. Although the house was much altered in later years, some sense of its sixteenth-century appearance may be seen in a panoramic view, probably made late in the century, as recopied in 1707 for a book by Pierre Vander, *Les Delices de la Grand Bretagne et de l'Ireland* (pl. 97).[9] Of particular interest is what appears to the left in the picture. There one sees a mount, set in a large garden compartment featuring hedged paths in a diamond pattern. Dome-shaped and topped with a

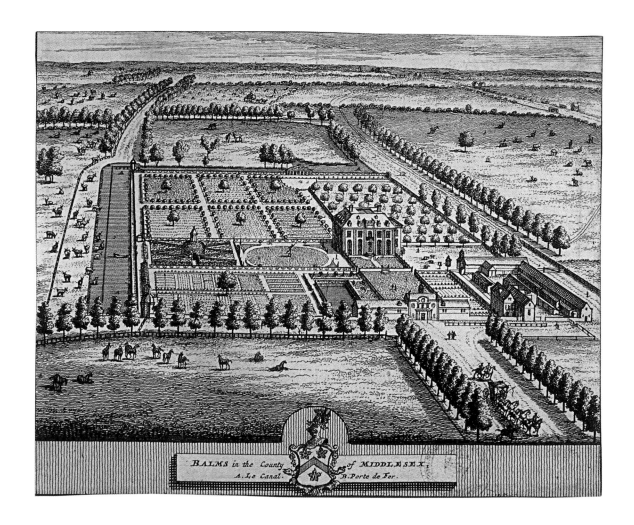

BALMS in the County of MIDDLESEX.
A. Le Canal. B. Porte de Fer.

97 *Baum's House, Hackney,*
copy after a sixteenth-
century drawing, 1707.
Guildhall Library,
Corporation of London

98 (*facing page*) *Plan of
Chelsea Estate Prepared for
Sir Robert Cecil* (detail of
pl. 51).

cupola, its structure further defined by what appear to be espaliered
"walls," the mount has certain similarities to the much grander
version built earlier by Henry VIII at Hampton Court. Conceivably,
More may have heard from Henry himself of his plan, perhaps as
early as 1529, for creating a great garden mount by the Thames, with
More, still his friend, deciding in playful rivalry to see whether his
own garden staff could anticipate this garden construction by
creating, at least in some crude form, a prototype in Chelsea. Or so
one might conjecture.

It is important to remember that More's Chelsea manor, both as a
farm and as a stately riverside residence, was laid out with many
different gardening areas. To the extent that the Cecil map of 1595

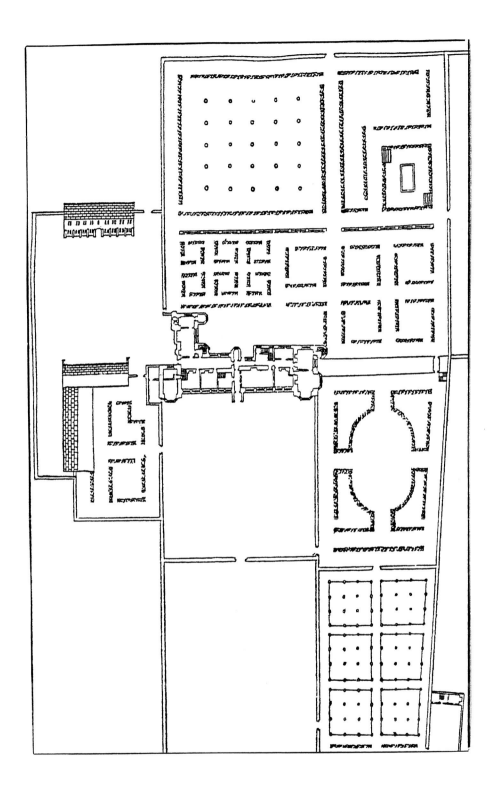

still reflected the gardens dating from More's tenure, one sees, in areas nearest the house, a series of garden arrangements (pl. 98). An orchard to the north shows the even spacing of hedged trees (traditionally planted 35 to 40 feet apart), while another to the south shows them deployed in six square beds separated by alleys. To the north and northeast of the house hedging again is used to create both large and small square plots or an L-shaped enclosure and a rectangular bed. In the Privy Garden to the east of the house, further hedging outlines beds in a formal geometric pattern. However close or not this map may be to More's own garden design, what continued as a constant garden feature throughout the sixteenth century was the notion of formal bed layout, with right-angled corners and arrow-straight outer boundaries. But how did the gardeners know how to do this? What skills were needed for laying out garden beds, of whatever sort, with precise measurement and accurate squared perimeters?

The answer, as Sylvia Landsberg has pointed out (and as any landscape gardener today well knows), lay in a gardener's use of measuring cords, knotted in a geometric progression ratio of $3:4:5$.[10] Perhaps one of the earliest tricks a gardener in training would have learned, this age-old technique for creating a right-angled triangle begins with staking a cord between two points as a base line, using, for example, a base unit of, say, 2 feet multiplied by three, equaling 6 feet. A second side of the triangle is next staked out, using a multiple of four for the base unit, equaling 8 feet. The right angle of a triangle is then "corrected" by staking the cord on the triangle's third side, as measured by a multiple of five for the base unit, equaling 10 feet. The process is then repeated to create an identical facing triangle, which then forms a perfect rectangle, whose perimeter measures 6 feet × 8 feet. To reduce this to a perfect square, the base line is then used to measure both sides of the rectangle, which are then shortened from 8 feet to 6 feet.

Such traditional knowledge would have been familiar to More's garden staff, and at Chelsea would have been used in laying out all the garden beds, of whatever size. Such expertise among gardeners did not need to be written down. Eventually, however, the method did get recorded, as may be seen in *Maison rustique; or, The Countrie Farme*, by Charles Estienne and John Liebault, translated into English in 1600:

You shall haue in your hande many measures of small corde and yet sufficient strong: many cord-reeles and dibilles, and such other things to finish the proportions which you desire to haue drawne in your quarter . . . When you haue cast your grounde, you shall begin to stretch your line with good and firme line-reeles, to take the bredth and length of your borders round about. Then you shall draw your line a cross [diagonally], from the which crosse, and from about the which borders, you shall not draw vp your line and line-reeles, vntil you have marked out all your border, or at least one side, or halfe of it, because this [becomes] the directorie, for the whole quarter and border . . . whereby you must be guided and directed for the making of compasses and largenes of your squares and rounds.[11]

The technique for laying out garden beds by precise measurement was not restricted to small expanses. Indeed, returning to the Privy Garden at Hampton Court, one can see how enormous such a task might be: how to lay out a series of beds in a space of approximately 200 feet × 300 feet? Although one can attempt only to reconstruct their configuration, it would appear, based on the Wyngaerde drawing (see pl. 13), that there were twenty such beds, each rectangular in shape and arranged in pairs running east to west in five contiguous rows running north to south, with each pair separated by a central alley (see pl. 61). Records of payment reveal also that 960 yards of wooden rails were purchased to mark all the outer boundaries of the beds as well as those intersecting them.

To measure and then prepare so many large-scale beds was no small undertaking. For the job, the London gardener John Hutton was brought in, charged with "makyng and levelyng of Beddes in the Kynges new garden wyth Dyggyng and Rakyng of the same." He was also supplied, as noted above, with "vj peces of rownde lyne to mesure and sett forthe the new garden." Assisting him was Roger Down, employed in "levelyng" and "makyng of bourders in the gardeyn." Hutton, working with amazing efficiency, proceeded in only twelve days to mark out beds of appropriate size and then complete their groundwork. By using a base measuring unit of 5 yards and employing multiples of 3 : 4 : 5, he had succeeded in laying out twenty beds, each measuring 45 feet × 60 feet, whose outer and shared boundaries measured exactly 2,880 feet, or 960 yards,

matching precisely the rail yardage purchased. He would also have marked out the positions of the supporting posts needed for the rails, located at the corners of each bed and halfway along the sides, for a total of 180, again exactly matching the number of wooden posts purchased, as the records indicate. Such was the expertise of gardeners at the time.

Other areas of gardeners' expertise also involved the inner design of garden beds. Although no one will ever know precisely how such designs were worked in More's garden beds, it is tempting to ask whether he might have been attracted, for some of them at least, by the latest fashion, the knot bed, such as those that Wolsey had created at Hampton Court and which More would have seen. His interest in such innovation may have been influenced too by knot beds being developed at the Bridge House garden in the 1520s, first referred to in 1525, when the Porter Thomas Chylde was paid 20d "for clyppyng of sundry knottes in the same garden."

Although it is impossible to say what such "knottes" looked like at the time, it would seem that they were ornamental square-bed designs, probably geometrically patterned, then coming into vogue in city gardens, the earliest appearing by name in the Carpenters' Company garden by 1490, the fashion later spreading (by the 1540s) to neighboring gardens, those of the Drapers' Company and of Sir William Paulet. An image of these gardens may be seen in a detail from the Agas map of around 1560, showing the northern part of the city, with the Guildhall to the left and, to the right, the garden of the Carpenters', below which lay that of the Drapers' Company and to the right of which, that of the old Augustinian friary, which Paulet acquired and expanded after 1540 (pl. 99).[12]

How such knot beds were made is suggested by a number of the Bridge House record entries, for example, the one dating from 1529/30 (see pl. 18), when the gardener Rauf Collyns and his assistants Richard Wright and Edward Fitton were paid for "workyng in drawyng of knottes and borders." A similar account is found in 1551/52, when the gardener Morys Antynor and two assistants were paid for "diching [ditching, that is, shallow furrowing] and drawing of knottes & bedes in the garden."

"Diching and drawing" here apparently refer to the marking out of a knot design. Such a pattern was first lightly outlined on the level soil surface of a raised bed that had previously been defined by

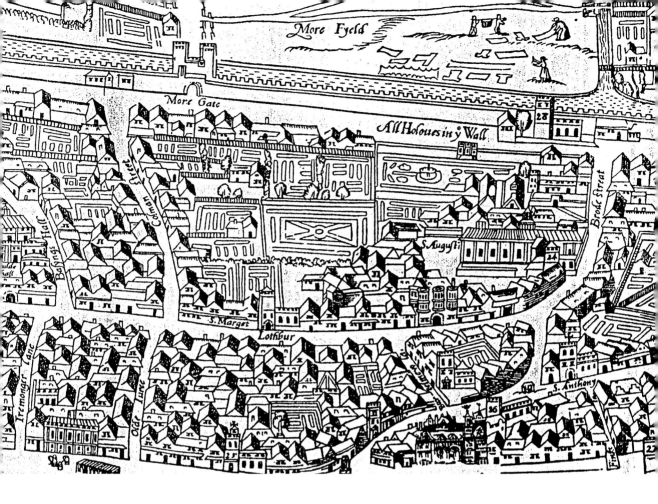

Labels visible on the map: More Fyeld · More Gate · All Hoſoues in ÿ Wall · 28 · Broke Street · Common Streete · S.Auguſt · Baſings Hall · S.Marget · Lothbur · S.Anthony · Iremonger Lane · Oldar Streve · 16 · Fincke · 2

a gridwork of staked cord lines. At the Bridge House garden the
cord used for these measuring lines was "pakthrede," a frequent
purchase at the time. The importance of maintaining the cord
running lines until whatever complete design for a knot has been
"drawn" is shown diagramatically in *Maison rustique*, in plates
showing how such grids are to be staked (pl. 100). Following this
elaborate step of graphing the plot and marking the design on the
soil, the shallow drawn lines were then cut as trenches. As Estienne
and Liebault put it, "to plant within the earth, whether it be roote,
or slip, you must cast trenches, rather with some short handled
handforke, or hand spade, than with a dibble, which you shall finde
a great deale more easie."[13] At the Bridge House garden, such
cutting of trenches for the knot was entrusted to Thomas Chylde in
1528/29 and again the following year. In the spring and early
summer of 1531/32 similar charges were given to William Tryme and

99 *Civitas Londinum*
(detail), *c.*1560. Guildhall
Library, Corporation of
London.

The manner to ſtretch the lines to make a quarter of broken ſquares. Let reſt and abide in their places the lines till you haue finiſhed the proportions. Take the meaſure of the ſtandards of the croſſe and corner line, whether it be a ſquare or a round, and let there be ſo many of them and as great as the ground will beare. And if perhaps you would plant any thing in the middeſt of the quarter, helpe your ſelfe with the running lines and their ſtandards, to plant there what you would, without putting downe any other ſtandards, or ſtretching any other lines, then are already : and thoſe you muſt not ſlacke, accord ng as hath beene ſaid before.

The manner of ſtretching the lines, vpon a quarter of broken ſquares.

The

100 "Plan of Cord Lines for a Knot Bed," from Charles Estienne and John Liebault, *Maison Rustique; or, The Countrie Farme,* trans. Richard Surflet (London: Edm. Bollifant, 1600). The British Library.

to John Davy, each paid "by ij days cutting of knottes in the gardeyn."

Once the design was so marked out by trench cuts, it was then planted with contrasting plant materials of the sort being purchased by the Bridge House at the time, such as low-growing thyme, hyssop, rosemary, sage, and lavender, which subsequently were regularly trimmed to preserve the pattern as designed, a process noted frequently in the records as "clypping of knottes." It was not until 1613 that "Boxe" for the garden knots at the Bridge House would be introduced. It would appear that the original planted knot designs, once established, were not infilled with other plants, but rather left simply as area plantings set off by bare soil, as suggested by a further entry in 1541/42, with payment of 6d "to a gardyner for erthyng of knottes."

The actual design for early garden knots (supposedly so named, as John Harvey has argued, after "the formal carved bosses of Gothic vaulting and timbered ceilings"[14]) has been a matter of recurring speculation among garden historians, for no unmistakable images of early knot plantings survive.[15] Clearly, however, there was a strong interest in knot gardening antedating its visual records, and this would appear to reflect a broader cultural interest in richly patterned design then current, as found, for example, in embroidery, goldwork, marquetry, and leather tooling in bookbinding.

At the Bridge House garden a good case can be made, on the basis of surviving records as here examined, that the gardeners were early advocates of such garden art and, during the second quarter of the sixteenth century, helped to set the fashion for knots in city gardens. One also can argue that the knot beds created by the Bridge House gardeners were drawn, cut, and planted to designs or "draughts" provided by the Clerk of the Works and his staff (who saw the garden daily and, in the case of the Clerk John Halmer, actually worked in the garden), men who, throughout the records they were keeping, showed themselves to be masters at drawing elaborate capital letters with their pens, often of a fanciful but highly geometric sort. Such cadels or strapwork, as they are called, were frequently decorated with the stylized figures, flowers, and birds then much in fashion in heraldic emblems, as may be seen in an example from the great volume of copy deeds to the Bridge House properties, completed about 1514 (pl. 101). Such designs done by the Clerk and his staff may also have been influenced by other pen designs then being perfected in notary marks, with their frequent geometric interlaces, as may be seen in the mark of Robert Hodgekynson, copied in the register of deeds in 1541 (pl. 102). Such a mark is comparable with some of the knot designs printed in *Maison rustique* (pl. 104). The knot beds today at Hampton Court, designed by Ernest Law in the 1920s, approximate later Tudor exemplars (pl. 103).

The argument over early knot garden beds and what they may have looked like will surely continue, until such time as new evidence for their design and execution emerge. Yet given their popularity in the late sixteenth century and into the seventeenth, one must be left with curiosity as to their prototypes in More's London. That More himself may have been drawn into their

101 (*above*) Decorated penwork with flowers, Corporation of London Records Office, MS Bridge House Estates Deeds: Large Register, p. 305, *c*.1514.

102 (*right*) The notarial mark of Robert Hodgekynson, Corporation of London Records Office, MS Bridge House Estates Deeds: Large Register, p. 455, 1541.

103 (*above*) Hampton Court, knot beds.

104 (*left*) "Design for a Knot Bed," from Charles Estienne and John Liebault, *Maison Rustique; or, The Countrie Farme,* trans. Richard Surflet (London: Edm. Bollifant, 1600). The British Library.

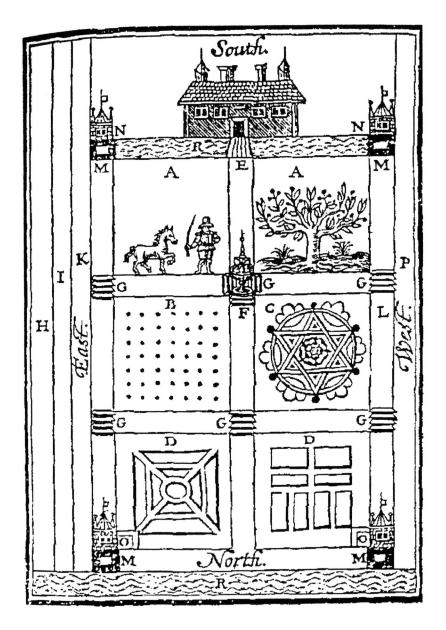

fashionable orbit at Chelsea would seem more than a likely possibility, given his interest and pride in the gardens at his estate.

Although More's garden interests have seldom drawn attention from those who have studied his life, Chelsea offered him a unique way to express in a tangible form both his ambition and his pride and to celebrate his affinity with others in a setting where his

dominant wit could shine. Certainly its garden expanse remained for him a most important place, increasingly so in his final years, when it served as a personal sanctuary, especially his study and chapel. Thus, of all the riverside gardens here under study, More's can be said to mirror most accurately its owner, even as it reflected what was new yet most harmonious in contemporary garden design. The garden estate he created also foreshadowed what was to come, anticipating by more than eighty years the kind of site plan for a riverside manor recommended by William Lawson in *A New Orchard and Garden* of 1618 (pl. 105).[16]

Yet for all the joy and beauty that followed from its initial creation, More's garden, in the end, could no longer serve as a mirror to the man, except perhaps with irony, for his life had begun to alter, particularly after he became Lord Chancellor (in 1529) and, more importantly, after he resigned his office (in 1532). To see how this was so, the next chapter deals with the ways in which More and his associates chose to use their gardens by the Thames; and it also explores how, finally, More changed such common customs.

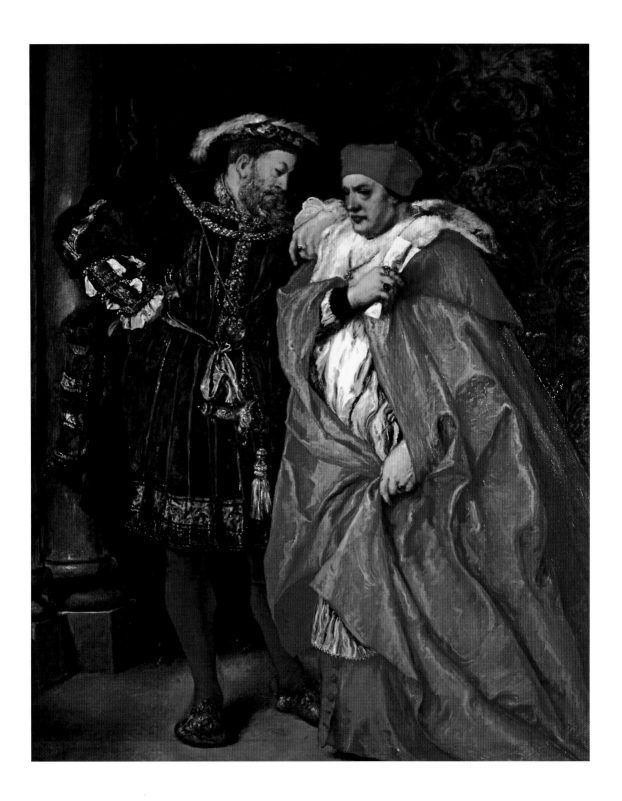

5 Garden Pride and Pleasure

A DRAWING IN THE GUILDHALL LIBRARY Print Collection, dating from 1747, shows a group of clergy, noblemen, and watermen standing on the bank of the Thames, opposite Lambeth Palace, with four bishops already on the water, three of them rowing with the tide, the fourth against it (pl. 107). The title reports the watermen's cry for business: "Haw'y, haw'y, l-b-th haw'y," and below the drawing a caption proclaims a piece of river doggerel:

> Sculls, sculls to Lambeth! See how hard they pull 'em!
> But sure the Temple's nearer much than Fulham.

Such an image, delightful as a piece of satire, is also a useful reminder of how much the Thames still served in the eighteenth century as London's busiest highway, much as it had in the early sixteenth century. The reference to Lambeth Palace, the Temple, and Fulham Palace in the verse offers a further reminder, of how important river access was, not only to these places, but to all the garden estates this study has visited, from the Tower of London to Hampton Court.

Up to this point, most attention has been given to the history of these riverside estates and to the people responsible for making their gardens, as told by the tools and techniques of garden enterprise. But to this study a further question now must be added: how were these gardens seen by those who owned them or who traveled on the Thames to visit them? Here the evidence turns to a very different social reality from that of the gardeners' world. Indeed, this is the world of Book I of More's *Utopia*, a place where, instead of the rather silent rational orderliness of Book II, one hears voices raised

106 Sir John Gilbert, *Ego et Rex Meus*, 1888. Guildhall Art Gallery, Corporation of London.

Haw'y Haw'y L--b--th Hawy.

Sold in May's Buildings Covent Garden where is 100 different sortments

Sculls Sculls to Lambeth! See how hard they pull'em!
But sure the Temple's nearer much than Fulham.

M. Bacquinet Inv. & f.

107 Anon., *Bishops Rowing on the River Thames*, 1747. Guildhall Library, Corporation of London.

in political debate and talk of strategy among those privileged with social power. This was also, it should be noted, very much a man's world, one often characterized by a ritual protocol combined with a competitive intimacy among equals that today seems foreign.

One sees this in part, for example, in Roper's account of Henry VIII's visits to Chelsea:

And for the pleasure he took in his company, would his grace suddenly sometimes come home to his house at Chelsea, to be merry with him. Whither on a time, unlooked for, he came to dinner to him, and after dinner, in a fair garden of his, walked with him by the space of an hour, holding his arm about his neck. As soon as his grace was gone, I, rejoicing thereat, told Sir Thomas More how happy he was whom the King had so familiarly entertained, as I never had seen him do to any other except Cardinal Wolsey, whom I saw his grace once walk with, arm in arm. "I thank our Lord, son," quoth he, "I find his grace my very good lord indeed, and I believe he doth as singularly

176

favour me as any subject within this realm. Howbeit, son Roper, I may tell thee I have no cause to be proud thereof, for if my head could win him a castle in France (for then there was a war between us) it should not fail to go."

Such meeting in intimacy between Wolsey and Henry VIII that Roper here mentions probably occurred at York Place or Westminster; it later became the subject of a painting by Sir John Gilbert, titled *Ego et Rex Meus*, dating from 1888 and now in the Guildhall Art Collection (pl. 106).

Even at the time of his last visit to Lambeth Palace in 1534, when meeting Thomas Cranmer and the other members of the Commission examining his loyalty, More could later report from the Tower in a letter to his daughter Margaret the humor of such intimate garden strolls:

> [When the Commissioners] saw that I refused to swear the same myself . . . I was in conclusion commanded to go down into the garden. And thereupon I tarried in the old burned chamber that looketh into the garden, and I would not go down because of the heat. In that time I saw Master Doctor [Hugh] Latimer come into the garden, and there walked he with divers other doctors and chaplains of my Lord of Canterbury. And very merry I saw him, for he laughed and took one or twain about the neck so handsomely that, if they had been women, I would have went [weened, i.e., believed] he had been waxen wanton.[1]

Such delight in human foibles, even at a time of adversity, supports the claim that Erasmus made earlier when describing More's personality: "There is nothing that occurs in human life, from which he does not seek to extract some pleasure, although the matter may be serious in itself."[2]

One take on such intimacy among the powerful follows in Erasmus's incisive but almost certainly biased view of More's investment in friendship:

> He seems to be born and made for friendship, of which he is the sincerest and most persistent devotee . . . Accessible to every tender of intimacy, he is by no means fastidious in choosing his acquaintance, while he is most accommodating in keeping it on foot, and constant in retaining it. If he has fallen in with anyone

whose faults he cannot cure, he finds some opportunity of parting with him, untying the knot of intimacy without tearing it, but when he has found any sincere friends, whose characters are suited to his own, he is so delighted with their society and conversation, that he seems to find in these the chief pleasure of life . . . What more need I say? If anyone requires a perfect example of true friendship, it is in More that he will best find it.[3]

For More, perhaps friendships well and good became a different matter when the friend was a king. Certainly his long and special relationship with Henry VIII appears to have been based on more circumspect intimacy. The picture of such as presented by Roper is one both of fascination and caution:

And so from time to time was he by the Prince advanced, continuing in his singular favour and trusty service twenty years and above. A good part whereof used the King upon holy-days, when he had done his devotions, to send for him into his travers [study], and there sometime in matters of astronomy, geometry, divinity and such other faculties, and sometimes in his wordly affairs, to sit and confer with him. And other whiles would he, in the night, have him up into his leads [lead-covered roof], there for to consider with him the diversities, courses, motions and operations of the stars and planets.

And because he was of a pleasant disposition, it pleased the King and the Queen, after the Council had supped, at the time of their supper, for their pleasure, commonly to call for him to be merry with them. When he perceived so much in his talk to delight, that he could not once in a month get leave to go home to his wife and children (whose company he most desired) and to be absent from the court two days together, but that he should be thither sent for again, he − much misliking this restraint of his liberty − began thereupon somewhat to dissemble his nature; and so by little and little from his former accustomed mirth to disuse himself, that he was of them from thenceforth at such seasons no more ordinarily sent for.[4]

Perhaps the crucial sentence here is he "began thereupon somewhat to dissemble his nature."

Indeed, whether called dissembling, tact, or strategic acting, the protocols of male intimacy in the riverside world of More's London

were essentially rhetorical, employing language men used artfully for political ends. A further important clue to this world of verbal play is to be found, once again, by looking at Book 1 of *Utopia*. Hythloday has just told the story of a group dining with Cardinal Morton at Lambeth Palace, at which, in the face of Morton's response to their arguments, the participants were quick to betray their convictions in the face of political expediency. He then turns to argue with More about public service, saying, "There is no place for philosophy in the councils of kings." More's rejoinder is the testimony of a seasoned political strategist:

> Don't give up the ship in a storm because you cannot direct the winds. And don't arrogantly force strange ideas on people who you know have set their minds on a different course from yours. You must strive to influence policy indirectly, handle the situation tactfully, and thus what you cannot turn to good, you may at least make less bad. For it is impossible to make all institutions good unless you make all men good, and that I don't expect to see for a long time to come.

Hythloday's response to More is filled with disgust:

> When you say I should "influence policy indirectly," I simply don't know what you mean: remember you said I should try to handle the situation tactfully, and what can't be made good I should try to make as little bad as possible. In a council there is no way to dissemble, no way to shut your eyes to things . . . Influencing things indirectly! You wouldn't have a chance.[5]

More, it would seem, spent his entire life "influencing things indirectly," adroitly managing the tactics of artful intimacy in the service of politics, so much so that the question of who More was "off the field" has remained perhaps the most difficult one to answer today.

Seeing More in such rhetorical terms, one might also then argue that his Chelsea privy gardens, as well as those of his intimates up and down the river, are perhaps best understood when seen as ideal settings, in season and upon certain occasions, for games of Tudor political discourse. To be sure, the formality of all these enclosed garden spaces also served to demonstrate, in a world accustomed to showy spectacle, one's social position and power, even while

celebrating personal achievement. Yet more was at stake, for each garden, quite clearly constructed to be "a place apart," could in fact serve as dedicated space, useful and at times well used for the play of ideas in an ongoing contest. Not just static symbols of social and natural order, gardens were places for the dialogue of human voices, most of them male. Only the gardeners were meant to be silent.

This is not to argue that gardens were the sole or even main location for political talk. The palace buildings themselves, those of Wolsey and the other ecclesiastics, as well as of Henry VIII, were perhaps the more common venue, especially given the conclaves frequently assembled there. Wolsey's busy life, both at York Place and at Hampton Court, for example, entailed a steady round of entertainment, often in the grandest of styles. His first biographer, George Cavendish, makes frequent note of this fact:

> All ambassadors of foreign potentates were always dispatched by his discretion, to whom they had always access for their dispatch. His house was also always the resort of noblemen, gentlemen, and other persons, with going and coming in and out, feasting and banqueting all ambassadors, divers times, and other strangers right nobly.
>
> And when it pleased the King's Majesty, for his recreation, to resort unto the Cardinal's house – as he did divers times in the year, at which time there wanted no preparations or goodly furniture, with viands of the finest sort that might be provided for money or friendship – such pleasures were then devised for the King's comfort and consolation as might be invented or by man's wit imagined.[6]

With a staff numbering more than 1,200, Henry VIII hosted entertainments at Hampton Court that were even more spectacular. On such occasions, a garden was at best only a prologue.

Yet gardens were meant as places of entertainment in their own right. At Winchester Palace, for example, there was a long tradition of royal entertainment, as was the case in 1424, when Bishop Henry Beaufort, half-brother to King Henry IV, held a lavish reception in the palace and the great garden, perhaps in the "domus gardini" or summer house, in honor of the marriage of his niece Jane, who had just wedded James I of Scotland at nearby St. Mary Overie's. In 1540 Henry VIII, in the same garden, would meet and woo Catherine

Howard, niece of the Duke of Norfolk, encouraged by Bishop Stephen Gardiner, who favored the match. In 1554 Gardiner would again entertain royalty in the palace and grounds, in celebration of the arrival from Greenwich on 17 August of the newly married Mary I and Philip of Spain.[7]

Not all such garden entertainment was of so lavish a nature. Gardens were also the venues of much more private meetings, and all the gardens examined here were equipped with special garden structures to accommodate such congress among smaller groups of visitors. Among these amenities, one of the most traditional was the garden bench, frequently constructed of wood or stone and covered with turf, as was the case in Wolsey's Privy Garden at Hampton Court, as noted above: "My garden sweet, enclosed with walles strong, Embanked with benches to sytt and take my rest." Understandably, no such garden seats survive today, although in the Moravian Burial Ground in Chelsea, next to the stretch of More's brick garden wall, a curious stone structure still remains. It appears to be a form of "exedra," or garden bench, which if not dating from More's tenure is perhaps from shortly thereafter (pl. 108).

108 Moravian Burial Ground, Chelsea, stone exedra.

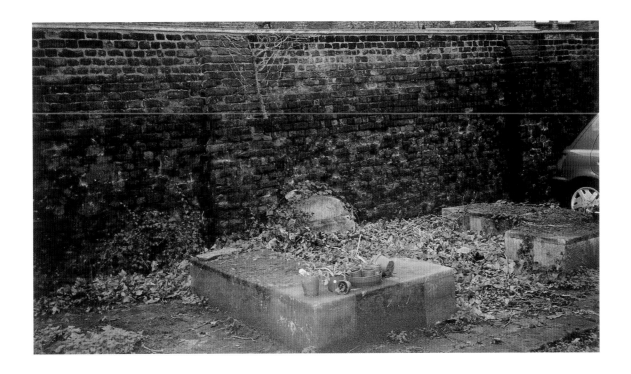

Other garden structures were meant to serve those who chose to walk in a garden and were intended to guide one's senses as well as one's pace. Such "Aleis and walkes," as noted by Thomas Hill in *The Gardeners Labyrinth*,

> serue to good purposes, the one is, that the owner may diligentlie view the prosperitie of his hearbes and flowers, the other for the delight and comfort of the wearied mind, which he may by himself or [in] fellowship of his friends conceiue, in the delectable sightes and fragrant smels of the flowers, by walking vp and down, and about the Garden.

Further pleasure was to be had by those walking through and under arbored places, "shadowed ouer with vaulting or Archhearbs, hauing windowes properlie made towards the garden, whereby they might the more fullie view and haue delight of the whole beautie of the garden." Such structures could range from the simple to the complex, the simplest being perhaps a free-standing trellis on which vines or flowers were trained to grow. An image of such a structure

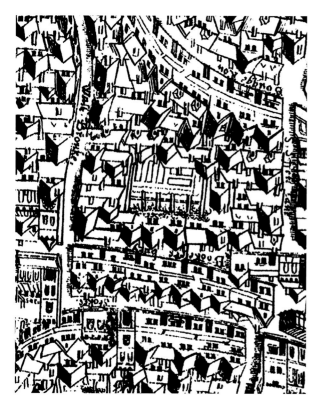

109 More's garden in Bucklersbury, copperplate map (detail), 1553–59. Museum of London.

may be seen in a detail from the copperplate map, showing what had been More's garden at Bucklersbury, where he often talked with his daughter Margaret (pl. 109).[8]

Other arbors were more complex, either arched, as depicted by Bruegel (see pl. 96) or upright in form (see pl. 69). In the latter case, a larger version of the arbor was intended as a framing device for those sitting in the structure, again as Hill points out:

> But first I meane to speak of those hearbes, which the Gardener planteth and ordereth to run for beauties sake in an vpright herbar . . . The plants to run vp and serue comeliest for the straight herbar ought to be those of fragrant savour . . . for delight and pleasure . . . The Rosemarie, the Jasmine, the redde Rose in manie gardens [are] set to grow

vpright, which in time growing, beautifie an vpright herbar, although these couer not the same, through their shorter and lower growing than the herbar; yet the commoditie ensueth by the herbar, that the owners friendes sitting in the same, may the freelier see and behold the beautie of the garden, to their great delight.[9]

Such old-fashioned garden structures were still part of the garden vocabulary even for Wolsey at Hampton Court. As noted above, one of his first garden expenses recorded was for 100 "penny naylis fixed upon the pale in thorchard for twyggis to bynd tharbor." In various guises, arbors would also have figured as amenities in the other gardens More and his friends knew.

At the Bridge House garden, for example, some form of large arbor used for entertainment had been a familiar feature since the fifteenth century. When this arbor was removed in the 1520s, part of the complete redesign of the garden area, it was replaced by an even larger structure adjoining the newly rebuilt countinghouse, whose windows looked into this new summer parlor. The parlor was presumably open to the garden on one side, and partly enclosed on the other three, with bench seating forming a large surround. The records note that work had begun on it by November 1524, and weekly thereafter into the spring of 1525 two carpenters named Evarston and Darrell received payment for work "vpon a fframe and type [tip] for the gardeyn wtin the brigehous," in reference to a structure built of oak, with a gabled roof. Work was completed by March, at a total cost of £2 3s 9d for labor. As a final touch, Andrew Wright, later to become Serjeant Painter to Henry VIII, was paid 3s 4d "for payntyng of the Kynges Armys in fyne Golde upon a ffane [vane] for a fframe set in the Briggehous Gardeyn." Such adornment to set off the new parlor was no doubt a handsome addition but also a diplomatic compliment to the king and therefore useful to the City's self-interests. Some sense of the image on the vane can be gained from a capital letter in the Bridge House's great register of deeds, done by John Halmer, the Clerk of the Works, and Wright's close friend (pl. 110).[10]

Although other features of the parlor were not recorded, its open front was presumably one of the garden sites where, shortly after completion of the "fframe," the gardener James Kettill was paid for 200 "Rosiars" and "for laieng of the same wtin the gardeyn of the

brigehous." These rose roots, which Kettill either grew himself or
may have acquired from the London rose merchant John Browne in
St. John's Street, were probably the old-fashioned red *Rosa gallica* or
white *Rosa alba*, with perhaps a few of the new hybrid *Rosa
damascena trigintipetala*. Near the parlor a "Jessemen" (jasmine) was
also planted, which by 1542 (possibly the earliest English reference to
the plant[11]) needed poles to underset it.

Once completed, the Bridge House summer parlor, overlooking
"the whole beautie of the garden" with its fountain, paved alleys,
and ornate knot beds, was set to continue its long use: for more
than two centuries festive meals were held there at the time of the
annual audit of the Bridge accounts and, after 1550, at the annual
Lady Fair dinner. Each year the Bridge records note costs of such
catering, in 1574, for example, "paid for a Banquett for my lorde
maior, his Brethren and Officers at our ladie ffaire xxxvs vjd."[12] Such
tradition of hospitality also involved other gala events, such as a
wedding party in 1562, as reported by Stow, which lasted two days,

184

attended by the Lord Mayor, Aldermen, "with many Ladies, and many other worshipful Men and Women," who, after the wedding, "went home to the Bridge House to Dinner . . . with all manner of Musick and Dancing all the Remainder of the Day: And at Night a goodly Supper; and then followed a Masque till Midnight."[13]

Similar structures, such as the "domus gardini" at Winchester Palace, were no doubt found in most of the gardens that More visited. A summer parlor was also eventually a feature at Fulham Palace, although there its roof was constructed as a terrace, something not possible at the Bridge House garden. As noted in 1647, the Fulham garden was bounded by "a stone gallery on the south side thereof and a fair summer parlour, wainscotted, on the west part thereof . . . [with a] terras chamber over the summer parlor [and] a great gallery matted and wainscotted over the stone gallery."[14] More than a century earlier, terraces for viewing a garden from above had upon occasion been built elsewhere atop garden walls: at More's Chelsea estate, and Hampton Court under Henry VIII. One also became an important garden feature at Lambeth Palace during Thomas Cranmer's later tenure. The stone gallery at Fulham, moreover, would have reflected origins in the protected vantage points of earlier garden galleries, such as those at the Tower of London, York Place, Hampton Court, and Lambeth Palace, as conceived by Henry VII, Wolsey, Henry VIII, and Cranmer. And Fulham's summer parlor itself, like its earlier counterpart at the Bridge House, would have shared amenities with another sort of early Tudor garden building, one that came to be known as a "banqueting house."

The most elaborate such places for entertainment and dining were, of course, those that captured the imagination of Henry VIII at Hampton Court, most notably the Mount, but also another grand structure built to the north of the palace, beyond the moat, called "the Round house in the grate orchard." Like the Mount, it too was equipped with its own kitchen. In some form, now almost impossible to discern either from archival or archeological record, Wolsey earlier had also constructed a free-standing building at York Place near the end of his long gallery, for use presumably as a garden dining chamber, as indicated in a record from 1531 in reference to "the galarye next unto the bankette house."[15] More's own garden constructions, as noted above, appear likewise to have

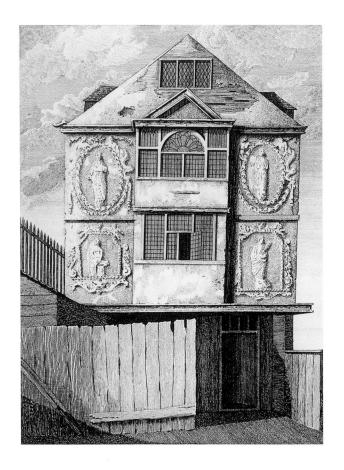

111 Anon., *Sir Paul Pindar's Lodge in Half Moon Alley, near his mansion house in Bishopsgate Street*, *c.*1600.Guildhall Library, Corporation of London.

included a banqueting house, in this case located at the end of the raised wall terrace overlooking the north side of the privy garden. The configuration would have been similar to that later developed by Thomas Cranmer in the privy garden at Lambeth Palace. Although no plans or records survive to document More's garden structure, its appearance can be seen in the Rowland Lockey miniature (see pl. 95). Built on several stories, the building was a forerunner of the timber-framed banqueting house built around 1600 in the Bishopsgate Street garden of Paul Pindar (pl. 111).[16]

All notice of amenities provided in these riverside gardens – from garden bench to banqueting house – is thus useful for a better understanding of their social dimensions. Yet it would be a mistake to define any such place simply as a venue for entertaining visitors. To the contrary, the use of some of these gardens reflected more

their owners' particular professional calling than their locale on a busy waterway. This would have been true particularly for the gardens of ecclesiastics, such as archbishops Morton, Warham, and Cranmer, or Cardinal Wolsey, or bishops Fox, Gardiner, Fitzjames, Tunstall, and Stokesley, each of whom used his garden as a place suitable to his station for meditation and the saying of the daily office. Even when traveling, as George Cavendish recorded, Wolsey tried to spend part of his day in a garden:

> And that done, he went to mass and said his other divine service with his chaplain, as he was accustomed to do. And then he went straight into a garden, and after he had walked the space of an hour or more and there said his evensong, he went to dinner and supper all at once. Making a small repast, he went to his bed to take his rest for that night.[17]

In similar but perhaps more personal fashion, More himself would have seen his Chelsea garden simply as a quiet setting for private reflection.

At other times, however, the strategic uses of these gardens were determined by their location near the Thames, with easy access by water for visitors, whether they came primarily for personal or for business reasons. At Lambeth Palace, for example, in the same garden where More had seen his merry behavior in 1534 while walking with other clergy, Hugh Latimer would report, some fifteen years later:

> I walk in the Garden looking at my book, as I can do but little good at it. But something I must needs do to satisfy the place. I am no sooner in the Garden and have read awhile but by-and-by cometh there someone knocking at the gate. Anon cometh my man and saith, "Sir, there is one at the gate would speak with you."[18]

More would have sympathized, no doubt, particularly after 1529, when petitioners made frequent calls at Chelsea to see the Lord Chancellor.

A number of these Chelsea visitors, however, came there unwillingly. Indeed, they were brought there by force, made to become participants in what for many today represents the sorest episode of More's political career, that of his intentional and zealous

pursuit of heretics. Between 1530 and 1532, as records make clear, More's Chelsea house and garden estate became the scene frequently for interrogation of people accused of heretical thought and practices. Although biased in the narratives of such captive ordeals, John Foxe in his *Book of Martyrs* also asserted that some suspects, in addition, had been beaten in More's garden and held there in stocks, a claim that More had denied strenuously at the time it was first made.[19] The accused included people from many different strata of society, such as the trader George Constantine, charged with being a "carrier of forbidden books," as was the leather-seller John Tewkesbery, who subsequently was put to death, and James Bainham, a lawyer educated at Gray's Inn and a member of the Stationers' Company, who suffered a similar fate.[20] A frequent visitor to Chelsea in all such inquisition was the Bishop of London from nearby Fulham, John Stokesley.[21] A sense of such an ordeal is recorded by one survivor, John Field, when he brought suit against More, Stokesley, and Stephen Gardiner (Bishop of Winchester), charging that

> the day after Twelfth Day 22 Henry VIII, Sir Thomas More, then being Lord Chancellor, had the petitioner, with others, brought to his place in Chelsea, and there kept them for 18 days, then set him at liberty, taking bonds for his appearance in the Star Chamber eight days after, i.e., Candlemas Eve. He was then sent to Fleet [prison], where he remained till Palm Sunday two years after.

When Field was finally freed from the Fleet, as the petition goes on to note, More, now no longer Chancellor, along with Stokesley and Gardiner, still had the power to remand him to Marshalsea prison.[22]

In explanation of these actions against heretics, More would write to Erasmus in 1533, defending his thinking at the time. Noting that he had recently written his Epitaph (still to be seen in Chelsea Old Church), More confided that he had done so because "I considered it my duty to protect the integrity of my reputation." He then went on to add:

> As to the statement in my Epitaph that I was a source of trouble for heretics – I wrote that with deep feeling. I find that breed of men absolutely loathsome, so much so that, unless they regain their senses, I want to be as hateful to them as anyone can

possibly be; for my increasing experience with those men frightens me with the thought of what the world will suffer at their hands.[23]

What is perhaps most revealing about this period in More's life is his turn away from what he once might have called the merry rhetoric of garden exchange as a way of "influencing things indirectly." To the contrary, More now increasingly had become what Tyndale called him, a man who "biteth, sucketh, gnaweth, towseth and mowseth Tyndale," or, to use Peter Ackroyd's description, a man "who epitomised, in modern terms, the apparatus of the state using its power to crush those attempting to subvert it."[24] During this bitter period of his life, More's betrayal of his past success is perhaps best seen in his feverish writing at Chelsea, which came to dominate much of his free time, especially his *Confutation of Tyndale's Answer*, a dialogue of quite staggering length, of more than 500,000 words, written often at night "by candlelight in his library at Chelsea." That the *Confutation* was conceived as a dialogue between More and Tyndale, full of wit and repartee, hearkens back to the earlier mode of garden protocol among intimates engaging in political debate. But unlike that carefully crafted exchange, this dialogue is everywhere also full of spleen and destructive argument, as seen, for example, in the following lines:

> WILLIAM TYNDALE: Marke whyther yt be not true in the hyest degree . . .
> THOMAS MORE: Tyndale is a great marker. There is nothynge with hym now but marke, marke, marke. It is pytye that the man were not made a marker of chases in some tenys playe.

Or:

> WILLIAM TYNDALE: Iudge whyther yt be possible that any good sholde come oute of [common people's] domme ceremonyes and sacramentes.
>
> THOMAS MORE: Iudge good crysten reader whyther yt be possyble that he be any better than a beste oute of whose brutyshe bestely mouth, commeth such a fylthye fome.[25]

The irony that such dramatic exchange was written down in silent isolation can only be heightened by the writer's locale, More's study in his beloved Chelsea garden.

Unlike the Garden of Eden or even those of *Utopia*, the gardens of More's London can be said to have been self-consciously constructed, tipped toward what was thought to be at the time an ideal of human interaction based on reason, defensible pleasure, and conservative stability. What they were not equipped for was radical social and cultural change. Indeed, even as such idealized sites continued to be designed for their owners' pride and pleasure, they were increasingly to become instead, as most dramatically seen in More's garden, places of social irony.

By 1532 More's star had set, his estrangement from the king and the king's intention to control the English Church for the sake of Anne Boleyn finally leading More to resign as Lord Chancellor. It is perhaps most ironically fitting that this formal surrender of office to Henry VIII should have taken place in a garden. Among the State Papers a record of their meeting survives, dated 5 June 1532:

> Memorandum that on the 16th May 24 Henry VIII, the Great Seal being in the custody of Sir Thomas More, chancellor of England, enclosed in a white leather bag sealed with his seal, was delivered into the King's hands in the garden at York Place by Westminster, about 3 o'clock p.m., in the presence of Thomas duke of Norfolk.[26]

In hindsight, further irony still clings to the words of Henry VIII's polite response: "For the service which you before have done me, you will find me a good and gracious lord unto you in any suit which should concern your honour or pertain unto your profit."[27]

With such ritual exchange of words in a garden setting thus ended, More's Thames journey back to Chelsea may have seemed long. But the sanctuary of his own garden lay waiting.

Epilogue The Uses of Garden History

"ALL GHOSTS OF THINGS ARE BEAUTIFUL" run the words of a poem about a garden at the end of its season. Such garden ghosts, seen historically, have become the subject of this book, whose argument has been that the long lost riverside gardens of early Tudor London and the values they embodied are most clearly defined for the modern reader when they are examined in the context of the political and social history bracketed by Thomas More's lifetime. Yet the ghosts remain. They remind us, if we allow them to, how variously we choose to witness the past. One final question thus demands attention, whether garden history of More's era can in its own right serve other sorts of enquiry, shedding additional light on the transitional world of England, in particular of London, during the late fifteenth and early sixteenth centuries? More important, does it have something new to say about the character of this period's most enigmatic citizen? In partial answer, one can look at three texts More wrote that seem to pertain.

The first of these dates from the autumn of 1504 and comes from a letter that More wrote to his friend John Colet, who had just been named Dean of St. Paul's. At the time, More was at the beginning of his career, within a few months of his first marriage, to Jane Colt. None of his children was yet born, nor was there yet any idea of a satiric book to be written on English society. His world, it would seem, was full of promise. Yet in his letter to Colet, who was detained in the country and had not returned to London, More offers an unexpected characterization of city and country life. Indeed, the London he depicts, although couched in exaggeration, is a far cry from the idealized picture he would be presenting in *Utopia* ten years later (see Introduction):

[I]n the city what is there to move one to live well? but rather, when a man is straining in his own power to climb the steep path of virtue, it turns him back by a thousand devices and sucks him back by its thousand enticements. Wherever you betake yourself, on one side nothing but feigned love and the honeyed poisons of smooth flatterers resound; on the other, fierce hatreds, quarrels, the din of the forum murmur against you. Wherever you turn your eyes, what else will you see but confectioners, fishmongers, butchers, cooks, poulterers, fishermen, fowlers, who supply the materials for gluttony and the world and the world's lord, the devil? Nay even houses block out from us I know not how large a measure of the light, and do not permit us to see the heavens. And the round horizon does not limit the air but the lofty roofs. I really cannot blame you if you are not yet tired of the country where you live among simple people, unversed in the deceits of the city; wherever you cast your eyes, the smiling face of the earth greets you, the sweet fresh air invigorates you, the very sight of the heavens charms you. There you see nothing but the generous gifts of nature and the traces of our primeval innocence.[1]

A second text dates from 1516, again part of a letter, this one to Erasmus, More's friend of more than fifteen years, in which he talks about Cuthbert Tunstall's reaction to *Utopia*. Again, the tone is one of witty excess:

Master Tunstal recently wrote me a most friendly letter. Bless my soul, but his frank and complimentary criticism of my commonwealth has given me more cheer than would an Attic talent. You have no idea how thrilled I am; I feel so expanded, and I hold my head high. For in my daydreams I have been marked out by my Utopians to be their king forever; I can see myself now marching along, crowned with a diadem of wheat, very striking in my Franciscan frock, carrying a handful of wheat as my sacred scepter, thronged by a distinguished retinue of Amaurotians, and, with this huge entourage, giving audience to foreign ambassadors and sovereigns; wretched creatures they are, in comparison with us, as they stupidly pride themselves on appearing in childish garb and feminine finery, laced with that despicable gold, and ludicrous in their purple and jewels and other

empty baubles. Yet, I would not want either you or our friend, Tunstal, to judge me by other men, whose character shifts with fortune. Even as heaven has decreed to waft me from my lowly estate to this soaring pinnacle which, I think, defies comparison with that of kings, still you will never find me forgetful of that old friendship I had with you when I was but a private citizen. And if you do not mind making the short trip to visit me in Utopia, I shall definitely see to it that all mortals governed by my kindly rule will show you the honor due to those who, they know, are very dear to the heart of their king.[2]

Finally, there is the text of yet another letter, this one to Peter Giles, his friend in Antwerp, at whose house More had conceived of *Utopia*. Written shortly after the letter to Erasmus, the message here is one of complaint about pressures on his time:

Most of my day is given to the law — listening to some cases, pleading others, compromising others, and deciding still others. I have to visit this man because of his official position and that man because of his lawsuit; and so almost the whole day is devoted to other people's business and what's left over to my own; and then for myself — that is, my studies — there's nothing left.

For when I get home, I have to talk with my wife, chatter with my children, and consult with the servants. All these matters I consider part of my business, since they have to be done unless a man wants to be a stranger in his own house. Besides, a man is bound to bear himself as agreeably as he can toward those whom nature or chance or his own choice has made the companions of his life. But of course he mustn't spoil them either with his familiarity, or by overindulgence turn the servants into his masters. And so, amid these concerns, the day, the month, and the year slip away.

What time do I find to write, then?[3]

Although the face value of all three of these documents must be measured both by the immediate context of their writing as personal letters and more generally by More's habitual play of rhetoric as a writer, yet their very exaggeration tells us something about the man behind the character these letters present. All three date from More's life in London, not in Chelsea, and therefore prefigure the family's

remove to the country and perhaps even their plans to do so. Seen in hindsight once that move had occurred, however, these documents suggest that setting up a new life in a rural garden estate may not in the long run have been for More a healthy choice, given the proclivities of his mind and ambition.

Not all gardeners later in More's employ, for example, would have appreciated being passed off, even in rhetorical jest, as "simple people, unversed in the deceits of the city," nor would they have seen the fields and gardens they so skillfully created for him as evidence of "the generous gifts of nature and the traces of our primeval innocence." For them, Chelsea was not Eden, nor was nature a gift. The activity of More's mind, of course, can not be reduced to the simple expression of a rhetorical formula. He was no foolish thinker. And yet his view of the natural world throughout his life, it seems, was affected by the stamp of his Christianity, and there is probably some truth about him to be learned by his desire to see nature in post-Edenic terms, part of a commitment to the Church's traditional view of a fallen world, whose history thus is to be seen as a story that must finally end. More's move to Chelsea may eventually have made such a narrative harder to hold on to, given both the practical realities of daily life on a developing country estate and the miracle of its soil's annual renewal.

The letter to Erasmus is further revealing in its playful depiction of More as chosen king of Utopia. Although written in merry jest with an irony that Erasmus especially would have appreciated, the document nonetheless suggests a relentless ego that seems to have characterized More's entire life. As a private citizen among the grandees of Church and State, he could take rightful pride in his achievements. He also showed how well he could compete in a society marked by established privilege. Yet the move to Chelsea, for all the equal footing it afforded him, may have gradually altered the balance of his common sense, allowing him quite literally to become "lord of the manor," to deleterious effect. His gardens were second to none in sophistication and beauty, although presented always in a self-styled modesty that wittily poked fun at his intimates, including Wolsey and the king, all of whom were much given to "childish garb and feminine finery, laced with that despicable gold, and ludicrous in their purple and jewels and other empty baubles." Such public success in competing with friends, however, seems to have

come at a price in his more private relations with his family and household, particularly after 1532.

In the past, much was written about More's Bucklersbury and subsequently his Chelsea establishments as models of Christian educational and intellectual values in a familial setting. For many of More's admirers there is a good deal to recommend this view, particularly as noted even as late as 1532, when Erasmus wrote in a letter describing More's Chelsea world (but only through the report of others, such as Holbein):

> You would say that Plato's Academy had come to life again [there]. But I wrong More's home in comparing it to Plato's Academy, for in the latter the chief subjects of discussion were arithmetic, geometry and occasionally ethics, but the former rather deserved the name of a school for the knowledge and practice of the Christian faith.[4]

Especially in his daughter Margaret, perhaps his nearest intellectual equal, and in the end his chief confidante, More, it would seem, found his educational ideals most fully realized. Always concerned that "Margaret's lofty and exalted character of mind should not be debased," More for most people today represents an enlightened view of women's right to learn.[5]

Yet More always must have lived with those closest to him in a position of authority, benevolent but with a distance maintained, as the letter to Peter Giles attests. His was a paternalism common to the age, at times commendable (as noted above in the context of his letter to Dame Alice), but nonetheless isolating. Again, the move to Chelsea may have served to encourage such authority and isolation, finally in damaging ways.

Perhaps most revealing about More in his letter to Giles is its complaint that business and family life leave too little time for study: "What time do I find to write, then?" The problem always for a man of More's intellectual stature was that of striking a balance amidst conflicting demands of family life, of action in the world and of equally important mental activity as thinker and writer. To what extent, one must therefore ask, did his life in Chelsea gradually upset that balance, one that he had managed to keep throughout most of his adult life? Here again, his garden's history is revealing. More appears early on to have created a special place for personal retreat

in the garden layout, as Roper's account describes (see p. 80 above). In *A Dialogue of Comfort against Tribulation*, written while More was a prisoner in the Tower, he would recite the need for a man to choose just such a "secret solitary place in his own house as far fro noyse & companye as he conveniently can" wherein he might "some tyme secretely resort alone ymagynyng hym selfe as one goyng out of the world."[6]

Did the opportunity for such isolated privacy in his garden eventually serve to alienate More, especially after his resignation of the Chancellorship in 1532? Refusing any longer to pursue an active public life (to which he had committed so much of his career), he had retreated back to Chelsea in order to engage the world of politics and morality as a full-time writer. But it was not a successful trade-off. Perhaps no one of More's temperament, with its need for public discourse, could live for long in a garden redoubt (which his library became) in such an intensely personal way without a toll ultimately taken. Again, Chelsea was no Eden or utopian ideal. Nor was it a sanctuary where More could stand in stubborn but lonely opposition to Henry VIII's Act of Supremacy over the Church, or now, to the Act of Succession. For the king, More was too prominent a man to be ignored. A day of reckoning had to come.

More's isolation – and with it, his seeming estrangement – may be seen in his final leave-taking from his family in 1534, his resolve still inexplicable to them, even as they walked together that April day through the Chelsea garden towards the river, where his boat waited to take him to Lambeth for his fateful interrogation by the Royal Commissioners. Again, Roper reports the scene:

> And whereas he evermore used before at his departure from his wife and children, whom he tenderly loved, to have them bring him to his boat, and there to kiss them all and bid them farewell, then would he suffer none of them forth of the gate to follow him, but pulled the wicket after him, and shut them all from him. And with an heavy heart, as by his countenance it appeared, with me and our four servants there took he his boat towards Lambeth. Wherein sitting still sadly a while, at last he suddenly rounded me in the ear, and said, "Son Roper, I thank our Lord, the field is won." What he meant thereby I then wist not, yet loath to seem ignorant, I answered, "Sir, I am thereof glad." But as I conjectured

afterwards, it was for that the love he had to God wrought in him so effectually that it conquered all his carnal affections utterly.[7]

More's dissociation would seem complete, already "a stranger in his own house."

What then does garden history have to say about More and about the world he inhabited? It seems to suggest, first of all, how separated he finally became from his fellow garden owners. From the outset, his Chelsea garden, like theirs, had been deliberately created to be far more than a pleasing amenity for a riverside property. In an early Tudor world in love with magnificence, display, and showy splendor, each was meant to serve as an outward token of one's renown. Designed as much for strategic as for aesthetic purposes, a garden thus became a means to express affinity with other powerful men, those charged with running London's entrenched institutions, the Monarchy, the Church, and the Parliament, as well as the Corporation of London. These riverside gardens, moreover, because they were artfully defined spaces set apart from an unruly urban world, were ideally suited to become playing fields in an elaborate game of statecraft. As such, they could when needed serve as ritual places for men's artful interplay of language in a highly political contest. More was a master at such verbal contest, especially when at home in his Chelsea garden. By resigning his office as Chancellor in 1532, however, he had in effect chosen to close his house and garden and to reject his colleagues' tourney, refusing any longer to participate. With his prominence still undiminished, More thus became in the end his coterie's political spoiler.

Garden history also seems to suggest a way to judge More and his increasing isolation from his family and household, one that his gardeners would well have understood. For them, one might argue, a garden was a place of rewarding definition and therefore served ultimately as a *memento vivere*, a reminder of life and its pleasures, to be valued because so fleet and mutable. Originally, More would have appreciated such an idea, given his delight in "gardens productive and elegant" and what would today be called his welcoming response to life and the open gifts of his mind. Yet in his later years, More was to change. For him Chelsea had also altered. At the last it was to become a far different setting, a place of withdrawal and even, finally, a kind of personal Gesthemene, serving now as a

memento mori, a reminder of life's end and destination. It is revealing that the last work More composed, left unfinished among his papers at the Tower, was *De tristitia Christi*, a meditation on Christ's solitude and betrayal, in a garden. Thus in the end, More apparently chose to say "no more" to his life as it had been. Always the strong and leading participant in whatever he set his mind to, he had elected instead, it seems, to enter into the morality play he saw as the necessary and ultimately overriding drama of his time, his self-assigned role now that of exemplary everyman, welcoming at last his true King's reckoning.

A final word must be left to those many gardeners at work in London during More's lifetime. Now all but forgotten, as is their garden enterprise, they still might assert if they could what every gardener soon discovers, that there is a time and a season for all things under the sun. And this is sufficient – a truth as plain to see as the garden dirt on your hand or as simple as the flower that finally forms and then fades. Unfortunately, to find human satisfaction here, in a world defined by a garden's time and season, was for More never enough, captured as he was by "the love he had to God wrought in him."

Notes

Introduction Gardens Productive and Elegant

1 For many people, More is best remembered in terms of his uniquely powerful relationship with Henry VIII, and especially for his intellectual and political support of the king during the 1520s. At the time, the two were collaborators, organizing English opposition to the reformist ideas of Martin Luther. For such effort and service, Pope Leo X was to award Henry the title "Defender of the Faith." More continued to enjoy the king's confidence, with Henry choosing his own singular honor for More by naming him, in 1529, as his Lord Chancellor, the first lay person to hold that high office. Even so, their long friendship was already in jeopardy. The breach had begun two years earlier, when the king had approached More with the topic of ending his marriage to Catherine of Aragon, who had produced no male heir to the throne. More, however, declined to support in any public way Henry's wish to annul the marriage, and he remained steadfast in this refusal. Undeterred, the king continued, even without More's accustomed help. After the Pope denied the annulment, Henry finally forced the issue, both with the Church establishment and with Parliament, ultimately gaining royal supremacy over the Church in England. In silent opposition to such an unacceptable challenge to traditional ecclesiastical authority and independence, More chose to resign the chancellorship in 1532. The break between the two men was complete.

In January 1533, the king and Anne Boleyn were finally married; by May, Thomas Cranmer, Henry's new archbishop of Canterbury, had annulled the king's marriage to Catherine of Aragon; and by June, Anne Boleyn was crowned queen. Then, in March 1534, Henry won a Parliamentary Act of Succession, whereby the inheritance of the Crown was settled on the king's sons produced by Anne, or by a subsequent wife. The Act also contained a provision that any subject might be required to affirm by sworn oath "the effects and contents" of the Act. To ensure this end, a Royal Commission was soon established to take the oaths of various people. Most prominent among them was More, who was brought to Lambeth Palace in April 1534, to appear before the commission members. Upon his refusal to take the oath, More was remanded, shortly thereafter, to custody at the Tower, where he remained a prisoner until 1 July 1535, when he was finally brought to trial in Westminster, charged with treason for denying the Act of Succession. Found guilty, he was executed on Tower Hill on 6 July.

For debate about More's character, see, for example, Alistair Fox, *Thomas More: History and Providence* (New Haven and London: Yale University Press, 1983); Louis L. Martz, *Thomas More: The Search for the Inner Man* (New Haven and London: Yale University Press, 1990); Peter Ackroyd, *The Life of Thomas More* (New York: Random House, 1999); John Guy, *Thomas More* (London: Hodden Headline, 2000).

2 Fox, p. 56.

3 This depiction of row houses is reminiscent of the location of More's own house, called Old Barge, which he rented from the Mercers shortly after his marriage in 1505 and where he lived for the next twenty years. Sited at the end of Bucklersbury, off Cheapside, directly across from St. Stephen Walbrook, the house, built of stone, had a garden to the rear abutting other gardens that ran behind the neighboring row of houses. It was in this Bucklersbury garden that More gently expostulated with his daughter Margaret over her husband William Roper's interest in Lutheran doctrines. See Ackroyd, pp. 120–21, 231. See also pl. 110.

4 The Elizabethan antiquarian John Stow was perhaps the first to raise the question, and in answer he noted that More's description "doth in every particular thing so exactly square and correspond with our city of London that I make little doubt that writer did thereby mean the same place." Quoted by Mildred Campbell, *The Utopia of Sir Thomas More* (Roselyn, NY: Walter J. Black, 1947), p. 77, ftn. 3.

It is important to note that uses of the term "City of London" refer only to the historic jurisdiction area of the Corporation of London, which, during More's lifetime, consisted of twenty-four wards within the roughly square mile bounded by the City's roman walls, and a twenty-fifth ward, called Farringdon Without, lying to the west of the walled city, bounded by Charterhouse Street and Holborn, running nearly to Chancery Lane, on the north side, and extending along the Thames to the Inns of Court, on the south side. Temple Bar, standing in the roadway at the point Fleet Street becomes the Strand, marks one of the original western boundaries of the City. With only slight changes, this jurisdiction area still remains today as the principal domain of the City of London.

5 The translation of these passages is that made by Robert M. Adams, *Utopia* (New York: Norton, 1975), See pp. 35–36.

6 Adams, p. 40.

7 For most people who have seen it, this drawing by Hans Holbein, made *circa* 1527, best captures in the arrested moment of the sitters their family solidarity in Chelsea. More is at the center, age 50, his father to his right, age 76, and to his far left his second wife, Dame Alice. The children surround the tableau, with Elizabeth Dauncey, age 21, to More's far right. Next to her stands More's adopted daughter, the brilliant Margaret Gigs, pointing to a passage in a book. Between More and his father is Anne Cresacre, More's ward and subsequently the wife of his son John, age 15, to More's immediate left. Next to John stands More's fool, Henry Patenson, age 40, and at his feet kneels Cecily Heron, age 20. In pride of place in the foreground is More's favorite child, his beloved Margaret Roper, age 22.

A further sense of the family's bond may be heard in Dame Alice's words to More while he was imprisoned in the Tower, shortly before his death in 1535, as reported by William Roper. See A. L. Rowse, ed., *A Man of Singular Virtue* (London: Folio Society, 1980), p. 84: "What the good year, Master More," quoth she, "I marvel that you, that have been always hitherto taken for so wise a man,

will now so play the fool to lie here in this close, filthy prison, and be content thus to be shut up amongst mice and rats, when you might be abroad at your liberty. And with the favour and good will both of the King and his Council, if you would but do as all the bishops and best learned of this realm have done. And seeing you have at Chelsea a right fair house, your library, your books, your gallery, your garden, your orchard and all other necessaries so handsome about you, where you might in the company of me your wife, your children and house-hold be merry, I muse what a God's name you mean here still thus fondly to tarry."

After he had a while quietly heard her, with a cheerful countenance he said unto her, "I pray thee, good Mistress Alice, tell me one thing." "What is that?" quoth she. "Is not this house," quoth he, "as nigh heaven as my own?"

8 Cf. Roper's account of such a garden exchange:

> Then took Sir Thomas More his boat towards his house at Chelsea, wherein by the way he was very merry, and for that I was nothing sorry, hoping that he had got himself discharged out of the Parliament bill. When he was landed and come home, then walked we twain alone in his garden together, where I, desirous to know how he had sped, said, "I trust, sir, that all is well because you be so merry."
>
> "It is so indeed, son Roper, I thank God," quoth he.
>
> "Are you then put out of the Parliament bill?" said I.
>
> "By my troth, son Roper," quoth he, "I never remembered it."
>
> "Never remembered it, sir," said I, "a case that toucheth yourself so near, and us all for your sake! I am sorry to hear it, for I verily trusted, when I saw you so merry, that all had been well."
>
> Then said he, "Wilt thou know, son Roper, why I was so merry?"
>
> "That would I gladly, sir," quoth I.
>
> "In good faith, I rejoiced, son," quoth he, "that I had given the devil a foul fall, and that with those lords I had gone so far, as without great shame I could never go back again."
>
> At which words waxed I very sad, for though himself liked it well, yet liked it me but a little.

> Rowse, p. 76.

9 Adams, p. 7.

10 Ackroyd, p. 140. See also CLRO, MS BHA, vol. 5 (1509–25), fols. 100v, 123v, 163. Even as late as 1521 More and his father continued legal work for the Bridge House Estates. See fol. 226. See also chapter IV.

11 Gordon Home, *Old London Bridge* (London: John Lane, 1931), pp. 151–52.

12 Jeremy Ashbee, "A Mediaeval Garden at the Tower of London," *London Gardener*, V (1999–2000), pp. 11–14; Ackroyd, p. 366.

13 Rowse, p. 42.

14 Ackroyd, pp. 313, 329.

15 See William Roper's account: "This Sir Thomas More – after he had been brought up in the Latin tongue at St. Anthony's in London – was by his father's pro-curement received into the house of the right reverend, wise and learned prelate, Cardinal Morton. Where, though he was young of years, yet would he at Christmas-tide suddenly sometimes step in among the players, and never study-ing for the matter, make a part of his own there presently among them, which made the lookers-on more sport than all the players beside. In whose wit and

towardness the Cardinal much delighting, would often say of him unto the nobles that divers times dined with him, 'This child here waiting at the table, whosoever shall live to see it, will prove a marvellous man.'" Rowse, pp. 27–28.

16 Adams, p. 11.

17 Ackroyd, p. 151.

18 More's own account of this episode survives in a letter to his daughter Margaret. See Rowse, pp. 117–20; cf. p. 118.

19 One of the king's visits is extensively reported by Roper. See Rowse, p. 44. See also chapter v, for discussion of this royal visit.

20 Cf. More's comments on Tunstall in *Utopia*: "I was companion and associate to that incomparable man Cuthbert Tunstall, whom the King has recently created Master of the Rolls, to everyone's great satisfaction. I will say nothing in praise of this man, not because I fear the judgment of a friend might be questioned, but because his learning and integrity are greater than I can describe and too well-known everywhere to need my commendation – unless I would, according to the proverb, 'Show the sun with a lantern.'" Adams, p. 5.

21 Ackroyd, p. 300.

1 Eight London Gardens on the River Thames

1 Only three of the copper map-plates survive. For discussion of all these maps, see Ann Saunders and John Schofield, eds., *Tudor London: A Map and a View* (London: London Topographical Society/Museum of London, 2001), pp. 34–35; Adrian Prockter and Robert Taylor, eds., *The A to Z of Elizabethan London* (Lympne Castle, Kent: Harry Margary, 1979).

2 William Harrison, *The Description of England*, ed. Georges Edelin (Washington, DC: Folger Library/Dover, 1994), p. 422.

3 See Laura Wright's rewarding and valuable study, *Sources of London English* (Oxford: Clarendon Press, 1996).

4 See W. E. Sykes, "The River Thames," in *Transactions of the Guildhall Historical Association*, ii (London: privately printed, 1957), pp. 91–101.

5 See C. Paul Christianson, "Movable Feasts on the River Thames," *Petits Propos Culinaires 71* (Totnes, Devon: Prospect Books, 2002), pp. 16–32.

6 Martha Carlin, *The Urban Development of Southwark, c. 1200 to 1550*, unpublished PhD dissertation, University of Toronto, 1983, p. 355.

7 The repository of these weekly and annual accounts is the Corporation of London Records Office. Chief among these documents are the following: ms Bridgemasters' Account Rolls, 17 rolls (1381–1405); ms Bridge House Accounts [BHA], vols. 1–52 (1404–1829); ms Expenditures of the Bridge [BHE], ser. 1–3 (1404–45, 1505–38, 1552–1741).

8 *Facsimile of the First Volume of the Manuscript Archives of the Worshipful Company of Grocers [1428–63]*, 2 vols., ed. J. Abernathy Kingdon (London: privately printed, 1886).

9 "To Raufe Colleyns gardyner for cuttyng and byndyng of vynes wtin the gardeyn at the brigge house this yer – ijs viijd To hym for xxxiiij dayes and a halfe takyng by every daye viijd Richard Wright by ix dayes and Edward ffitton by ij daies eu[er]y of them takyng by the daye vjd workyng in drawyng of knottes and borders Delving setting and sowyng wythin the said gardeyn thys yere Sum xxviijs vjd To Mother Tubbys and Willyam Hewet for wedyng in the said gardeyn this

yere vs iiijd To Thomas Causy for sedys for the same gardeyn xxd To the said Raufe for a Baskett polys and roddys for the said gardeyn xvjd To Richard Wassher for castyng skoryng and clensyng of a ponde wtin the berehouse nexte vnto the brigge house in Suthwerk at tax vs."

10 The daily wages used as a measure nationally by Christopher Dyer, *Standards of Living in the Later Middle Ages*, rev. edn. (Cambridge: Cambridge University Press, 1998), p. 215.

11 Cf. his comments on the raising of vegetables: "from Henry the Fourth till the latter end of Henry the Seventh and beginning of Henry the Eight there was little or no use of them in England, but they remained either unknown or supposed a food more meet for hogs and savage beasts to feed upon than mankind. Whereas in my time their use is not only resumed among the poor commons – I mean of melons, pompions, gourds, cucumbers, radishes, skirrets, parsnips, carrots, cabbages, navews, turnips and all kind of salad herbs – but also fed upon as dainty dishes at the tables of delicate merchants, gentlemen, and the nobility, who make their provision yearly for new seeds out of strange countries, from whence they have them abundantly." See Harrison, p. 264.

Harrison's claims have been challenged as too restrictive by recent studies of late medieval diet. See Dyer, *Standards of Living*, pp. 158–60, and his "Did the Peasants Really Starve in Medieval England?," in *Food and Eating in Medieval Europe*, ed. Martha Carlin and Joel T. Rosenthal (London and Rio Grande: Hambledon Press, 1998), pp. 53–72; see also Charles Quest-Ritson, *The English Garden: A Social History* (London: Viking, 2001), p. 37.

12 Charles Welch, *History of the Tower Bridge* (London: Smith, Elder, 1894), pp. 102–03.

13 John Stow, *A Survey of London*, ed. Henry Morley (Stroud: Alan Sutton, 1994), pp. 126–27. Cf. "For iij poundes Mydsomer candell expended within the Brigge-hous gate and in the Porters logge vd [1483]"; "for a pottell of lamp oyle lampes weiers bowes and flowers at the bridgehous gate . . . at the fest of mydsomer xvjd [1497]"; "to the Porter for birche ffennell and floures for the bridgehous gate at the fest of mydsomer iiijd [1507]" (BHA, vol. 3 [1460–84], fol. 387r; vol. 4 [1485–1509], fol. 187; BHE, ser. 2 [1505–15], fol. 49v).

14 In later years 20d was paid quarterly to the Westminster clockman Brise Augustyn "for kepinge of the clocke." Augustyn was also employed by Henry VIII at Hampton Court, supplying twenty sundials in June 1534, for the king's new privy garden. Additional duties, after 1540, involved maintenance of the great astronomical clock in the palace's inner courtyard.

15 CLRO, *Comptroller's Bridge House Plan*, 202/5 c. 1750 1/100. Cf. 205/10 c. 1772.

16 During this tenure, Hasylfote was also renting a shop on the bridge, on the "principall west part," at the substantial annual rate of £6 6s 8d.

17 By 1657, for example, the Bridge House gardens were featuring mown box-edged "grass platts" and "grass knots," then coming into favor at Hampton Court; by 1714 there were "Inke roats" (*Statice limonium*) and by 1727 "Assareans" (*Antirrhinum asarina*), plants only recently introduced into England.

18 See John Harvey, *Early Nurserymen* (London: Phillimore, 1974), p. 40; Harvey, "The Medieval Garden before 1500," in *The Garden: A Celebration of One Thousand Years of British Gardening*, ed. John Harris (London: Victoria and Albert Museum, 1979), pp. 6–11, esp. p. 9.

19 Jeremy Ashbee, "A Mediaeval Garden at the Tower of London," *London Gardener*, v (1999–2000), p. 11.

20 *Cal. Pat. Rolls, Henry VII*, ii (1494–1509), p. 14.

21 Ashbee, p. 11.

22 Simon Thurley, *The Royal Palaces of Tudor England* (New Haven and London: Yale University Press, 1993), pp. 27–34.

23 G. Kipling, ed., *The Receyt of the Ladie Kateryne* (Oxford: Oxford University Press/EETS, 1990), p. 73, cited in Thurley, *Royal Palaces*, p. 31.

24 *Passetime of Pleasure; or, The Historie of Graunde Amoure*, cited in Robin Whalley and Anne Jennings, *Knot Gardens and Parterres* (London: Barn Elms, 2000), p. 30.

25 *Cal. Pat. Rolls, Henry VII*, ii (1494–1509), pp. 54, 347, 484; *LP Henry VIII*, i (1509–13), pp. 5, 111, 473; *LP Henry VIII*, v (1531–32), p. 760.

26 See, for example, *LP Henry VIII*, vii (1533), pp. 2–5; see also Edward Impey and Geoffrey Parnell, *The Tower of London: The Official Illustrated History* (London: Merrell, 2000), pp. 51–52.

27 J. C. Dickinson, *An Ecclesiastical History of England: The Later Middle Ages* (London, 1979), p. 47, cited in Mark Page, *The Medieval Bishops of Winchester: Estate, Archive and Administration* (Winchester: Hampshire County Council, 2002), p. 2.

28 Much of the information in this section is drawn from the landmark study of Southwark history done by Martha Carlin. See her *Medieval Southwark* (London and Rio Grande: Hambledon Press, 1996), and "The Reconstruction of Winchester House, Southwark," *London Topographical Record*, CXXII (1985), pp. 33–57.

29 Carlin, "The Reconstruction of Winchester House," pp. 46–47; see also her *Medieval Southwark*, p. 43.

30 Carlin, *Medieval Southwark*, p. 44. Part of the manor's administration involved prison housing, first located in the great outer court south of the Privy Garden but by More's time moved nearer the river, to the west of the Great Hall, there to achieve notoriety as the Clink Prison. Even in Chaucer's day, the bankside area of the manor had become famous for its brothels ("Stews"), London having outlawed prostitution in 1383; by 1506 the number of Southwark brothels had grown to eighteen, most of them within the Winchester manor area and therefore of necessity to be regulated by the manor's bailiff, steward, and constables. See pp. 213–19. Because of this association, one popular term for these prostitutes was "Winchester geese."

31 Hampshire Record Office, Bishopric of Winchester Pipe Rolls: 11 M 59/222–235.

32 PRO, E36/236, E36/251, E36/252.

33 Simon Thurley, *Whitehall Palace: An Architectural History of the Royal Apartments, 1240–1690* (New Haven and London: Yale University Press, 1999); Thurley, *The Lost Palace of Whitehall* (London: RIBA British Architectural Library Drawings Collection, 1998); Thurley, *Royal Palaces*. See also Roy Strong, *The Artist & the Garden* (New Haven and London: Yale University Press, 2000).

34 Oxford, Bodleian Library, MS Vet. E. l, b. 6–7.

35 Cf. ibid.; London, British Library, MS Royal 14 B. IV B; Oxford, Bodleian Library, MS Eng. Hist. b. 192/1, fol. 1. A German visitor, Lupold von Wedel, was to describe the Great Garden in 1584: "From there we walked into the Queen's garden. In it there are thirty-four high, painted various animals of wood, with gilt horns placed upon columns. On these columns are, further, banners with the Queen's coats of arms. In the centre of the garden is a beautiful fountain and thereto a large gnomon which shows the hours in thirty different ways. Between the herbaceous plants that are set in the garden there are beautiful, pleasant grassy walks. The plants are artistically set out in various ways and surrounded by hedges trimmed

in the form of seats. By this garden there is an orchard beneath whose trees fragrant herbs are planted." Cited in Thurley, *Whitehall Palace*, p. 74.

36 Harvey, *Early Nurserymen*, p. 30

37 PRO, E36/251, pp. 286–69, E36/252, pp. 355–56, 472.

38 PRO, E36/251, p. 17. Later that year, on 26 August 1532, the records further show payments to Thomas Swallow and John Laurence of Westminster for hauling "Rubisshe and Erthe oute of the grounde appoyntid for an Orcheyard and a gardeyn there/for the levellyng of the same togethere with the Cariage of Erthe for the amending of the grounde about a bridge between the said manor and Seynte James in the ffelde within the grounde appoyntid for the forenamed parke, at jd euery lode" (PRO, E36/252, p. 17).

39 George Cavendish, *Thomas Wolsey Late Cardinal his Life and Death* (London: Folio Society, 1962), p. 47.

40 PRO, E36/236, pp. 19, 24, 29, 37, 42, 55, 71.

41 PRO, E36/236, p. 42.

42 PRO, E36/236, pp. 53–54v.

43 *LP Henry VIII*, v (1531–32), pp. 750–51.

44 *Statutes of the Realm*, iii, p. 668.

45 For discussion of these issues, see the important study by Tim Tatton-Brown, *Lambeth Palace: A History of the Archbishops of Canterbury and their Houses* (London: SPCK, 2000); see also Dorothy Gardiner, *The Story of Lambeth Palace: A Historic Survey* (London: Constable, 1930). For detailed study of the conflict between the two men, see Peter Gwyn, *The King's Cardinal: The Rise and Fall of Thomas Wolsey* (London: Barrie & Jenkins, 1990, reprinted 2002), pp. 33–57.

46 Tatton-Brown, p. 56.

47 London, Lambeth Palace Library, MS ED 545; see also Gardiner, p. 32.

48 Lambeth Palace Library, MS ED 572, 574–75, 577.

49 Gwyn, p. 28.

50 Gardiner, p. 115.

51 For discussion of the history of the property, see Randall Davies, *The Greatest House at Chelsea* (London: John Lane, 1914).

52 This miniature and its relation to the Holbein studies of the More family is discussed by Angela Lewi, *The Thomas More Family Group* (London: HMSO, 1974). See also Roy Strong, *Artists of the Tudor Court: The Portrait Miniature Rediscovered, 1520–1620* (London: Victoria and Albert Museum, 1983), pp. 159–61.

53 For discussion of this map and of drawings of the More mansion, see Walter H. Godfrey, "New Light on Old Subjects: Sir Thomas More's House at Chelsea," *Architectural Review* (March 1911), pp. 131–35; (May 1911), pp. 270–75; "The Site of Beaufort House," *LCC Survey of London*, IV (1913), pp. 18–27, plus plates.

54 A. L. Rowse, ed., *A Man of Singular Virtue* (London: Folio Society, 1980), pp. 46–47.

55 Strong, *The Artist & the Garden*, pp. 28–31.

56 Godfrey, p. 271.

57 This is the interpretation also put forward by E. E. Reynolds, *Margaret Roper: Eldest Daughter of St. Thomas More* (London: Burns & Oates, 1960), pp. 44–46.

58 Roger Lee Deakins, trans., *Il Moro: Ellis Heywood's Dialogue in Memory of Thomas More* (Cambridge, MA: Harvard University Press, 1972), pp. 3–5.

59 Reprinted in Davies, p. 44.

60 PRO, E36/257, fol. 55, as cited and discussed in John Guy, *Thomas More* (London: Hodder Headline, 2000), pp. 76–78.

61 Elizabeth Frances Rogers, ed., *St. Thomas More: Selected Letters* (New Haven and London: Yale University Press, 1961), pp. 170–71.

62 John Schofield, *The Building of London from the Conquest to the Great Fire* (London: British Museum/Museum of London, 1984), pp. 136–37; Schofield, *Medieval London Houses* (New Haven and London: Yale University Press, 1994), pp. 150–51.

63 The fullest discussion is found in Sandra Morris, "Legacy of a Bishop: The Trees and Shrubs of Fulham Palace Gardens Introduced, 1675–1713" and "The Flowers of Fulham Palace Gardens Introduced, 1675–1713," *Journal of Garden History*, XIX (1991), pp. 47–58; XXI (1993), pp. 14–23.

64 London, Guildhall Library, MS 10,464, fols. 45v–46v.

65 Warwick Rodwell, *Fulham Palace, London SW6: Archaeological Appraisal and Plan* (London: Borough of Hammersmith and Fulham, 1987–88), pp. 118–19.

66 Cited in David Daniell, *William Tyndale: A Biography* (New Haven and London: Yale University Press, 1994), p. 85.

67 David Daniell, ed., *Tyndale's New Testament* (New Haven and London: Yale University Press, 1989), p. 29.

68 Cited in June Osborne, *Hampton Court Palace* (London: HMSO, 1984), p. 19. See also Simon Thurley, *Hampton Court: A Social and Architectural History* (New Haven and London: Yale University Press, 2003), pp. 15–16.

69 PRO, E36/235, pp. 689–811.

70 The orchard walls were completed over the course of the next three years, as indicated in final payment for the work by James Bettes, Master of the Works for Wolsey. See *LP Henry VIII*, iv (1518–30), 3 parts, p. 1427.

71 Ibid.

72 PRO, E36/237, p. 301.

73 This same record notes payment to More of £159 "for Cuttyng, makyng and karvyng ['in tymber'] of vij (xx) xjx [159 in all] of the Kynges and the quenys beestes stondyng in the Kynges new garden at xxs the pece." Ibid., p. 301.

74 Cited in Roy Strong, *The Renaissance Garden in England* (London: Thames and Hudson, 1979, 1998), p. 24.

75 A point argued by Ernest Law, *Hampton Court Gardens: Old & New* (London: G. Bell & Sons, 1926), pp. 67–68: "The foundations and bases of the enclosing walls [of the Orangery Garden] here are Tudor, and were, doubtless, built by Wolsey. This renders this spot particularly interesting, as his private rooms adjoin, and it must have been down the turret stairs here that he came into this garden."

76 PRO, E36/239, pp. 94–95. Record of the additional payment to Ripley in January of the following year for seven more beasts for the "privie orchard" is noted in Strong, *The Renaissance Garden in England*, pp. 25–27, citing PRO, E36/237, p. 374. In July 1530 other payments were made to "Anthony Clockmaker of Westminster" for "brason dyalles & Reparacion of oon other brokyn in the lytill orchard," for "three newe Iron dyalls . . . in the lytell orchard," and for "the making of a Shadowe for oon of the brokyn dyalls and for a pece of Iron for store at all tymes." See PRO, E36/239, p. 127. These entries suggest that garden dials may already have been a feature in Wolsey's garden. Although Strong argues that the Privy Orchard "seems to have been a preliminary canter for what was to follow, for it is not referred to again in the accounts," he does not suggest that the garden may once have been Wolsey's.

77 Osborne, p. 18.

78 These and other references to construction of these gardens are found in PRO, E36/241.

79 *LP Henry VIII*, v (1531–32), p. 720.

80 Strong, *The Renaissance Garden in England*, pp. 33, 43.

81 David Jacques, "The History of the Privy Garden," in *The King's Privy Garden at Hampton Court Palace, 1689–1995*, ed. Simon Thurley (London: Apollo Magazine, 1995), pp. 23–24.

82 PRO, E36/241, p. 93: "Item to John Herne for Kyllyng of iij molles in the sayd new garden xijd."

83 PRO, E36/241, p. 119; E36/237, p. 61.

84 PRO, E36/241, p. 109.

2 The London Gardeners

1 Robert M. Adams, ed. and trans. *Utopia* (New York: Norton, 1975), p. 88.

2 Cited in Louis L. Martz, *Thomas More: The Search for the Inner Man* (New Haven: Yale University Press, 1990), p. 75.

3 Listed in *LP Henry VIII*, i (1509–13), pp. 5, 111, 422, 465, 473; v (1531–2), pp. 305, 317, 458, 747–52, 755–56, 759–60; vii (1534), p. 559. Cf. chapter 1, n. 25. See also John Harvey, *Early Nurserymen* (London: Phillimore, 1974), pp. 28–30.

4 *LP Henry VIII*, v (1531–32), pp. 751, 755; these are among the first references to the plant recorded in English.

5 PRO, E36/237, p. 19.

6 See Mollie Sands, *The Gardens of Hampton Court* (London: Evans Brothers, 1950), pp. 52–55.

7 Cited in Harvey, *Early Nurserymen*, p. 29.

8 CLRO, MS BHA, vol. 6 (1525–41), fols. 134, 175.

9 Harvey, *Early Nurserymen*, pp. 26, 167–68. See also Harvey, *The Nursery Garden* (London: Museum of London, 1990), p. 1, where he further lists the plant materials that Russell was able to offer: "Among his plants were whitethorn for hedges at 6s 8d the thousand, osiers for making an arbour, cherry, damson, peach and filbert trees at 4d each, damask roses at 1s the hundred, and quantitites of sets of privet, apparently for topiary work, at 4,000 for £1. Aromatic plants were germander, hyssop, lavender, rosemary, sage and thyme; with primroses and violets for the flower garden, along with strawberry roots."

10 See C. Paul Christianson, "The London Gardener: A Tudor-Age Profile," *London Gardener*, VIII (2002–03), pp. 11–26.

11 CLRO, MS BHA, vol. 4 (1485–1509), fol. 233.

12 Brigid M. U. Boardman, "The Gardens of the London Livery Companies," *Journal of Garden History*, II (1982), pp. 85–116; see p. 97.

13 Penelope Hunting, *A History of the Drapers' Company* (London: Drapers' Company, 1989), p. 44. See also Harvey, *Early Nurserymen*, p. 31, who finds ordinary gardeners' payments at a slightly lower rate at the time.

14 See Steve Rappaport, *Worlds within Worlds: Structures of Life in Sixteenth-century London* (Cambridge: Cambridge University Press, 1989), pp. 129–30. See also p. 61, where London's population in 1485 is estimated at not quite 50,000; in 1550 at 70,000.

15 Cawsway's trade location in Houndsditch is established by John Stow, *A Survey of London*, ed. Henry Morley (Stroud: Alan Sutton, 1994), p. 151.

3 *Tools of the Gardeners' Trade*

1 See, for example, Kay Sanecki, "Tools of the Trade," in *The Garden: A Celebration of One Thousand Years of British Gardening*, ed. John Harris (London: Victoria and Albert Museum, 1979), pp. 111–16; Sanecki, *Old Garden Tools* (Aylesbury: Shire, 1979, 2nd edn. 1987); Alistair Morris, *Antiques from the Garden* (Woodbridge: Garden Art Press, 1996, 2nd edn. 1999); C. Paul Christianson, "Tools from the Medieval Garden," *London Gardener*, VII (2001–02), pp. 11–21.

2 Robert M. Adams, *Utopia* (New York: Norton, 1975), p. 12.

3 CLRO, MS BHA, vol. 3 (1460–84), fols. 738, 747, 780.

4 Cited in Alicia M. T. Amherst, "A Fifteenth Century Treatise on Gardening by 'Mayster Ion Gardener'," *Archeeologia*, LIV (1894), p. 162.

5 Thomas Hill, *The Gardeners Labyrinth*, ed. Richard Mabey (Oxford: Oxford University Press, 1987), pp. 81–82.

6 John Rea, *Flora: seu, De Flora Cultura* (London, 1665, 2nd edn. 1676), n. p.

7 Hill, p. 83.

8 John Evelyn, *Elysium Britannicum*, ed. John E. Ingram (Philadelphia: University of Pennsylvania Press, 2001), pp. 88–89.

9 For photographs of these lead cisterns, see Morris, pp. 68–71. Hill (p. 32) comments on other forms of cisterns, such as those built below ground level: "If a wel or pit to purpose cannot be made in the Garden, then frame up a square pit or Cestern levelled in the bottom with Brick and Lime to receive the Rainewater falling, with which in the hottest Summer daies, you may water the beds of the Garden."

10 PRO, E36/252, p. 550, cited by H. M. Colvin, ed., *The History of the King's Works*, vol. III: *1485–1660*, 2 parts (London: HMSO, 1975), p. 315.

11 Other "erthen pottes" were also purchased the same year from "John Pallmer of Stocke in Essex," the order consisting of 468 "stewe pottes" at £7 16s. These pots were presumably for use in the palace kitchens.

12 Susan Campbell, *Walled Kitchen Gardens* (Princes Risborough: Shire, 2002), p. 20: "'Green houses' were heated by pans of charcoal or small stoves. The plants were grown in tubs so that they could be carried outside in summer. In winter they were returned to the 'greenhouse', 'conservatory', 'orangery' or 'stove'. Here they were further protected from frost by thick, insulated walls and ceilings. Light came only from tall windows in the front, which did not necessarily face south." Hitherto the first record of a stove house to protect exotic plants at Hampton Court dates from 1689; see Campbell, p. 21.

13 Roy Stephenson, "Post-Medieval Ceramic Bird Pots from Excavations in Greater London," *London Archaeologist*, VI, 12 (Autumn 1991), pp. 320–21.

14 Max Labbé, *Ces etonnants nichoirs traditionnels* (Paris: Max Labbé, 1990), with a list of sixteenth- and seventeenth-century paintings and drawings with representations of bird pots, pp. 48–50.

15 Ivor Noël Hume, *Pottery and Porcelain in Colonial Williamsburg's Archaeological Collections* (Colonial Williamsburg, VA, 1969), pp. 30–33. In England, bird pots were still in use well into the nineteenth century. See N & Q, 6th ser., IV (July–December 1881), p. 456: "Sparrow Bottles of redware, with a hole to hang on a nail, are continuously used by most of the farmers in Thorney Fen, to prevent the birds destroying the thatch, and also for ease in destroying the young birds, which are generally killed and thrown to the pigs. I have seen sparrow bottles hung on the walls of houses in the Netherlands, and they are often represented in old Flemish pictures and engravings."

4 Garden Design and Innovation

1 See Introduction, n. 10.

2 John Schofield, *Medieval London Houses* (New Haven and London: Yale University Press, 1994), pp. 210–12.

3 Simon Thurley, *The Royal Palaces of Tudor England* (New Haven and London: Yale University Press, 1993), pp. 40–44.

4 John Schofield, *The Building of London from the Conquest to the Great Fire* (London: British Museum/Museum of London, 1984), p. 153.

5 For the development of brick as a building material, see Schofield, *Medieval London Houses*, pp. 150–52; Schofield, *The Building of London*, pp. 127–29, 136–37.

6 Cited in Teresa McLean, *Medieval English Gardens* (London: Barrie & Jenkins, 1981, 1989), p. 195.

7 Cf. Roy Strong's comments on the rarity of such tree arbors in English paintings in his *The Artist & the Garden* (New Haven and London: Yale University Press, 2000), pp. 42–43.

8 The argument takes on point if one reads the word *posto* grammatically as the past participle of the verb *ponere*: "to put or place," i.e., involving active intervention. Thus: a small meadow *constructed* in the middle of the garden and at the crest of a little hillock. I am indebted to Lisa Erdberg for this suggestion.

9 See William Robinson, *History and Antiquities of the Parish of Hackney*, 2 vols. (London: John Bowyer Nichols, 1842), vol. I, p. 154.

10 Sylvia Landsberg, *The Medieval Garden* (London: British Museum, 1995), pp. 16, 90–91.

11 Charles Estienne and John Liebault, *Maison rustique; or, The Countrie Farme*, trans. Richard Surflet (London: Edm. Bollifant, 1600), p. 326.

12 *Records of the Worshipful Company of Carpenters, 2: Warden's Account Book, 1438–1516* (Oxford: Oxford University Press, 1914), pp. 89, 139, 162, noting payments for "makyng & settyng of knottes." For knots in the Drapers' Company garden, see Penelope Hunting, *A History of the Drapers' Company* (London: Drapers' Company, 1989), p. 44. For knots in Paulet's garden, see Robin Whalley and Anne Jennings, *Knot Gardens and Parterres* (London: Barn Elms, 2000), pp. 44–45; John Schofield, "City of London Gardens, 1500–c.1620," *Journal of Garden History*, XXVII (1999), pp. 73–88; see pp. 75–78.

13 Estienne and Liebault, p. 325.

14 John Harvey, *Restoring Period Gardens* (Princes Risborough: Shire, 1988, 2nd edn., 1993), p. 28.

15 In the absence of surviving visual evidence to the contrary, Roy Strong (*The Artist & the Garden*, p. 31) has argued that "knots in the form of complex interlacing patterns did not appear before the 1580s. Before and even after that time any arrangement within a compartment of beds was also referred to as a knot." See also David Jacques, "The Compartment System in Tudor England," *Journal of Garden History*, XXVII (1999), pp. 32–53, and Whalley and Jennings, who likewise look to the second half of the sixteenth century for clear evidence of English knot design. See also C. Paul Christianson, "The London Gardener: A Tudor-Age Profile," *London Gardener*, VIII (2002–03), pp. 11–26.

16 See Judith Roberts, "The Gardens of the Gentry in the Late Tudor Period," *Journal of Garden History*, XXVII (1999), pp. 89–108. In the accompanying key to this garden plan, Lawson offers various comments on the features of such a riverside manor: "A. All these squares must bee set with trees, the Gardens and other ornaments

must stand in spaces betwixt the trees, and in the borders and fences. B. Trees 20 yards asunder. C. Garden Knots. D. Kitchin Garden. E. Bridge. F. Conduit. G. Staires. H. Walkes set with great wood thick. I. Walkes set with great wood round about your Orchard. K. The Out fence. L. The Out fence set with stone fruit. M. Mount. To force earth for a Mount or such like, set it round with quick[sets] and lay boughes of trees strangely intermingled, the tops inward, with the earth in the middle. N. Still-house. O. Good standing for Bees, if you have an house. P. If the river run by your doore, and under your Mount it will be pleasant."

5 Garden Pride and Pleasure

1 William Roper in A. L. Rowse, ed., *A Man of Singular Virtue* (London: Folio Society, 1980), pp. 117–20; cf. p. 118.

2 Robert M. Adams, *Utopia* (New York: Norton, 1975), p. 130.

3 Adams, pp. 129–30.

4 Rowse, pp. 33–35.

5 Adams, pp. 28–30.

6 George Cavendish, *Thomas Wolsey Late Cardinal his Life and Death* (London: Folio Society, 1962), p. 53.

7 Martha Carlin, "The Reconstruction of Winchester House, Southwark," *London Topographical Record*, CXXXII (1985), p. 47; June Osborne, *Hampton Court Palace* (London: HMSO, 1984), pp. 74–75; Gordon Home, *Old London Bridge* (London: John Lane, 1931), pp. 180–81.

8 Ann Saunders and John Schofield, eds., *Tudor London: A Map and a View* (London: London Topographical Society/Museum of London, 2001), p. 5.

9 Thomas Hill, *The Gardeners Labyrinth,* ed. Richard Mabey (Oxford: Oxford University Press, 1987), pp. 45–47. See also Sylvia Landsberg, "Medieval Pergolas, Arbours and Arches," and Jan Woudstra, "Bowers, 'Berceaux' and Cradle Walks," both in *Pergolas, Arbours and Arches*, ed. Paul Edwards and Katherine Swift (London: Barn Elms, 2001), pp. 21–34, 35–50.

10 At the same time that Wright was working on the heraldic vane for the summer parlor, he was also employed in decorating the refurbished hall of the Bridge House: "Item to Andrew Wright paynter for payntyng of the border in the hall wtin the briggehous and for vj elles diuers lynnen clothe for the same. xxiijs iijd." He appears to have made somewhat a specialty of heraldic painting, as may be seen three years earlier, when the Bridge House records note payment of 5s to him "for payntyng wt fyne gold of ij lyons set upon the gate at london brigge," or seven years later, when employed by Henry VIII, to paint the royal arms in the molded fretwork of the ceiling in the King's Privy Gallery at York Place, as appear in the painting *The Family of Henry VIII* (pl. 41 above). See Simon Thurley, *Whitehall Palace: An Architectural History of the Royal Apartments, 1240–1690* (New Haven and London: Yale University Press, 1990), pp. 45–46; Thurley, *The Royal Palaces of Tudor England* (New Haven and London: Yale University Press, 1993), p. 106. John Halmer named Wright, "my special affixed frinde," as one of the executors of his will, dating from 1536. See C. Paul Christianson, *Memorials of the Book Trade in Medieval London: The Archives of Old London Bridge* (Woodbridge: D. S. Brewer, 1987), pp. 13, 39, 44.

11 Cf. John Anthony, *The Renaissance Garden* (Princes Risborough: Shire, 1991), pp. 11–12: "In 1548 William Turner published his *The names of herbs in Greek, Latin English, Dutch and French . . .* This constitutes the earliest mention of many foreign plants as growing in Britain and is thus usually accepted as the date by which they must have been introduced. Thus jasmine, paeony and southernwood make their appearance in the English literature of botany."

12 See C. Paul Christianson, "Movable Feasts on the River Thames," *Petits Propos Culinaires 71* (Totnes, Devon: Prospect Books, 2002), pp. 16–32.

13 Cited in Home, pp. 188–89.

14 London, Guildhall Library, MS 10,464, fols. 45v–46v.

15 Thurley, *Whitehall Palace*, pp. 27–28. See pl. 42.

16 John Schofield, *Medieval London Houses* (New Haven and London: Yale University Press, 1994), pp. 89, 149, 164.

17 Cavendish, p. 90.

18 Cited in Gladys Taylor, *Old London Gardens* (Hornchurch: Ian Henry, 1977), p. 54.

19 John Guy, *Thomas More* (London: Hodder Headline, 2000), pp. 107–08; Peter Ackroyd, *The Life of Thomas More* (New York: Random House, 1999), p. 298.

20 For Bainham, see Peter W. M. Blayney, *The Stationers' Company before the Charter 1403–1557* (London: Worshipful Company of Stationers and Newspapermakers, 2003), pp. 30–32.

21 Ackroyd, pp. 299–305.

22 *LP Henry VIII*, vi (1533), pp. 448–49. Field's petition alleged that 10s in money and three books – a Greek vocabulary, Cyprian's works, and More's *Supplication of Souls* – were taken from him and he asks for the money and books to be returned to him.

23 Elizabeth Frances Rogers, ed., *St. Thomas More: Selected Letters* (New Haven and London: Yale University Press, 1961), pp. 179–80.

24 Ackroyd, p. 302.

25 Ackroyd, p. 308.

26 *LP Henry VIII*, v (1531–32), p. 489.

27 Quoted in Ackroyd, p. 313. Even as these words were spoken, both men may have remembered the day in October five years earlier when the king had first broached to More the topic of the legality of his marriage. The setting had been the gallery outside Wolsey's chapel at Hampton Court, one end of which overlooked the knot garden below. Like the garden's design, Henry VIII's tie to the queen was "so enknotted, it cannot be exprest," as both men would come to see in the following years of verbal contest between them over this issue. See Rogers, pp. 207–08.

Epilogue The Uses of Garden History

1 Elizabeth Frances Rogers, ed., *St. Thomas More: Selected Letters* (New Haven and London: Yale University Press, 1961), pp. 4–5.

2 Rogers, pp. 84–85.

3 Robert M. Adams, ed. and trans., *Utopia* (New York: Norton, 1975), pp. 110–11.

4 Cited in E. E. Reynolds, *Margaret Roper: Eldest Daughter of St. Thomas More* (London: Burns & Oates, 1960), pp. 46–47. As early as 1518, More would write to his children's tutor William Gonell that his chief goal for his children was for them to

learn "in their studies to esteem most whatever may teach them piety towards God, charity to all, and modesty and Christian humility in themselves. By such means they will receive from God the reward of an innocent life, and in the assured expectation of it will view death without dread, and meanwhile possessing solid joy will neither be puffed up by the empty praise of men, nor dejected by evil tongues. These I consider the real and genuine fruit of learning." See Rogers, p. 105.

5 Even so, Margaret Roper, despite her brilliance, suffered by her gender in More's eyes. In the same letter to William Gonell in 1518, More reveals another form of bias typical of his age. Employing gardening images, he says of a woman: "Nor do I think that the harvest is much affected whether it is a man or a woman who does the sowing. They both have the name of human being whose nature reason differentiates from that of beasts; both, I say, are equally suited for the knowledge of learning by which reason is cultivated, and, like plowed land, germinates a crop when the seeds of good precepts have been sown. But if the soil of a woman be naturally bad, and apter to bear fern than grain, by which saying many keep women from study, I think, on the contrary, that a woman's wit is the more diligently to be cultivated, so that nature's defect may be redressed by industry." More's bias is further revealed by his own statement, when writing to Margaret in 1523. Praising her skill as a writer and "her singular love of virtue [in] the pursuit of literature and art," he concludes the letter: "In your letter you speak of your imminent confinement. We pray most earnestly that all may go happily and successfully with you. May God and our Blessed Lady grant you happily and safely to increase your family by a little one like to his mother in everything except sex. Yet let it by all means be a girl, if only she will make up for the inferiority of her sex by her zeal to imitate her mother's virtue and learning. Such a girl I should prefer to three boys. Good-bye, my dearest child." See Rogers, pp. 105, 155.

6 See Peter Ackroyd, *The Life of Thomas More* (New York: Random House, 1999), p. 254.

7 William Roper, in A. L. Rowse, ed., *A Man of Singular Virtue* (London: Folio Society, 1980), pp. 77–8.

Appendices

A Royal Gardeners under Henry VIII

Thomas Alvard, Keeper of York Place, Keeper of the King's Garden, Keeper of New Park (St. James's), 1530–35

John Bryket, Keeper of the King's Garden at Eltham (Kent), 1534

John Chapman, Keeper of the King's Garden at Hampton Court, 1529–32

John Colynson, Keeper of the King's Garden at Eltham (Kent) (d. 1534)

Robert Draper, Keeper of the King's Garden at the Tower of London, 1532

Philip Enys, King's Gardener at Greenwich, 1546

John Gardener, Keeper of the King's Garden at West Horsley, 1546

Edmund Gryffyn (Gryffith), King's Gardener at Hampton Court, 1532–36

Richard Hart, Keeper of the King's Garden at Eltham (Kent), 1509–34 (d. 1534)

Robert Hasilrig, Keeper of the King's Garden at the Tower of London, 1511–32

Stephen Jasper, Keeper of the King's Great Garden at Beaulieu, 1529–31

John Lovell, King's Gardener at Greenwich, 1519; King's Gardener at Richmond, 1529–32 (d. 1550)

Richard Mounteyn, Keeper of the King's Garden at St. James's, 1545

Robert Pury, King's Gardener at Wanstede, 1529–32

John Rede, King's Gardener at Beaulieu, 1529–30

John Reigne (Reygny), King's Gardener at Hanworth (Middlesex), 1510

Henry Russell, "gardiner and servaunte unto the Kinges majestie" in Westminster, 1539–49

William Rutter, King's Gardener at Windsor, 1528–32

Richard Smith, Keeper of the King's Garden at the Tower of London, 1506-11 (d. 1511)

Anthony Talwyn (Tawvyn), Keeper of the King's Garden in Southwark, 1546

—— Welshe, King's Gardener at Greenwich, 1530–37

John Whitwell, Keeper of the King's Garden at Langley, 1511; Surveyor of the King's Garden at Woodstock, 1511

John Wolf, "maker and devisour of the King's arbours" at Hampton Court, 1538–42

facing page Title-page illustration, from John Gerard, *The Herball, or Generall Historie of Plantes* (detail of pl. 64)

B Henry VIII's Garden Staff and Plant Suppliers at York Place and Hampton Court

Elisabeth Allen, garden laborer, Hampton Court, 1531
Jane Allen, weeder, Hampton Court, 1535
Maybell Allen, waterer, Hampton Court, 1531
Thomas Ansell, garden laborer, Hampton Court, 1531
Ales Atwode, waterer, Hampton Court, 1531
George Ayer, garden laborer, Hampton Court, 1531
Morys Ayer, garden laborer, Hampton Court, 1531

William Baldewyn (Ballewyn), gardener, Hampton
 Court, 1531, 1538; gardener, York Place, 1532
John Bandrey (Bonney), gardener, Hampton Court,
 1531–32
John Barette, gardener, York Place, 1532
John Barton, garden laborer, Hampton Court, 1531
Robert Bean, garden laborer, Hampton Court, 1531
John Bertlett, plant supplier, Hampton Court, 1533
Robert Bessame, garden laborer, Hampton Court,
 1531
Matthew Birde, weeder, Hampton Court, 1531
Jolie Bix, waterer, Hampton Court, 1531
Allys Bray, weeder, Hampton Court, 1535–37
Ales Brewer, plant supplier, Hampton Court, 1531
John Bridgeman, gardener, Hampton Court, 1535
John Browne, plant supplier, Hampton Court, 1531,
 1533
Thomas Bryne, gardener, York Place, 1532

Richard Chauntry, gardener, Hampton Court, 1531
Thomas Chester, garden laborer, Hampton Court, 1531
Gilian Cole, weeder, Hampton Court, 1531

Clement Colyn, plant supplier, Hampton Court, 1533
William Conweye, gardener, York Place, 1532
John Combe, garden laborer, Hampton Court, 1531
Margaret Cooke, weeder, Hampton Court, 1535
John Coole, gardener, York Place, 1532

William Doche (Duke), garden laborer, Hampton
 Court, 1531–32
John Dory, plant supplier, Hampton Court, 1531
Johanna Down, weeder, Hampton Court, 1531
Richard Down, garden laborer, Hampton Court, 1532
Roger Down, gardener, Hampton Court, 1531–32
Thomas Down, garden laborer, Hampton Court, 1532
Jane Downer, plant supplier, Hampton Court, 1531

John Edall (Idiall), garden laborer, Hampton Court,
 1531
John Eliatte, gardener, York Place, 1532
Ales Evell, waterer, Hampton Court, 1531

John Farmen, plant supplier, Hampton Court, 1531
Elizabeth Farrer, waterer, Hampton Court, 1531
John Faryngton, plant supplier, Hampton Court, 1531
Richard Flemyng, gardener, York Place, 1532
Margaret Flowre, waterer, Hampton Court, 1531, plant
 supplier, Hampton Court, 1531
Mawde Flowre, waterer, Hampton Court, 1531
James Fylle, gardener, York Place, 1532
John Fynen, gardener, York Place, 1532

John Gaddisbe, plant supplier, Hampton Court, 1531–32, 1534, 1536

William Gardener, plant supplier, Hampton Court, 1532

Martha Garrarde, weeder, Hampton Court, 1531

Matthew Garrett, gardener, Hampton Court, 1531

Thomas Graunte, gardener, York Place, 1532

William Grenesmyth, garden supplier, Hampton Court, 1533

Nicholas Hackette, gardener, York Place, 1532

John Hages, garden laborer, Hampton Court, 1531

Patrick Halfepenny, gardener, York Place, 1532

John Hasyll, plant supplier, Hampton Court, 1531

James Hayward, gardener, York Place, 1532

John Hayward, gardener, Hampton Court, 1531

Robert Hayward, gardener, Hampton Court, 1531–32

Gillian Hellor, weeder, Hampton Court, 1531

Jane Hert, waterer, Hampton Court, 1531

Jone Hert, waterer, Hampton Court, 1531

Annes Hewett, weeder, Hampton Court, 1537

Thomas Hobard, plant supplier, Hampton Court, 1536

Patrick Hongle, gardener, York Place, 1532

William Hongle, gardener, York Place, 1532

Agnes Hunt, weeder, Hampton Court, 1534–35

Agnes Hutton, plant supplier, Hampton Court, 1531

John Hutton, gardener, Hampton Court, 1531–32, plant supplier, 1532

Johanna Ingram, weeder, Hampton Court, 1531

Jone Iustice, waterer, Hampton Court, 1531

Johanna Johnson, waterer, Hampton Court, 1531

Magdalen Johnson, waterer, Hampton Court, 1531

Henry Kelye, gardener, York Place, 1532

John Kelye, gardener, York Place, 1532

Richard Kelye, gardener, York Place, 1532

Richard Kenette (Kenedie), gardener, York Place, 1532

Cristiana Knyght, waterer, Hampton Court, 1531

John Laurence, garden laborer, York Place, 1532

Agnes Layton, waterer and garden laborer, Hampton Court, 1531

John Layton, gardener, Hampton Court, 1531–32

Annys Lewis, weeder, Hampton Court, 1531

Johanne Lix, weeder, Hampton Court, 1531

Patrick Mandos, gardener, York Place, 1532

Sysley Marytt, weeder, Hampton Court, 1530–37

John Maybank, gardener, Hampton Court, 1531–32, 1535

John Meryman, gardener, York Place, 1532

Ales More, waterer, Hampton Court, 1531

Annes More, weeder, waterer, and plant supplier, Hampton Court, 1531

James Mounteyne, gardener, York Place, 1532

William Moyse, garden laborer, Hampton Court, 1531

Elizabeth Nassgem, waterer, Hampton Court, 1531

Agnes Nasshe, waterer, Hampton Court, 1531

Jone Nele, waterer, Hampton Court, 1531

Agnes Oker, waterer, Hampton Court, 1531

Jane Oker, garden laborer, Hampton Court, 1531

Johanna Oker, weeder, Hampton Court, 1531

Ales Owen, weeder, Hampton Court, 1531

John Pakk (Peck), garden laborer, Hampton Court, 1536–37

Thomas Pakk (Peck), garden laborer, Hampton Court, 1537

Jone Parrott, waterer, Hampton Court, 1531

Annes Parson, weeder, Hampton Court, 1534–37

Margaret Patt, weeder, Hampton Court, 1531

Agnes Pounche, plant supplier, Hampton Court, 1531

John Prior, garden laborer, Hampton Court, 1532

John Prynce, garden laborer, Hampton Court, 1531

Ales Rock, weeder and garden laborer, Hampton Court, 1530–37

Margaret Rogers, weeder and plant supplier, Hampton Court, 1531

Margaret Rowland, weeder, Hampton Court, 1531

Elizabeth Rym, weeder, Hampton Court, 1531

John Samson, weeder, Hampton Court, 1531

John Shepherd, plant supplier, Hampton Court, 1531

William Shore, plant supplier, Hampton Court, 1531

Jane Shorloke, weeder, Hampton Court, 1531

William Shorloke, gardener, York Place, 1532
Robert Smythe, plant supplier, Hampton Court, 1531
Agnes Swallow, garden laborer, Hampton Court, 1531
Allis Swallow, weeder and garden laborer, Hampton
 Court, 1530–37
Margaret Swallow, waterer, Hampton Court, 1531
Thomas Swallow, garden laborer, York Place, 1532

Edward Vincent, plant supplier, Hampton Court, 1531
Laurens Vincent, plant supplier, Hampton Court,
 1531–33

Jone Warren, waterer, Hampton Court, 1531
William Welsshe, gardener, York Place, 1532
Richard Williford, garden laborer, Hampton Court,
 1531
Kateryn Wode, waterer, Hampton Court, 1531
Mawde Wode, waterer, Hampton Court, 1531
Annes Wodowes, weeder, Hampton Court, 1534–37
Ales Wolff, waterer, Hampton Court, 1531

John Yorke, garden laborer, Hampton Court, 1531

C Wolsey's Garden Staff at York Place and Hampton Court in 1515

Jane Abraham, weeder, Hampton Court
Agnes Athy, weeder, York Place

Richard Baker, gardener, Hampton Court; gardener, York Place
John Bekwith (Bekit), garden laborer and gardener, York Place
Julian Betchem, weeder, Hampton Court
Elisabeth Billington, weeder, York Place
Elisabeth Bradsale, weeder, York Place
John Bray, gardener, York Place
Richard (Reynold) Brown, gardener, Hampton Court and York Place
John Button, garden laborer, York Place

Peter Casse, garden laborer and gardener, York Place
John Chapman, head gardener, York Place and Hampton Court
Alice Clark, weeder, York Place
Agnes Cokes, weeder, York Place
Alice Cokes, weeder, York Place
John Cokes, gardener, York Place
Johanna Colson, weeder, York Place
Margaret Cookstole, weeder, Hampton Court
Johanna Copyes, weeder, York Place
John Curtase, gardener, York Place

Thomas Dixon, garden laborer, York Place

John Estoppe, garden laborer, York Place

Julyana Filling, weeder, York Place
Alice Flod, weeder, York Place
Elisabeth Forest, weeder, York Place
John Fowle, weeder, Hampton Court
Richard Fuller, gardener, Hampton Court

John Gardyner, garden laborer, Hampton Court
John Gybson, garden laborer, York Place

Edward Hinby, garden laborer, York Place
John Holgate, garden laborer, York Place
John Hollyer, gardener, Hampton Court and York Place

John Johnson, gardener, York Place

Marion Kensett, weeder, York Place

Elisabeth Lark, weeder, York Place
Margaret Lasket, weeder, York Place
Johanna Latton, weeder, York Place
Annes Lewes, weeder, Hampton Court
Johanna Luyges, weeder, York Place

Kathryn Mays, weeder, York Place
Thomas Milford, garden laborer, York Place
Katryn Mute, weeder, Hampton Court
Raymond Myller, gardener, Hampton Court

Johanna Nele, weeder, York Place
Agnes North, weeder, Hampton Court

John Parson, garden laborer, York Place
Thomas Parson, gardener, Hampton Court
John Patrik, garden laborer, York Place
Robert Pincok, garden laborer, York Place
Agnes Place, weeder, York Place
Johanna Pop, weeder, York Place
John Pop, gardener, York Place
Margaret Portt, weeder, York Place
Thomas Proud, gardener, Hampton Court and York Place

John Randall (Randolf), gardener, Hampton Court and York Place
Richard Reynolds, gardener, Hampton Court and York Place
Richard Rowland, gardener, York Place
Thomas Sharpe, gardener, Hampton Court
Richard Smyth, gardener, Hampton Court
Henry Squyre, garden laborer, York Place

John Sutthe, garden laborer, York Place
William Sutton, garden laborer, York Place
Elisabeth Symson, weeder, York Place

Myrsha Thomson, weeder, York Place
William Thomson, gardener, York Place
Marion Todd, weeder, York Place
Johanna Turner, weeder, York Place
Johanna Tyler, weeder, York Place

William Walter, gardener, York Place
Eloy Walys, weeder, York Place
Margaret Welles, weeder, York Place
Andrew Whitacre, gardener, York Place
Davy Whitacre, gardener, York Place
Patrick White, gardener, York Place
Richard Whitlok, garden laborer, York Place
Patrik Wryght, gardener, York Place
Christian Wyly, weeder, Hampton Court

D Garden Staff and Plant and Seed Suppliers at the Bridge House Garden, 1406–1567

1406, 1413	Roger Goodwynne, garden laborer	1511–13	wife of John Marlow, weeder
1406	John Shope, garden laborer	1512–13	Thomas Gunnows, gardener
1440	Walter Loye, garden laborer	1512–13	Hugh Kelly, gardener
1461–62	Julian Arnold, garden laborer	1512–13	Richard Tegge, gardener
1461–62	James Baas, garden laborer	1512–13	William Whyte, gardener
1466–67	William Bachille, garden laborer	1514–15	Robert Ellys, gardener
1466–67	William Bonar, garden laborer	1514–15	Thomas Kendall, garden laborer
1472–73	William Cramond, Bridge House Porter	1514–15	Patryk Welshe, gardener
		1515–16	Agnes Kendall, weeder
1472–73	John Grene, garden laborer	1515–16	Nicholas Melton, plant and seed supplier
1476–77	John Page, garden laborer		
1488–89	Robert Atkyns, garden laborer	1515–16	James White, garden laborer
1489–92	William Norice, garden laborer	1516–17	John Owen, gardener
1492–98	John Norice, garden laborer	1517–22	Robert Harman, garden laborer
1497–98	Walter Reynoldson, garden laborer	1520–21	John Tubbys, garden laborer
1498–1505	John Dawle, gardener	1521–22	John Hasylfote, gardener
1501–02	Patryk Annice, garden laborer	1522–23, 1526–27	Richard Savell, gardener and plant and seed supplier
1502–03	John Wode, garden laborer		
1503–04	John Hely, gardener and seed supplier	1523–24, 1528–29	William Hayward, gardener
		1523–24	John Langham, gardener
1505–06	John Yonge, gardener	1523–25	James Kettill, gardener and plant supplier
1506–08, 1515–16	Nicholas Melton, gardener and plant and seed supplier		
		1524–25	Robert Freman, gardener
1507–08	Robert Garlond, garden laborer	1524–25	Roger Middelton, gardener
1508–09	John Bekyngham, seed supplier	1524–25	John Sparrow, gardener
1508–09	William Bekyngham, seed supplier	1524–26, 1528–29	Thomas Childe, Bridge House Porter
1508–09	John Halmer, garden laborer (later Clerk of the Works)		
		1524–31, 1543–44	Rauf Collyns, gardener and plant and seed supplier
1508–09	Thomas Melton, garden laborer		
1509–11	Richard Saddeler, gardener	1524–50	Mother Tubbys, wife of John, later wife of William Hewett, weeder and seed supplier
1511–12	Tey Fuller, gardener		
1511–12	Patryk Onyons, gardener		

1525–27	John Blakeman, gardener	1535–36	Roger Roberts, gardener and plant supplier
1527–28	Thomas Stamer, gardener		
1528–29	John Benet, garden laborer	1535–36	—— Bisshope, gardener
1528–29	Thomas Cawsway, gardener and seed supplier	1536–37	—— Buttler, gardener
		1536–40	Henry Myllis, gardener
1529–30	Edward Fitton, garden laborer	1540–41, 1545–46	John Collyns, gardener
1529–30	William Hewett, garden laborer (later Bridge House Porter)	1540–41	wife of John Collyns, garden laborer
1529–30	John Wright, garden laborer	1540–41	John Conway, gardener
1529–30	Richard Wright, garden laborer	1544–45	Thomas Derby, gardener
1530–31	William Carter, garden laborer	1547–48	Hugh Sexlebie, garden laborer
1530–31	William Partrich, garden laborer	1551–52	Morys Antyner, gardener
1531–32	John Davy, gardener	1551–52	Hugh Lewis, gardener and plant and seed supplier
1531–32	old John Gardyner, garden laborer		
1531–32	Richard Parker, garden laborer	1551–52	Harry Stoke, gardener and plant and seed supplier
1531–32	Henry Russell, gardener		
1531–32	Edward Sampson, gardener	1552–53	Thomas Bonham, gardener
1531–32	William Tryme, gardener	1552–53	Thomas Bowman, gardener and plant and seed supplier
1531–33	Tey Kellet, gardener		
1532–33	Alexander Morrys, gardener	1552–53	John Drinke, gardener
1532–33	John Myrson, gardener	1552–53	Katheryn Sherman, garden laborer
1532–33	George Stubbyng, gardener	1552–58	William Johnson, gardener and plant and seed supplier
1532–33	Thomas Stubbyng, gardener		
1533–34	William Bawdewyn, gardener	1558–59	John Roche, gardener
1534–35	Peter Tyrrell, gardener and plant and seed supplier	1559–60	Richard Hall, gardener
		1566–67	—— Larke, garden laborer
1534–36	Symond Holden, gardener		

Botanical Illustrations

The following list identifies the botanical drawings by George W. Olson that appear throughout the book and gives the page on which each is reproduced.

page

i	Hazelnut (*Corylus avellana*)
iv	Hyssop (*Hyssopus officinalis*)
v	Cherry (*Prunus cerasus*)
19	Borage (*Borago officinalis*)
83	Gillyflower (*Dianthus caryophyllus*)
94	Primrose (*Primula vulgaris*)
105	Medlar (*Mespilus germanica*)
113	Foxglove (*Digitalis purpurea*)
119	Herb Robert (*Geranium robertianum*)
173	Clary (*Salvia sclarea*)
198	Tudor Rose (*Rosa damascena*)
213	Strawberry (*Fragaria vesca*)

Index

NOTE: Page numbers in italics indicate an illustration; page numbers followed by *n* indicate a note; page numbers followed by *App.* indicate that information is in the Appendices.

Abraham, Thomas 95
Ackroyd, Peter 189
Act of Succession (1534) 196, 199*n*.1
Adam Delving (stained glass) *106*
Adam and Eve 128
Adams, Thomas 40
Agas, Ralph 21, *52*, *53*, 58, 166
agricultural land: More's Chelsea manor 82; in *Utopia* 4; Winchester Palace 44–45, 48
Allen, Elisabeth 110–11
Allen Hall Seminary 75, 154, *155*
alleys 32, 96–97, 182
Alvard, Thomas 62, 110
Amaurot (London in More's *Utopia*) 1–4
amenity gardens 28–29; *see also* garden uses; kitchen gardens
Amer, William 128
Andrewes, Lancelot 50
Anglo-Netherlandish School: *View of London from Southwark 25*
Anon.: *Bishop's Rowing on the River Thames 176*; *Family of Henry VIII* 58, *59*, *60–61*; *Fulham Palace 15*; *Plan of Chelsea Estate 79*; *Sir Paul Pindar's Lodge 186*; *View of Lambeth Palace 73*
Antynor, Morys 166
arbors (herbers) 29, 96–97, 104, 160–61, 182–83; *see also* parlors

Arnold, John 118–19
Arundel House 152
Ashbee, Jeremy 36
Augustyn, Brise 203*n*.14
Avercamp, Hendrik: *Winter Landscape with Iceskaters* 146–47, *147*

Baas, James 116
Bachile, William 116
Bainham, James 188
Baker, John 64, 91, 94, 95
Baldwyn (Ballewyn/Bawdewyn), William 59, 111, 114, 116
Ball, John 128
Ballewyn, William *see* Baldwyn
Balm's House *see* Baum's House
Banister, John 87
banquets and banqueting houses 184–86; Bridge House parlor 29; Hampton Court 100, 104, 185; More's Chelsea manor 185–86; York Place/Whitehall Palace 51, 55, 185
Baum's House, Hackney 161–62, *162*
Bawdewyn, William *see* Baldwyn
Beaufort, Henry, bishop of Winchester 180
Beaufort House *see* Chelsea manor and gardens
Beaulieu, Hants 109, 117
Becket, Thomas 23, 45
Bedene, Robert 128
Bekyngham, John 119
Bekyngham, William 119
benches 96–97, 181, *181*
Bening, Simon: Book of Hours illustration 132, *133*

Bettes, James 206*n*.70
Bible: Tyndale's translation 89–90
bird bottles/pots 144–47, *146, 147, 148,* 149, *149*
Bishop of Bath's Inn 152
Bishop of Exeter's Inn 152
Bishop of Norwich's Inn 152
Blakeman, John 118
Blankston, Henry 97, 104
Bol, Hans: *April* 124, *125,* 143
Boleyn, Anne, queen of England 11, 40–41, 199*n*.1
Book of Hours illustration 132, *133*
Bowman, Thomas 118
Brewer, Agnes 111
brick constructions 100, 153–54, 156–57; *see also* walled gardens; walls
bricklayers 95, 100, 156, 157
Bridewell Palace 152, *153*
Bridge House Estates 7, 24
Bridge House and garden 7–8, 23–32, *26, 28, 30, 33,* 114; administrative staff 25–26; amenity garden 28–29; arbors 183; bird pots 147, 149; brick constructions 156–57; "Bridge Masters Gardin" 31; clock tower 30–31; countinghouse 28–29, 31, 183; garden records 26–28, *28,* 32, 115–19, 121; garden staff 27–28, 113–14, 115–16, 117, 118–21, 166, 221–22*App.*; gatehouse 29; granaries 31, *33*; kitchen garden 28, 31–32; knot gardens 32, 166, 167–68, *169*; Master's Garden 31, 32; More's connection with 151–52; muniment room 31, 32, *33*; parlor 29, 30, 31, 183–85; renovations 29–31, 130–31, 151–52, 156; tools 27, 32, 133–35, 136, 149; topiary 144; vines 27, 116, 131–32; walls 156; water features 65, 157; women as garden workers 119, 121
Bridgeman, John 112
brothels in Southwark 204*n*.30
Brown, Richard 64, 91, 94, 95
Browne, John 41, 104, 184
Bruegel, Pieter, the Elder: *Ver (Spring)* 157, 159–61, *159, 160,* 182
Bryket, John 117
Bryne, Thomas 59
Bucklersbury house (More) *182,* 200*n*.3
Bulloke, William 156
Burdoyes, Roger 131
Bylby, Robert 156

Campbell, Susan 208*n*.12
Campion, William 32, 151
Canaletto: *Whitehall and the Privy Garden* 51, 55, *56*
Canterbury, archbishop of *see* Lambeth Palace
Canterbury cathedral: *Adam Delving* 106
Carel de Moor: *Boy with a Flagon and a Bird's Nest* 147, *149*
Carlin, Martha 48
Carpenters' Company garden 166
Carter, Thomas 32
Catherine of Aragon, queen of England 85–86, 199*n*.1
Cavendish, George 62, 96–97, 180, 187
Cawsway (Causy/Casy), Thomas 114, 119, 202–03*n*.9
Cecil, Sir Robert 78, 163–64
Chapman, John: Hampton Court 91, 94–95, 102, 109–11, 140–41; tool and equipment purchases 91, 95, 128, 132–34, 144; wages 91, 116, 117; York Place/Whitehall Palace 62, 64, 95, 112–14
Charles v, Holy Roman Emperor 7–8
Chelsea manor and gardens (More) 18–19, 74–83, *75, 78, 79,* 114, *163*; agricultural production 82–83; banqueting house 185–86; bench remains 181; Danvers House 76, 80, 81; design of gardens 152–53, 161–62, 164, 172–73; Dovecote Close 76, 80; entertaining visitors 14, 81–82; fire 82–83, 121; garden staff 108; garden talks 4, 6, 81–82, 176–77, 179–80, 197; Gorges House 76, *77*; great garden 76, 78, 80; hedging 164; Henry VIII at 176–77; interrogation of heretics 15, 187–89; Lindsey House 76, *77*; and More's personality 7, 18–19, 194–95, 197–98; "New Building" location 80–81; orchard 76, 78, 82, 164; privy garden 76, 78, 80–82, 164; as retreat 80, 195–96, 197–98; stable block 76, 78; staff 82; terraces 157; walls and walled gardens 76, 78, 154–56, *155, 156,* 157
Chelsea Old Church 76, 188
Childe, Thomas 136
Chylde, Thomas 121, 166, 167
cisterns 142–43
City of London *see* London
Civil War: Fulham Palace 87; Lambeth Palace 71
Civitas Londinum 20, 52, 167
Clink Prison 42, 204*n*.30
clock towers 30–31
coats of arms: Bridge House 183, *184*; Fulham Palace 88–89, *89*; Hampton Court 95–96, *96*

225

"Coles" 140–41, 142
Colet, John 74; More's letter 191
Collaert, A.: *April* (after Hans Bol) 124, *125*
Collyns, John 118
Collyns, Mrs. John 119
Collyns, Rauf 116, 118, 166, 202*n*.9
common wealth 107–8
Compton, Henry, bishop of London 86–87, 88
Constantine, George 188
container plants 143–44, 160
Conweye, William 59
cord lines 130, 159, 164–65, 166–67, *168*
Corporation of London Record Office *170*, *184*
costs *see* garden costs
Cotman, John Sell: *Winchester Palace 46*
Cramond, William 28
Cranmer, Thomas, archbishop of Canterbury 13, 70, *70*, 73, 74, 177, 187, 199*n*.1
Cresacre, Anne 5, 200*n*.7

Dallyn, John 100
Dance, George, the Younger 31
Danyell, Richard 48
Dauncey, Elizabeth 5, 200*n*.7
Davy, John 167–68
Dawle, John 115–16, 118
"debelles" 131
Dene, Henry, archbishop of Canterbury 67
design *see* garden design and layout
"dibbers" 131
Dickes, William 87
Dory, John 111
Down, Roger 110, 117, 165
Downer, Jane 111
Draper, Robert 40
Drapers' Company garden 116, 166

ecclesiastical estates 42–43, 50, 186–87; *see also* Fulham Palace; Lambeth Palace; Winchester Palace
Edward I, king of England 36
Edward II, king of England 38
Eliatte, John (Thomas) 59
Eltham Palace 117
Emmerson, Basil: *More's Chelsea Mansion 75*
entertaining in gardens 14, 29, 48, 81–82, 180–81, 184–86

Enys, Philip 117
Erasmus, Desiderius 74, 177–78, 188; on More's Chelsea establishment 195; More's letter on Tunstall 192–93
"erbers" *see* arbors; parlors
Estienne, Charles: *Maison Rustique* 164–65, 167, *168*, *171*
Eve 128
Evelyn, John: *Elysium Britannicum* 141–42, *142*, *143*
exedra (garden bench) 96–97, 181, *181*

Faithorne, William: *Map of Southwark 49, 49*; *Map of Westminster 57, 57*
farming *see* agricultural land
Faryngton, John 111
Field, John 188
Fishburn, William 130
Fitton, Edward 166, 202*n*.9
Fitzjames, Robert, bishop of London 86, 88–89, 153–54, 187
Flicke, Gerlach: *Thomas Cranmer 70*
flower pots 143–44, *143*, *146*, 160
flowers *see* plants; roses
Flowre, Margaret 111
"foixts" 141–42, *142*
food *see* agricultural land; kitchen gardens; outdoor eating; vegetables
Forestier, Amadee: *View of Medieval London 34–35*
forks 126
fountains 32, 57, 58, 157
Fox, Richard, bishop of Winchester 10, 50, 187
Foxe, John: *Book of Martyrs 188*
Freman, Robert 116
fruit trees 36, 103, 104, 111–12
Fryer, John 48
Fulham Palace and gardens 15, *15*, 84–90, *84*, *85*, *86*, *87*, *88*, 114; fountain 157; gatehouse 153, *154*; great garden 88; kitchen garden 87, 88; More's visits 15, 89; orchards 87, 88–89, 153–54; plant collection 87; privy gardens 88; rose garden 88; "stone gallery garden" 87–88, 185; summer parlor 87, 185; walled garden 87, 153–54, *155*
Fuller, Richard 94

Gaddisbe, John 111
galleries: Fulham Palace 87–88, 185; Lambeth Palace

70–71; Tower of London 38–39; York Place/ Whitehall Palace 11–12, 53, 59, 62

garden amenities 181–87

garden costs 25–27; building work 100, 156–57, 183; heraldic beasts 97; seeds and plant materials 27, 111–12, 118; tools and materials 27, 32

garden design and layout 16–17, 151–73; Henry VIII's designs 55; historical development 152–54; knot gardens 166–72; layout of flower beds 164–66; More's Chelsea manor 162, 164; preparation of ground 128, 130–31, 159

garden history 16–19; reflection of More's personal history 7, 18–19, 197–98

garden implements *see* tools and materials

garden staff 107–21, 215–22*App.*; Bridge House 27–28, 113–14, 115–16, 117, 118–21, 132, 166, 221–22*App.*; and design of gardens 157, 159–61; employment duration 118; Hampton Court 62, 91, 94–95, 109–12, 113, 114–15, 117, 119, 215–20*App.*; Lambeth Palace 71, 73–74; More's Chelsea manor 157; payment for sundries 118–19; as plant suppliers 118–19; sourcing plants 111–12; Tower of London gardens 40, 117; and universal truths 198; wages comparative to other crafts 117; wages and conditions 28, 40, 91, 115–17, 119, 121; women as 110–11, 113, 119, 121; York Place/Whitehall Palace 59, 62, 64, 110, 111, 112–15, 117, 119, 216–20*App.*; *see also* tools and materials

garden structures 181–87

garden uses 28–29, 175–90; challenging heretics 15, 187–89; for entertaining 14, 29, 48, 81–82, 180–81, 184–86; garden amenities 181–87; intimate meetings 181; political discussion and friendships 175–80, 197; spiritual uses 186–87; walking 182–83

Gardener, John 113, 117

Gardener, William 112

gardeners *see* garden staff

Gardiner, Stephen, bishop of Winchester 10, 50, 181, 187, 188

Garrett, Matthew 110

Garth, Richard: *London Bridge with Tower and Southwark* 42, 43

Gascoyne, John: *Tower of London* 36, 37, 38

gatehouses 29, 66, 67, 153, 154

Gerard, John: *The Herball* 122, 124, 138

Gigs, Margaret 5, 200*n*.7

Gilbert, Sir John: *Cardinal Wolsey 12*; *Ego et Rex Meus 174*, 177

Giles, Peter: More's letter 193, 195

Godfrey, Walter 80

Gold, Thomas 134

Gonell, William 211–12*n*.4, 212*n*.5

grafting tools 132–33

grapevines 27, 36, 116, 131–32, *133*, 159

grass features 55, 57

Graunte, Thomas 59, 110, 117

Greatorex, Ralph 53, *54*, 55

"green houses" 208*n*.12

Greenwich Palace 109, 117

Grocers' Company 27, 116

Grocyn, William 74

Grove, Roger 112

Gryffith (Gryffyn), Edmund 102, 111–12, 117

Gwen, William 142

Haiward, William: *Tower of London* 36, *37*, 38

Halmer, John 169, 183

Hampton Court and gardens 15–16, *16*, 50, 59, 90–105, *92–93*, *98*, *99*, *101*; banqueting house 100, 104, 185; building costs 100; entertainment at 180; garden records 91, 131; garden staff 62, 91, 94–95, 109–12, 113, 114–15, 117, 119, 215–20*App.*; gateway and base court 153, *154*; grass features 55; hedging 111; heraldic beasts 97, 102–03, 104; innovative "hot howse" 144; King's gardens 100–05; knot garden 95–97, 169, *171*; moat 95, 111; Mount Garden 100, *101*, 102, 103, 112, 161; Orangery 97, *99*; orchards 94, 95, 97, 103, 104, 111–12; origins 90–91; plants and seeds 94, 103–4, 109, 110–12, 131; Pond Garden 95, 97, 102, 103, 111; Privy Garden (Henry VIII) 41, 100, *101*, 102–03, 104, 110–11, 131, 140, 165; Privy Garden (Wolsey) 97, *99*–100, 181; royal coat of arms 95–96, *96*; sundials 103, 203*n*.14; tools and materials 91, 94, 95, 128, 131, 132–34, 136; walls and walled gardens 95, 154; water features 65, 95, 102; watering arrangements 140–41, 142–43; Wolsey's gardens 91–100

Harrison, William 21, 28

Harvey, John 169, 207*n*.9

Hasilrig, Robert 40, 117

Hassell, Edward: *The Bridge House* 31, *33*

Hasylfote, John 31

Hasyll, John 111
Hawes, Stephen 39–40
Haydon, John 49
Haydon, Richard 156
hedging 111, 164; topiary 144, 159–60
Hely, John 118
Henry of Blois 44
Henry III, king of England 9, 36
Henry VII, king of England 9, 36, *36*, 38, *41*
Henry VIII, king of England *14*; courtship of
 Catherine Howard 180–81; designs for gardens 55,
 58–59; garden staff 109–12, 215–18*App.*; Hampton
 Court and gardens 15–16, 50, 97, 99–105;
 horticultural interest 17; and More 11–12, 14,
 176–77, 178, 190, 196, 199*n*.1; and York Place/
 Whitehall Palace 11, 50–65, *64*, 110, 190
heraldic beasts: Hampton Court 97, 102–03, *104*; York
 Place/Whitehall Palace 58–59
herbers *see* arbors
heretics 15, 187–89
Heron, Cecily 5, 200*n*.7
Hewett, William 121, 144, 202–03*n*.9
Heyden, Pieter van der: *Ver (Spring)* (after Pieter
 Bruegel, the Elder) 157, 159–61, *159*, *160*, 182
Heywood, Ellis: *Il Moro* 81–82, 161
Hill, Thomas: *The Gardeners Labyrinth* 128, *129*, 130,
 130, 137–38, 139–40, *139*, *140*, 182–83
Hobard, Thomas 111
Hodgekynson, Robert 169, *170*
hoes 135, *135*
Hogenberg, Franz: *Civitas orbis terrarum* 3, *3*, 4, 7, *8*,
 10–11, *11*, 21
Holbein, Hans, the Younger: *Family of Sir Thomas More*
 5, 200*n*.7; *King Henry VIII* *14*; *Sir Thomas More* vi;
 William Roper (attrib.) *6*; *William Warham* (after Hans
 Holbein) *13*; *see also* Lockey, Rowland
Holden, Symond 118
Holinshed, Ralph: *Chronicles* 21
Holkham Bible 127–28, *127*
Hollar, Wenceslaus: *Long View of London from Bankside*
 10, 48; *View of Lambeth Palace* 66, *67*; *View of
 Lambeth, the Thames, and Westminster* 66, *68–69*
Hollyer, John 64, 91, 94, 95
Hongle (Hongille), Patrick 59
Hongle (Hongille), William 59
hooks 133–34

hortus conclusus 16
"hot howses" 144
Howard, Catherine, queen of England 180–81
Hutton, Agnes 110
Hutton, John 110, 117, 165

implements *see* tools and materials
irrigation systems 139–40, *140*

James I, king of Scotland 180
Jasper, Stephen 109, 117
Jay, Robert 36
John the Gardener 132
Johnson, William 116, 118
Jones, Inigo 51, 55

Kellet, Tey 118
Kendall, Agnes 119
Kenedie, Richard 59
Kettill, James 116, 118, 183–84
King James Bible 90
Kip, Johannes: *Beaufort House, Chelsea* 76
kitchen gardens: Bridge House 26, 28, 31–32, 48;
 Fulham Palace 87, 88; Lambeth Palace 71;
 Winchester Palace 48
Knights Hospitallers of St. John 91
knives: pruning knives 131, *131*
knot gardens 166–72; Bridge House 32, 166, 167–68,
 169; designs *168*, *169*, *170*, *171*; Hampton Court
 95–97, 169, *171*; Southwark 49, *49*
Knyff, Leonard: *Beaufort House, Chelsea* 75–76, *77*;
 Hampton Court 90–91, *92–93*; *Whitehall Palace* 55, *57*

Lady Fair dinner 184
Lambeth Palace and garden 12–13, 66–74, *67*, *68–69*,
 73, *74*, 114, 187; checkered history 66, 71; Cranmer's
 building projects 70–71; gallery and terraces 70–71,
 185; garden records 67, 70, 71, 73–74; garden staff
 71, 73–74; Lollards' Tower 66, *67*; moat 71; More
 rejects Royal Commissioners 13, 70, 177, 196–97,
 199*n*.1; More visits 74, 177; Morton Gatehouse 66,
 67, 153; orchard 71; Privy Garden 71, 74; water
 features 65
Landsberg, Sylvia 164
Langley 117
Latimer, Hugh 177, 187

Laurence, John 205*n*.38

Law, Ernest 169

Lawson, William: *A New Orchard and Garden* 172, 173

Leighton, Agnes 110–11

Leo x, Pope 199*n*.1

Lewis, Hugh 118

Liebault, John: *Maison Rustique* 164–65, 167, *168*, 171

Lincoln's Inn 153

Lockey, Rowland: *The Family of Sir Thomas More* (after Hans Holbein the Younger) 76, 78, *78*, 80–81, *150*, 157, *158*, 186

London, bishop of *see* Fulham Palace

London: City boundaries 200*n*.4; City charter and control of Thames 22–23; depiction in maps 21; imagined in *Utopia* 1–4; St. John the Baptist festival 29; *see also* Thames

London Bridge (old bridge) 7, 23–24, *24*, 25, 42, *43*; in More's *Utopia* 2, 3; *see also* Bridge House and garden

Lovell, John 109

Low Countries: bird pots 146–47

Lyte, Garret 95

Malcolm, James Peller: *Fulham Palace 85*

market gardening 48

Marlow, Mrs John 119

"Martin pots" 149

Mary i, queen of England 181

Mascall, Leonard: "Orchard Tools" 133, *134*

Matson, Rouland 48

mattocks 128

Maybank, John 112

Melton, Nicholas 116, 118

Merston (Weston), John 48

Middelton, Roger 116

Miller, Reynold 94

moats 71, 84, 95

Moravian Burial Ground, Chelsea 76, 154–55, *156*, 181, *181*

More, Agnes 111

More, Dame Alice (More's second wife) 5, 82–83, 200–01*n*.7

More, Edmund 96

More, Jane (More's first wife, *née* Colt) 191

More, John (More's father) 7, 151

More, John (More's son) 5, 200*n*.7

More, Margaret (More's daughter) *see* Roper, Margaret

More, Sir Thomas vi, 5; Christianity 187–89, 194–95; *Confutation of Tyndale's Answer* 189; *De tristitia Christi* 198; *Dialogue of Comfort against Tribulation* 108, 196; epitaph 188–89; Erasmus on More's friendship 177–78; family portrait *see* Lockey, Rowland; and friendship 177–78; garden history parallel 7, 18–19, 197–98; and garden staff 108; gardens *see* Bucklersbury house; Chelsea manor and gardens; and Henry VIII 14, 176–77, *178*, 190, 196, 199*n*.1; imprisonment and execution for treason 7, 8–9, 13, 196–97, 199*n*.1, 200–01*n*.7; interrogation of heretics 15, 187–89; legal career 7, 151, 193; and London 1–4; personality 18–19, 191–98; political dissembling 178–79; surrender of office 12, 59, 62, 190, 199*n*.1; takes leave of family 196–97; views on women 195, 212*n*.5; *see also Utopia*

Morton, Cardinal John, archbishop of Canterbury 12–13, 66, 187; *see also Utopia*

Mounteyn, James 59, 62

Mounteyn, Richard 59, 62

mounts 161–62; Hampton Court 100, *101*, 102, 103, 112, 161; More's Chelsea manor 82

Museum of London: garden equipment 123, *124*, 125–27, 131, 138, 143, 144–46

Myliss, Henry 118

Newcourt, Richard: *Map of Southwark* 49, *49*; *Map of Westminster* 57, *59*

Nonesuch garden, Surrey 17

Norden, John: *View of London* 45, *46*

Oker, Jane 110–11

Old Barge, Bucklersbury (More's house) *182*, 200*n*.3

orangeries: Hampton Court 97, *99*

orchards: Bridge House 32; fruit trees 36, 103, *104*, 111–12; Fulham Palace 87, 88–89; Hampton Court 94, 95, 97, 103, *104*, 111–12; Lambeth Palace 71; More's Chelsea garden 76, 82, 164; sourcing trees 111–12; tools for use in 132–34, *134*; Tower of London 9, 36; Winchester Palace/Southwark 48, 49, *49*; York Place/Whitehall Palace 53, 59, 62, 65, 110

Orgar the Rich 44

Otford, Kent 67

outdoor eating 24, 29, 160, 184–86; *see also* banquets

Paget's Place 152
"pakthrede" 167
paring irons 128, 159
Parker, Margaret 73–74
Parker, Matthew, archbishop of Canterbury 73
parlors: Bridge House 29, 30, 31, 183–85; Fulham
 Palace 87, 185; *see also* arbors
Parson, Thomas 94
Patenson, Henry 5, 200*n*.7
Paulet, Sir William 166
Paulmer (Palmer), John 144
Philip of Spain 181
Pindar, Paul: banqueting house 186, *186*
plants: for arbors 182–83; Bridge House parlor 183–84;
 costs 27, 111–12, 118; Fulham Palace collection 87;
 Hampton Court 94, 103–4, 109, 110–12; for knot
 gardens 168; Lambeth Palace 71, 73–74; preparation
 for planting 131, 159; suppliers 111–12, 113, 114,
 118–19, 207*n*.9, 216–22*App.*; Tower of London 36,
 40–41; York Place/Whitehall 64–65; *see also* hedging;
 trees; vegetables
Plea Rolls of the Court of the King's Bench 40–41, *41*
pleasure gardens 32, 48, 104; *see also* garden uses
ponds: Hampton Court 95, 97, 102, 103, 111; York
 Place/Whitehall Palace 65
pots: bird pots 144–47, 149, *149*; containers for plants
 143–44, 160
Pounche, Agnes 111
privy gardens: Fulham Palace 88; Hampton Court 41,
 97, 99–100, *101*, 102–03, 104, 110–11, 131, 140, 165,
 181; Lambeth Palace 71, 74; More's Chelsea manor
 76, 78, 80–82, 164; Tower of London 8–9, 38–40;
 York Place/Whitehall Palace 51, 53, 55, *56*, 57–59,
 64–65, 67
prostitution in Southwark 204*n*.30
Proud, Thomas 64, 91, 94, 95
pruning knives 131, *131*
pumps for watering 139–40, *139*, 141
Pury, Robert 117

quicksets 111

Rake, Robert 48
rakes 128, *129*
Randolf, John 64, 91, 94, 95
Ratford, Robert 116

Rea, John: *Flora* 138
Rede, John 109
Reynolds, Richard 64, 91, 94, 95
Reynolds, Walter, archbishop of Canterbury 71
Richmond Palace gardens 38–39, 109
Ripley, John 97
river language 22
riverside gardens 6–16, 152, 197
Roberts, Roger 118
Roche, John 116
Rocque, John: *Fulham Palace, Surveyed* 86–87, *86*, 88
Rodwell, Warwick: *Reconstruction of Fulham Palace
 Gardens 89*
Rogers, Margaret 111
Roper, Margaret (*née* More) 5, 195, 200*n*.7, 212*n*.5; and
 Chelsea manor 76, 80, 81
Roper, William 6, 7, 176–77, 178, 196–97, 200*n*.3; and
 Chelsea manor 76, 80, 81, 196; garden talks with
 More 4, 6, 201*n*.8
Rosa damascena trigintipetala 40–41, 104
roses and rose gardens 40–41, 88, 104, 183–84
rowing 175, *176*
royal coat of arms 95–96, *96*, 183, *184*
Royal Commission oaths 13, 177, 196–97, 199*n*.1
Russell, Henry 113–14, 119
Russhe, John 156
Rutter, William 117
Ryce, Symond 32, 151
Ryley, John 140
Ryley, Thomas 140

Saddeler, Richard 118
St. John the Baptist festival 29
St. Mary Overie priory 42, *43*, 180
St. Olave's church 7
Sands, Mollie 112
Savell, Richard 118
seeds: costs 27; gardeners as suppliers 118–19; Hampton
 Court 94; preparation and planting 131, 159; *see also*
 plants
servants of noblemen 128–29
"setting drag" 131
Sharpe, Thomas 94
Shepherd, John 111
Shepherd, Thomas Hosmer: *The Bridge House,
 Southwark* 30, *30*

Sherman, Katheryn 119

Shippe, William 71

Shore, William 111

Shorlocke, Walter 59

shovels 125–27

Shugesby, Robert 156

Smith, Richard 40, 94

Smith, William: *View of Westminster* 58, *58*

Snethe, William 149

Snow, John 95

Somerset, Lord Protector 153

Southwark *25*, 42, *43*, *49*; brothels 204*n*.30; gardens and market gardening 48–49; *see also* Bridge House; Winchester Palace

Southwark cathedral 42

spades/spade irons 124, 125–27, *126*, *127*

Sparrow, John 116

sparrow pots 145, *146*, 149

Speed, John: *View of London* 45, *46*

Stafford, John, archbishop of Canterbury 71

status and gardens 7, 102–03, 197

Stoke, Harry 118

Stokesley, John, bishop of London 15, 187, 188

"stove houses" 208*n*.12

Stow, John 29, 184–85, 200*n*.4

Strabo, Walahfrid: *Hortulus* 137, *137*

Strong, Roy 80, 102, 209*n*.15

summer houses/parlors: Bridge House 29, 30, *31*, 183–85; Fulham Palace 87, 185

sundials 103, 203*n*.14, 206*n*.76

Swallow, Ales 110–11

Swallow, John 95

Swallow, Thomas 205*n*.38

Teniers, David, the Younger: *Smell* 144, *145*

terraces 70–71, 157, 185

Tewkesbery, John 188

Thames: depiction in maps 21; in More's *Utopia* 1–2; river language 22; riverside gardens 6–16, 152, 197; rowing 175, *176*; as thoroughfare 21, 22–23, 175

Thomson, William 64

Thorpe, J. B.: *View of Old London Bridge* 24

Thorpe, John 82

Thurley, Simon 38, 53, 62, 87

Titian: *Noli me tangere* 135, *135*

tools and materials 65, 91, 94, 95, 123–49; costs 27, 32

topiary 144, 159–60

Torrigiani, Pietro: Henry VII bust *36*

Tower of London gardens 8–9, 32–41, *37*, *39*, *43*; gallery 38–39; garden staff 40, 117; Henry VIII's preparations for Anne Boleyn 40–41; King's Privy Garden 8–9, 38–40; Nine Gardens 9, 36; Queen's garden 38

Tradescant, John, the Elder 66

Tradescant, John, the Younger 66

trees: fruit trees 36, 103, 104, 111–12; and garden design 159–61; *see also* hedging; orchards

Treveris, Peter *120*, 121

Tryme, William 167–68

Tubbys, John 121

Tubbys, Modor (Mother) (*later* Hewett) 121, 202–03*n*.9

tubs for water 136, 140–41

Tull, Jeffrey 157

Tunstall, Cuthbert, bishop of London 15, 89–90, 187, 192–93

Tyndale, William 89–90, 189

Tyrrell, Peter 118

Usher, Yeoman (gardener) 40

Utopia (More): on Cardinal Morton 12–13; on common wealth 107–8; on Cuthbert Tunstall 202*n*.20; gardens of 3–4, 6; London imagined in 1–4; on lot of idle servants 128–29; on political debate 175–76; on political dissembling 179; Tunstall's reaction to 192–93

Vander, Pierre: *Les Delices de la Grand Bretagne* 161–62

vanes 31, 183

vegetables: attitudes towards 203*n*.11; *see also* kitchen gardens

"verjuice" 131

Vertue, George: *Survey of Whitehall* 53, *54*

viewing structures 160–61; *see also* galleries; mounts

Vincent, Edward 111

Vincent, Lawrence 111

vines 27, 36, 116, 131–32, *133*, 159

Visscher, C. J.: *Long View of London* 9

walks 182–83; *see also* alleys; galleries; terraces

walls and walled gardens 16, 153–54; Fulham Palace 87, 153–54, *155*; Hampton Court orchard 95, 154;

More's Chelsea garden 76, 78, 154–56, *155*, *156*, 157; Tower of London 36

Walter, William 64

Wanstede 117

Warham, William, archbishop of Canterbury 13, *13*, 67, 73, 74, 187

Warman, Richard 40

Wassher, Richard 202–03*n*.9

water features 65, 157; Hampton Court 95, 102; *see also* fountains; moats; ponds

watering methods and tools 136–43, *139*, *140*, *142*, 159; irrigation systems 139–42; storage containers 136, 142–43; watering pots *127*, 136–38, *136*, *138*

weather vanes 31, 183

Webster, John 48

Wedel, Lupold von 204–5*n*.35

weeding: tools for 134–35; women's work 119, 121

Welshe (gardener) 109

West Horsley: King's Garden 113, 117

Weston (Merston), John 48

wheelbarrows 128

Whetele, Thomas 71

Whitehall Palace *see* York Place/Whitehall Palace

Whitwell, John 117

Williamsburg: bird bottles 149

Winchester, bishop of 42, 44; *see also* Winchester Palace

"Winchester geese" 204*n*.30

Winchester Palace and gardens 9–10, 42–50, *44*, *45*, *46*, *47*; Clink Prison 204*n*.30; "domus gardini" 185; as ecclesiastical estate 42–43, 50; entertaining visitors 48, 180–81; extent of estate 42; fire 50; kitchen and pond gardens 48; reeves' accounts and garden leases 48–49; the Wild 44–45, 48

Windsor 117

Wolsey, Cardinal Thomas 10, *12*; census 82; election as cardinal 64; entertainment of dignitaries 180; garden staff 112–15, 219–20*App*.; Hampton Court and gardens 15–16, 50, 62, 67, 91–100, 181; and Henry VIII *174*, 176, 177; importance of gardens 187; and Lambeth Palace 66–67, 70; Winchester Palace 50; York Place/Whitehall Palace 11–12, 50–53, 62, 64–65, 67, 110

women: garden staff 110–11, 113, 119, 121, 140; More's views on 195, 212*n*.5

Woodstock 117

Wright, Andrew 183

Wright, Richard 166, 202*n*.9

Wylcokes, John 144

Wyngaerde, Anthonis van den 21; *Hampton Court from the South 16*, 102–03; Whitehall Palace image 58

Wynkefelde (Wyngfeld), Louis 48

"wyre" 134

York Place/Whitehall Palace and gardens 11–12, 17, 50–65, *52*, *54*, *55*, *56*, *63*, 152; banqueting house 51, 55, 185; design 55, 57–59; fire (1698) 53, 57; fountains 57, 58; gallery 11–12, 53, 59, 62; garden staff 59, 62, 64, 110, 111, 112–15, 117, 119, 216–20*App*.; Great Garden/Privy Garden 51, 53, 55, 56, 57–59, 64–65, 67; Holbein Gate 53, 55; lack of records 50–51, 53; More visits 11–12; and More's surrender of office 12, 59, 62, 190; orchard 53, 59, 62, 65, 110; ponds 65; Privy Garden *see* Great Garden *above*; royal coat of arms 210*n*.10; tool purchases 128; topiary 144